紫禁城宮殿

PALACES OF THE FORBIDDEN CITY

紫禁城宮殿

于倬雲主編

Chief Compiler: Yu Zhuoyun
Translators: Ng Mau-Sang, Chan Sinwai and Puwen Lee
Consultant Editor: Graham Hutt

VIKING

VIKING
Penguin Books Ltd, Harmondsworth, Middlesex, England
Viking Penguin Inc., 40 West 23rd Street, New York, New York 10010, U.S.A.
Penguin Books Australia Ltd, Ringwood, Victoria, Australia
Penguin Books Canada Limited, 2801 John Street, Markham, Ontario, Canada L3R 1B4
Penguin Books (N.Z.) Ltd, 182–190 Wairau Road, Auckland 10, New Zealand

First published in Chinese under the title *Tzu Chin Ch'eng Kung Tien*
by The Commercial Press Ltd 1982
This translation first published simultaneously in Great Britain by Allen Lane
and in the U.S.A. by The Viking Press 1984
Reprinted 1987

Copyright © The Commercial Press Ltd, Hong Kong Branch, 1982
English translation copyright © The Commercial Press Ltd, Hong Kong Branch, 1984

All rights reserved. No part of this publication
may be reproduced, stored in a retrieval system, or transmitted
in any form or by any means, electronic,
mechanical, photocopying, recording or otherwise, without
the prior permission of the copyright owner.

Chief Compiler: Yu Zhuoyun
Executive Editor: Chan Man Hung
Arts Editor: Wan Yat Sha
Photographers: Alfred Ko and Hu Chui
Designer: Yau Pik Shan
English Translation: Ng Mau-Sang,
Chan Sinwai and Puwen Lee

Set in Great Britain by Rowland Phototypesetting, Bury St Edmunds
Printed in Hong Kong by C & C Joint Printing Co., (H.K.) Ltd.

British Library Cataloguing in Publication Data

Palaces of the forbidden city.
　1. Peking-Description
　I. Yu, Zhuoyun　　II. Hutt, Graham
　915.11'56'0458　　DS795

　ISBN 0 7139 1620 6

Library of Congress
Catalog Card Number 83-5741
ISBN 0-670-53721-7

FOREWORD

The long history of China has seen the construction of many famous palace complexes, such as the Palace of A Fang of the Qin dynasty, the Wei yang Palace of the Han, the Tang capital of Chang'an, the capital of Bian of the Song, and the 'Great Capital' of the Yuan dynasty. Today the little knowledge we have concerning the shapes of these palace buildings must be gleaned from contemporary documents and historical remains. Only the Forbidden City which was built during the Ming and Qing dynasties has been preserved intact. Towering over the central axis of the capital city of Beijing, the Forbidden City is not only the largest group of wooden structures extant in China, but is also the rarest ancient palatial complex in the world.

Built in the 1420s, the Forbidden City is a distillation of many centuries of traditional Chinese palace construction. Drawing on the experience and achievements of palace architecture of past dynasties, it surpassed its predecessors in both design and construction. Thus the Forbidden City occupies a very important place in the history of Chinese architecture.

It was with the aim of producing a comprehensive and systematic introduction to the Forbidden City, and to demonstrate the arts and techniques employed in traditional Chinese architecture, that the Palace Museum and the Commercial Press, Ltd, Hong Kong Branch, agreed to collaborate on the present volume. It was compiled by a committee headed by a senior engineer, Yu Zhuoyun, Vice-President of the Society for the Preservation of Cultural and Historical Relics of China, and Deputy Director of the Department of Ancient Architecture of the Palace Museum. In his Introduction he gives a succinct description of the construction, design, and arts of the architecture of the Forbidden City.

The many photographs contained in this book show the major palaces, halls, buildings, pavilions, and gates of the Forbidden City, their exterior and interior views, decoration as well as other service facilities. The book is divided into chapters which briefly explain each topic. Extended captions have been provided to help the reader towards a greater understanding of the photographs and make their perusal a more interesting and rewarding experience. In addition, there are many reproductions of paintings, architectural maps and blueprints from the collections of the Palace Museum.

The task of compiling this volume was successfully completed thanks to the concerted effort and cooperation of the various departments within the Palace Museum, including the Department of Ancient Architecture, the Research Department, the Exhibitions Department, the Conservation Department and the Works Department; Mr Liu Beizhi, Assistant Director of the Publication Committee and Chief Editor of the *Journal of the Palace Museum*, and Mr Wu Kong, Assistant Director of the Publications Committee and Director of the Research Department at the Palace Museum, assisted in the editing and production; researchers in traditional Chinese architecture, Mr Zheng Lianzhang, Mr Liu Ce and Miss Ru Jinghua helped in the writing of the introductory articles and the preparation of the maps; Miss Zhou Suqin organized the photography and the collecting of materials. The majority of the photographs in this album were taken by Mr Alfred Ko and Mr Hu Chui.

Thanks are also due to Mr Tong Heling, Associate Professor of Architecture at the University of Tianjin, who prepared the aerial view painting of the Forbidden City reproduced on the frontispiece.

The Palace Museum
March 1982

Note: The Forbidden City is now called *Gu gong bo wu yuan* (abbreviated to *Gu gong*) or the Palace Museum.

CONTENTS

FOREWORD 5

INTRODUCTION by Yu Zhuoyun 16
 History 18
 Construction 20
 Famous craftsmen and their work 22
 The art of architecture 24
 The principles of *yin* and *yang* and the Five elements in architectural design 26

MAIN STRUCTURES OF THE FORBIDDEN CITY 30
 The city walls and moat 32
 The Outer Court 48
 The Inner Court 72
 Gardens 120
 Theatrical stages 162
 Buddhist and Taoist halls and other places of worship 176
 Reading rooms and libraries 200
 Government offices 206

ARCHITECTURAL COMPOSITION AND DECORATION 210
 Terraces and balustrades 212
 Timber construction 222
 Bracketing 228
 Roof forms and their decoration 232
 Inner and outer eave fittings 236
 Caissons and ceilings 252
 Painted decoration of structural members 266
 Glazed ornaments 280

SERVICES 286
 Bridges and culverts 288
 Water supply and drainage 292
 Heating 296
 Lighting 300

APPENDICES 308
 Plans of the main structures of the Forbidden City 310
 Chronology 325
 Outline of the major dynasties of China 327
 Bibliography 328
 Selected further reading 328
 Index and Glossary 329

1 Site of Altar to the Earth
2 De sheng Gate
3 Moat
4 Xi zhi Gate
5 Shi sha Lake
6 Drum Tower
7 An ding Gate
8 Dong zhi Gate
9 Di an men Avenue
10 Di an Gate
11 North Lake
12 PROSPECT HILL
13 Fu cheng gate
14 FORBIDDEN CITY
15 Wang fu jing Street
16 Altar to the Sun
17 Altar to the Moon
18 Meridian Gate
19 Square of Heavenly Peace
20 Gate of Heavenly Peace
21 Chang an Avenue
22 Fu xing Gate
23 Zheng yang Gate
24 Chong wen Gate
25 Dong bian Gate
26 Tong hui River
27 Xi bian Gate
28 Xuan wu Gate
29 Qian men Street
30 Guang an Gate
31 Guang qu Gate
32 Temple of Heaven
33 Tao ran Pavilion Lake
34 Yong ding Gate
35 Zuo an Gate

Fig. 1 Plan of Beijing.

1 Meridian Gate
2 Moat
3 City Wall
4 Watchtower
5 West Glorious Gate
6 East Glorious Gate
7 Golden River Bridge
8 Gate of Supreme Harmony
9 Hall of Supreme Harmony
10 Hall of Complete Harmony
11 Hall of Preserving Harmony
12 Hall of Military Eminence
13 Garden of the Palace of Compassion and Tranquillity
14 Hall for Worshipping Buddha
15 Palace of Longevity and Good Health
16 Palace of Tranquil Old Age
17 Hall of Exuberance
18 Palace of Compassion and Tranquillity
19 Hall for Worshipping the Great Buddha
20 Pavilion of the Rain of Flowers
21 Garden of the Palace for the Establishment of Happiness
22 Hall of the Ultimate Principle
23 Hall of Manifest Origin
24 Palace of Eternal Spring
25 Palace of Complete Happiness
26 Grand Council
27 Hall of Mental Cultivation
28 Palace of Longevity
29 Hall of Manifest Harmony
30 Palace of Gathering Excellence
31 Gate of Heavenly Purity
32 Palace of Heavenly Purity
33 Hall of Union
34 Palace of Earthly Tranquillity
35 Gate of Earthly Tranquillity
36 Imperial Garden
37 Hall of Imperial Peace
38 Gate of Martial Spirit
39 Palace of Great Benevolence
40 Palace of Inheriting Heaven
41 Palace of Gathering Essence
42 Palace of Eternal Harmony
43 Palace of the Great Yang
44 Five East Lodges
45 Hall of Literary Glory
46 Arrow Pavilion
47 Hall for Worshipping Ancestors
48 Hall of the Treasures of the Sky
49 Three South Lodges
50 Nine Dragon Screen
51 Gate of Imperial Supremacy
52 Hall of Imperial Supremacy
53 **Palace of Tranquil Longevity**
54 **Garden of the Palace of Tranquil Longevity**
55 **Hall of Spiritual Cultivation**
56 **Hall of Pleasurable Old Age**
57 Pavilion of Pleasant Sounds
58 Palace of Great Happiness
59 Buddhist Building

Fig. 2 Plan showing present layout of the Forbidden City.

紫禁城宮殿
鳥瞰圖

1. Artist's impression of the original Forbidden City and environs.
2. Aerial photograph of the Forbidden City showing Beihai Park and modern Beijing.

INTRODUCTION

專論──于倬雲

紫禁城宮殿的營建及其藝術

HISTORY

The Forbidden City, the imperial palace complex of the last two dynasties of China, lies at the centre of present-day Beijing. It was from here that fourteen Ming and ten Qing dynasty emperors issued edicts and ruled China for 491 years.

The name 'Forbidden City' is steeped in symbolism. In Chinese the three words, *Zi jin cheng*, incorporate a wealth of traditional Chinese beliefs. *Zi* refers to the Ziwei Star, the Pole Star, in which the supreme deity lived in his abode, the Ziwei Palace. Fixed in time and space, it was to be found at the apex of the vault of heaven and the gods of all the other stars revolved around it in homage. Because the emperor, who, having received heaven's mandate to rule on earth, was also known as the Son of Heaven, occupied the central and highest position amongst men, the analogy soon suggested itself. The capital city of the huge landmass that was China from the Yuan and the Ming dynasties and generally remains so to the present, was naturally of the greatest strategic and political importance so that it was heavily guarded along its many kilometres of walls. Even the ordinary people of the outer part of the capital were never permitted to set foot inside the city gates. It is, then, from the Chinese word *jin* that the English 'forbidden' is derived. (*Cheng* means 'a walled city'.) Perceiving merely the golden-yellow glazed tiles above the high walls, the huge populace could only wonder at this massive architectural feat, the very name of which deepened the sense of awe and mystery that surrounded it.

The Forbidden City was built during the reign of the third Ming emperor, Zhu Di. When the rebel leader Zhu Yuanzhang re-established the empire after the expulsion of the Mongol Yuan dynasty, which had ruled China between 1227 and 1368, he set up his capital at Jinling, calling it Nanjing, or 'Southern Capital', and the title of Hong wu was given to his reign. He created his fourth son, Zhu Di, Prince of Yan with military responsibility for the prefecture of Beiping (Beijing). When the Hong wu emperor died after a reign of thirty-one years and was succeeded by his grandson, the Jian wen emperor, Zhu Di refused to submit to his authority, took Nanjing by force of arms, assumed the throne, and changed the name of the reign period from Jian wen to Yong le, 'everlasting happiness', the name by which he is commonly known. Because he had lived for so long in the north of China, the emperor had become deeply aware of the threat posed by the remnants of the Yuan dynasty forces there. For strategic reasons, and in order to consolidate his political power, in the fourth year of his reign he issued a proclamation for the removal of the capital. By the fifth month of the following year construction work had begun on the palaces and temples of a new 'Northern Capital', Beijing, as well as on his own tomb, Chang ling, the first of the imperial Ming tombs to be built in the mountains some 45 km northwest of the city. At the outset, the Yong le emperor had sent ministers to the provinces of Sichuan, Hunan, Guangxi, Jiangxi, Zhejiang and Shanxi to select timber. Marquis Chen Gui was appointed to oversee the reconstruction of Beijing and the Forbidden City, and Wu Zhong, an experienced and renowned master planner, was given the task of producing the actual plans.

Three significant points emerge from a study of the Forbidden City. First, the Ming palaces were built on the site of the 'Great Capital', Dadu, of the Yuan dynasty. By acquiring a grasp of local conditions and becoming thoroughly acquainted with the very ground upon which each building stood, as well as the workings of the covered water and drainage systems, the Ming planners were able to exploit to the full the materials which had been bequeathed to them and to economize greatly on their own efforts. Because the Forbidden City possessed no natural surface supplies of its own, water was channelled into it from the Great Liquid Pool at the northwest corner. From here it ran southward and entered the Inner Court where it became the Inner Golden River as it passed from west to east across the courtyard inside the Meridian Gate. Reaching the southeast section it re-emerged from the city to converge with the Chang pu, Imperial and Tong hui rivers.

Second, although the planners drew on all that was best in traditional Yuan palace construction, they made several alterations to the layout. Because the distance between the front gate of the Great Inner Court, called the Gate of Worshipping Heaven (later the Meridian Gate), and the front gate of the city was not very great, it lacked the grandeur of the wide avenue which ran along the front of the Northern Song dynasty palace at the capital of Bianjing. The Ming planners, therefore, adopted the Song layout with the 'Street of Heaven running north–south across the Zhou Bridge' and removed the city wall several *li* (1 *li* =

0.5 km.) further south to where the Gate of Positive Yang now stands, thus creating a very long route on the central axis leading directly to the entrance of the Forbidden City. One's gaze travels northward through the Gate of the Great Ming Dynasty (renamed Gate of the Great Qing Dynasty by the Manchus), over the Outer Golden River Bridge, through the Gate of Succeeding to

Legend

— Reconstruction of Yuan dynasty capital

⌒ Gate in city wall ⌇⌇ Earth wall ⥥ Bridge over moat

1. Altar of Earth and Grain
2. Great Liquid Pool
3. Palace of Imperial Happiness
4. Imperial Garden
5. Walls around imperial palaces
6. Palace of Prosperity and Happiness
7. Great Inner Court
8. Gate of Worshipping Heaven
9. Right Thousand Step Corridor
10. Left Thousand Step Corridor

— Subsequent layout of Beijing
Walled sections of the Manchu Qing dynasty capital

A. Manchu
B. Imperial
C. Forbidden City
D. Chinese

1. Altar of Heaven
2. North Lake
3. Jasper Island
4. Prospect or Coal Hill
5. Forbidden City wall
6. Middle Lake
7. Forbidden City
8. South Lake
9. Altar of Land and Grain
10. Great Imperial Ancestral Temple
11. Gate of Positive Yang
12. Temple of Heaven
13. Altar of Agriculture

Fig. 3 Portrait of the Ming dynasty emperor Yong le (reigned 1403–24) who was responsible for the rebuilding of the northern capital.

Fig. 4 'The Kang xi emperor's tour of the South.' By Wang Hui (1632–1717) *et al.* (Horizontal scroll, Palace Museum, Beijing.) Detail showing the procession through Beijing from the Gate of Positive Yang to the Gate of Uprightness.

Fig. 5 Plan showing major areas of the Ming and Qing dynasty capital (black) superimposed on a reconstruction of the original Mongol Yuan dynasty Great Capital, Dadu (red).

Heaven (called the Gate of Heavenly Peace from the beginning of the Qing dynasty) and the Gate of Uprightness, and is finally arrested at the lofty and awe-inspiring main Meridian Gate. This lofty procession of gateways surmounted by grand structures, like the smaller gates and screen walls before individual palaces inside the city, forms a prelude to the dignified, stately atmosphere of the Forbidden City. Government offices and the extremely long 'thousand step corridors' were placed on either side of this central axis outside the Gate of Succeeding to Heaven. Inside the gate were the Great Imperial Ancestral Temple and Altar of Earth and Grain both of which in Yuan times had been situated some distance away.

Third, the Yuan palace complex had consisted of three palace groups – the Palace of Imperial Happiness, the Palace of Prosperity and Happiness and the Great Inner Court – centred on Jasper Island. The first two were the residences of the empress, imperial concubines and princes; the Great Inner Court comprised the offices and inner apartments of the emperor and empress. Although surrounded by palaces and walls, the latter possessed neither moat nor hill behind it. However, during the Ming the residences of the empress and the imperial concubines were brought within the Forbidden City and a moat 52 m. wide was dug along its city wall in order to make it more secure. The soil excavated to form the moat, in excess of one million cubic metres, was piled to a height of 49 m. in the garden at the rear of the palace complex to create Longevity Hill. This grand design corresponded to the arrangement at the Ming palace in Nanjing; an additional advantage lay in the economical disposal of so much earth. During the Qian long era of the Qing dynasty, exquisitely wrought pavilions were constructed on five peaks of the hill which was renamed Prospect Hill. The Pavilion of Eternal Spring here still provides a unique panorama over a sea of shimmering gold-glazed tiled roofs, stretching away into the distance, almost as far as the eye can see.

CONSTRUCTION

The buildings in the Forbidden City number nearly one thousand – magnificent palaces, halls, pavilions, courtyards and turrets, decorated with exquisitely wrought handicrafts, all of which required building materials on an uncommonly grand scale. Planning and budgeting for such a huge project was a delicate task.

Collecting timber

Timber was the most important material in traditional Chinese architectural construction. Very strict standards were set by Ming dynasty planners regulating the quality of the wood used. For example, *nan mu* (*phoebe nanmu*), the best of all hardwoods, was used for frames as well as for decoration. *Nan mu* grew only in the southwestern province of Sichuan and the task of felling the trees and transporting them to Beijing, some 1,500 km. away, was an arduous one. A common saying of that time was, 'One thousand people go into the mountains but only five hundred come out.'

The method of transporting the logs involved first rolling them into the dry mountain gullies. They were lashed together to form rafts and left to await the torrents which plunged down the mountainside during the rainy season, filling the

Fig. 6 Map of sources of building materials used in the construction of the Forbidden City and their transportation routes.

ravines and bearing up the craft on the swirling waters. If they went downstream they were easily poled to their destination, but if they had to be transported upstream then they were hauled by tow-rope from the banks. There were two main routes: the first made use of the Grand Canal and Tonghui River as the main waterways to the Sacred Timber Yard in Beijing. Because the timber was of the highest quality it used to be called *shen mu*, 'sacred timber'. For example, timber from Zhejiang province was transported along the Fuchun River which connected with the Grand Canal, then from Tianjin to the North Canal and via the Tonghui River to Beijing; timber from Jiangxi province travelled along the Gan to the Yangtze River before joining up with the Grand Canal; timber from Hunan and Hubei provinces went by way of the Xiang and Han rivers to the Yangtze; and timber from Sichuan was sent along the Jialing or Min rivers to the Yangtze. Timber from Sichuan normally took three to four years to reach the capital and because these forests were so vast and the supply of wood plentiful, there was an endless stream of timber travelling between the province and the timberyards in Beijing. The second route that the timber followed was from the Sanggan River in Shanxi via the Yongding River to Beijing.

The present Great Timberyard Hutong (Alley) in west Beijing acquired its name from the huge timber stores used for building the Forbidden City some five hundred years earlier. There was ample storage space in the timberyards of the east and west at that time. During the years of construction it would have never occurred to the workers that work would come to a halt because of a shortage of timber. There were 3,600 storerooms in all and until the year 1437, due to the excellent conditions, there were more than 380,000 pieces of timber still in storage.

Tiles and bricks

The range and quantity of bricks and tiles needed for building the imperial palaces and halls is astonishing. The large number of buildings and the sheer size and scale of the city walls were two reasons for such a huge consumption of materials but the way in which the buildings and courtyards were constructed was another significant factor. For example, courtyards were paved with at least three, and sometimes up to seven, layers of brick. For the courtyards alone more than 20 million bricks were required. The quantity needed for the city and palace walls and the three-tiered terraces was even greater. It is estimated that for the city wall alone more than 80 million bricks were used weighing more than 24 kg. apiece. To produce and transport 1·93 million tons of bricks into this site was a Herculean task in those days.

There were several types of brick, distinguished by size, shape and quality. The most abundantly used were the so-called 'stopping mud city wall bricks', *ting ni cheng zhuan*. Although extremely strong, they were unsuited to the slow but inevitable wear brought about by countless feet and so were used as infill or in unexposed areas. The second type was called 'settled clay bricks', *deng jiang zhuan*. The name was derived from the process of mixing untreated clay with water to form a slurry and allowing the suspension to settle. After precipitation, fine clay particles formed the top layer which was taken and formed into bricks. These were dried in the sun and then fired, producing a fine quality brick which was smooth, durable and highly suited for use as surface paving which could withstand constant wear. Linqing, in Shandong province, was the main centre of production. Current regulations stipulated that every grain-carrying boat passing through Linqing could only proceed northward once a fixed number of bricks had been taken aboard for transportation to Beijing. A third type of square brick was used to tile the interior floors as well as external corridors. They were of different size and quality: 1·2 *chi* (1 *chi* = 33·3 cm.) for small chambers; 1·4 *chi* square for side rooms; and 1·7 *chi* square for larger rooms. 'Metal bricks', *jin zhuan*, were somewhat larger, measuring between 2 and 2·2 *chi* square. Smooth and dense, these 'metal bricks' were so called because they resounded like metal when struck. Produced in the seven prefectures of Suzhou and Songjiang, they were used to pave the floors of most of the major halls in the Forbidden City.

Most of the square bricks were brought to Beijing via the Grand Canal and Tonghui River. During the early years of the Ming dynasty, the portion of the Grand Canal inside the capital was still open to traffic so the bricks could be shipped directly to the Square Brick Yard which was situated at the eastern part of the Drum Tower, outside the Gate of Earthly Peace. The Square Brick Yard Hutong of today was the site of the brick store of the Ming period.

Three types of tiles were used for roofs. While a few buildings used either 'metal tiles' or *qing wa*, 'black tiles', the majority of buildings were covered with yellow-glazed tiles. There were many different kinds of glazed tile. As it took a long time to prepare the clay, make the mould, glaze and fire them, the tiles had to be made to order. A traditional method of calculating in advance the materials that would be needed was employed each time, no matter what the job, by the specialist tilers. Given the size of the building, the shape of the roof and the size of the tiles they were able to draw up a list of the type and number of tiles needed and the kiln could go straight into production.

Situated to the southwest, between the present Front Gate and Gate of Proclaimed Military Strength, outside the Forbidden City wall, is the site of the Ming dynasty 'glazed tile works', *liu li wa chang*. Two places, Liu li chang, a well-known area for antiques, and Chang xi men, Gate at the West of the Works, still exist which have taken their names from this kiln. The place where black

Fig. 7 Carpenter's ink marker.

Fig. 8 Wooden rule divided into *chi* (0·36 m.) and *cun*. Ten *cun* equalled one *chi*. The marker and rule are of types used in the construction of the Forbidden City.

tiles were fired was known as *hei yao chang*, 'black tile kiln', near where present-day Tao ran ting (Joyful Pavilion) Park and the Kiln Terrace now stand. The lakes, which we can see today in Tao ran ting Park, are the result of earth excavations carried out there from which clay was extracted for producing architectural ceramics some 500 years ago.

During the Ming, and later during the reign of the Qian long emperor of the Qing dynasty, there was a ruling that 'no kilns are to be built within 5 *li* (2½ km.) north of the capital'. This was because the prevailing winds in Beijing came from the northwest and the firing of clay in the northwestern suburbs could easily pollute the city air. During the Kang xi period, the kiln was moved to the Glazed Tile Canal at Men tou gou. The move at the same time brought the works nearer to the source of the raw materials as well as conserving the pure air of the capital.

Quarrying stone

In general, wooden structures built on level ground do not require a large quantity of stone as a supplementary building material. However, the stones used in the Forbidden City were not only great in number but also huge in size. During the early years of the Ming dynasty, particularly, high standards were set concerning the building materials employed in the construction of palaces. For example, the length of the slabs forming the steps of the terraces had to match the space between the pillars of the building which stood above them. The space between the central posts supporting the Palace of Heavenly Purity measured 7 m. and so the length of each of the stone steps had to be more than 7 m. in order to account for the width of the posts themselves. It was a tall order not just to extract stones of this size but also to obtain them in the vast amounts required. It is not surprising, however, as we can see for ourselves, that great difficulties were encountered when trying to maintain these standards during the repairs undertaken after the Manchu conquest. Even the great and important Hall of Supreme Harmony seems not to conform to this relationship of measurements. This was because several changes in method were introduced. In order to resolve the problem of hewing such long blocks of stone, the rules were relaxed, and a greater number of shorter blocks were allowed.

There were also strict rules governing the stone that could be used for the huge inclined carved slabs over which the emperor was carried when mounting the steps in front of the principal audience halls, some of which approach 5,000 kg. in weight. Despite their size, however, they were not restricted to these positions. Undecorated flagstones paved the full length of the Imperial Way along the central axis of the Forbidden City, running north–south, from the Meridian Gate, Gate of Uprightness and Gate of Heavenly Peace. These were quarried from Da shi wo (Big Stone Hole) in Fang shan xian and Qing bai kou (Green-white Stone Hole). Known for its hardness and green-white colour, this kind of stone was called 'green-white marble' or 'mugwort marble'. More than 10,000 pieces of this stone, each weighing 5,000 kg., would have been needed in the construction of the Ming dynasty capital. The two slabs carved with dragon designs, mentioned above, on the three-tiered terraces at the front and back of the Hall of Supreme Harmony both measure 16·57 by 3·07 m. To be able to extract such huge blocks in one piece, free from cracks and blemishes, was no mean feat. It is estimated that each slab weighs 250 tons which means that the original uncarved blocks must have exceeded 300 tons each.

When the three major halls were rebuilt during the Wan li reign period (1573–1620) of the Ming dynasty the carved slab needed for the front of the Hall of Supreme Harmony was 'one *jiang* (3·33 m.) wide, five *chi* (1·66 m.) thick and more than three *jiang* (10 m.) long'. Its weight has been estimated at 180 tons. Transportation by cart was out of the question and nor was it possible to roll it on logs along the ground. The ingenious solution lay in waiting for winter to arrive. Wells were sunk at 1 *li* intervals to provide water that, when thrown across the route, froze into a glassy sheet which allowed the heavy slab to glide along relatively easily. Given the conditions of the time, this was a most effective mode of transport. Nevertheless, it took over 20,000 workers a total of more than 28 days to drag the stone to Beijing. However, it measured only three-fifths of the total length required and so two other pieces had to be added. In order to avoid ugly seams becoming obvious when the stones were laid end to end, detracting from the full impact, skilled masons made use of the undulating surfaces of the lines of the clouds, carved in high relief, to effect perfect, concealed joints. It was not until crevices appeared with the passage of time that the joints were discovered and the long-kept secret that the Hall of Supreme Harmony did not possess – as did the Hall of Preserving Harmony – a single carved slab, was revealed.

Apart from the 'green-white marble', Fang shan xian was also rich in a white stone. Included in this category was one type which was, like jade, hard, smooth, oily to the touch and white, called *han bai yu* '*han* white jade', a kind of white marble. The ubiquitous balustrades in the Forbidden City are all made from *han bai yu* and commonly referred to as 'jade balustrades'. White marble weathers very quickly. However, the *han bai yu* paving the Imperial Way leading to the Hall of Mental Cultivation and making up the balustrades in the Hall of Imperial Peace, as well as the stands bearing strange rocks or 'miniature landscapes' (*pen jing*), are obviously of unusually high quality as they still maintain their original gleaming, crystalline appearance.

Other building materials

Lime was also used in large quantities. Lime kilns were mostly to be found in Zhoukoudian (the cave home of Peking Man), and Cijiawu, both near Beijing, at Niulan shan, in Shunyi xian, in Huirou xian and in many other areas in Shanxi province. The lime works at Ma'an shan still produce lime of top quality today. Unlimited amounts of red clay were also needed to produce the red wash for city walls. Mixed with lime it created a glutinous substance which was employed in fixing roof tiles. Red clay is extracted in Lu shan and processed at Bo shan, both in Shandong province; Bo shan is well known for red clay production. Another type, 'gold clay', was used to make the deep yellow wash which covered the walls of great halls. Yellow was also the imperial colour. This came from Yantong shan, north of the city of Xuanhua in Hebei province. These materials apart, gold, an integral part of palace decoration, was liberally applied to the thrones inside the buildings as well as to exterior decoration in the form of an admixture of real gold powder and transparent lacquer. Fine gold leaf, produced mainly south of the Yangtze, especially in the Suzhou area, was also used in large amounts.

FAMOUS CRAFTSMEN AND THEIR WORK

Although some structural components were made during the initial long and careful planning stages of the palaces, it was not until 1417 that actual construction of the Forbidden City began; and work was completed in 1420. That such an enormous project could be finished within such a short period of time is an unprecedented architectural phenomenon. This was partly due to the labour of over one million workers and the ingenuity and collaboration of the 100,000 planners and craftsmen who had been drafted from all parts of the country. Some of the skilled artisans were engaged in the planning, some in management, and others in the production of the objects themselves. Three famous craftsmen of the day, Lu Xiang, Yang Qing and Kuai Xiang, were the master builders of the palace, each having inherited his speciality from his family.

The master mason, Lu Xiang, learned his craft from his father. When the emperor, Zhu Yuanzhang, built his capital in Nanjing (Nanking), Lu applied to serve there. His stonework is distinctive for its precision and scrupulous attention to detail. Examples can be found in the white marble balustrades in the Hall of Imperial Peace and the 'thousand dragons spurting water' carvings of the three-tiered terrace of the Hall of Supreme Harmony. The master tiler, Yang Qing, an expert in materials and labour, supervised and coordinated the manufacture of enormous quantities of tiles needed for the project. The master carpenter, Kuai Xiang, came from Wu xian, Suzhou. His father, Kuai Fu, was an experienced and skilful carpenter-builder who had overseen the timber construction of the imperial palace at Nanjing. Kuai Xiang learned his father's trade, served his apprenticeship in Nanjing, and later became a master carpenter in his own right. When his father retired, Kuai Xiang took over his position. It was only natural, therefore, that he should follow the Yong le emperor to Beijing to take charge of all timber working in the Forbidden City in 1417.

The overall design and planning of the palace was first carried out through the collaboration of the experts of the different trades, then examined by the Ministry of Works, and finally submitted to the emperor through the eunuchs. Work could only proceed with the emperor's stamp of approval, but he relied heavily upon these advisors and confidants who took advantage of their privileged position, greatly enhanced during this period, in the Inner Court to gain the upper hand over the state bureaucracy. It is often recorded that the expert planners of the palace were Marquis Chen Gui, Wu Zhong, the Minister of Works, and the eunuch Ruan An. In fact, the person who contributed most to the planning and design of the city was Cai Xin, a master builder in all respects, a skilful designer and manager who won the respect and cooperation of the master craftsmen of the different trades.

By the ninth lunar month of 1420, construction work neared completion. On the ninth day of that month the emperor proclaimed that the new palace would be blessed and that Beijing would be named the new capital on the first day of the new year. By the twelfth month of the same year all the palaces and temples were completed, but in the fourth month of 1421, only 100 days after its completion, fire broke out and the three main halls were reduced to ashes. In the court, the opinions of ministers were divided, some advocating a return to the old capital, Nanjing. Reconstruction was thus delayed, and the Gate of Serving Heaven served temporarily as the imperial court. After the death of the emperor, his son Hong xi decided to move the capital back to Nanjing and orders were issued for the renovation of the Nanjing palace. After only one year on the throne, however, the Hong xi emperor died and it was not until four years later in 1439 that the decision was finally made to reconstruct the two palaces and the three halls by the new Zheng tong emperor. The Minister of Works, Wu Zhong, was entrusted with administering the entire project, and Kuai Xiang, the master mason, with planning and overseeing the actual work. Reconstruction began in 1440 and continued for two years. By that time Kuai Xiang had attained perfection in craftsmanship and under his supervision the work proceeded to order.

One evening in 1557, one hundred and twenty years after the reconstruction, the imperial palace was again damaged by fire caused by lightning, and several palaces and gates were destroyed. Because no files had been kept of the original drawings of these buildings, the officials in the Ministry of Works were reluctant to propose plans for reconstruction. Two master builders, Xu Gao and Lei Li, who had a firsthand knowledge of the burned-out palaces, came forward with a proposal and reconstruction work began in the tenth

month of that year. Restoring the woodwork of the Gate of Serving Heaven took the whole of the following winter, tiling and painting the entire spring, and work was finally finished in the seventh month, when it was renamed Gate of the Great (Ming) Dynasty. Work on the three halls was finished in 1562. Fearing that lightning might strike again, the emperor decreed that a Temple to the God of Thunder be built and that some buildings be renamed.

Seventy-nine years later the Forbidden City suffered another conflagration and several palaces were devastated. Because of a current shortage in stocks, timber orders had to go out direct to the distant provinces of Sichuan, Hunan, Guangdong, Guangxi, and Guizhou, and reconstruction could not be completed until eighteen years later, in 1615. The Hall of Complete Harmony and the Hall of Preserving Harmony, as we know them today, are a result of that reconstruction. From 1625 to 1627 there was also extensive renovation of the three front audience halls. According to some records the two above-mentioned halls were built in the reign of Tian qi. However, from an analysis of the construction of their framework, we find many similarities in method between these and buildings of the Wan li period. It is true that some timbers were replaced during the 1625 reconstruction, yet the basic framework nevertheless remains that of 1615.

The Master of Works, Feng Qiao, a skilful carpenter, contributed his talent to refurnishing the palaces in the reigns of Wan li and Chong zheng. He discovered that a young carpenter named Liang Jiu showed great promise and so, taking him under his wing, the older man taught Liang all he knew. It was due to Feng's encouragement and inspiration that Liang later began employing an inch–foot scale and produced architectural scale models to use in supervising the site work when the Hall of Supreme Harmony was rebuilt in the thirty-fourth year of Kang xi, during the Qing period. By using these models, Liang was able to explain to the workers the shape, structure and proportions of the building.

In China, just as older craftsmen passed their techniques and craft to young disciples, so fathers handed down family knowledge to their sons. This was the way that the carpenter Kuai Xiang and the master mason Lu Xiang learned their trades. In the early years of the Qing dynasty, Lei Faxuan and Lei Fada served their apprenticeships in Beijing as carpenters. Because of their superb skill, they were quickly promoted to the position involving palace planning and design. In the course of his work, Lei Fada invented the use of architectural modules made with cardboard. The craft of the Lei family was handed down through seven generations until the end of the Qing dynasty, spanning a period of more than 240 years. During this period, the Lei family had a hand in the building of all the palaces and courts, which included the imperial resort at Chengde, just north of Beijing, and the famous Yuanming yuan in Beijing. During 1669 the Kang xi emperor personally officiated at a ceremony for the positioning of the central beam during the reconstruction of the Hall of Supreme Harmony. When the beam was lifted up to be fitted into the tenon, the latter did not fit and officials were afraid that this would incur the anger of the emperor. At that very moment Lei Fada, already over fifty, climbed up, dressed in his official court dress, sat on the beam and with his hatchet reworked and shaped the mortise and tenon so that the beam would fit. The ceremony could therefore proceed accordingly. The emperor was so impressed that he immediately made Lei a Director of Works.

Imperial building in the Qing dynasty was undertaken by two separate departments, the design office and the planning office. While architectural design and construction was undertaken by the Lei family, budgeting and management were under Liang Jiu, Liu Tingzhan, and Liu Tingqi.

THE ART OF ARCHITECTURE

The Forbidden City was built on the legacy of traditional palace architecture for, like earlier palaces, it symbolized the supreme glory of the emperor. The palace complex of the Forbidden City, however, is exceptional in the breadth and unity of its conception, as well as in the variety of design within this uniformity.

Spatial composition

In order to vary spatial composition and convey different visual impressions by employing different layouts, the architect must understand spatial relationships between buildings, and the relationship between the buildings and the people.

The Meridian Gate is the front gate of the Forbidden City proper. The Imperial Way leads to

| Gate of Martial Spirit | Hall of Imperial Peace | Gate of Earthly Tranquillity | Palace of Earthly Tranquillity | Hall of Union | Palace of Heavenly Purity | Gate of Heavenly Purity | Hall of Preserving Harmony | Comple |

10

it from the Gate of Heavenly Peace and on through the Gate of Uprightness. The Imperial Way, also called the Street of Heaven, was the main route leading straight through to the imperial palaces. The corridor and galleries flanking both sides of the avenue constitute a deep, narrow and enclosed space. Walking along this street one has the impression that one is inspecting a guard of honour on both sides. In addition, the symmetry directs one's gaze toward the Meridian Gate ahead, enhancing the air of solemnity pervading the approach to the palace. Had the covered walkways to either side been taller or less monotonous they would have detracted from the focal point and the loftiness of the Meridian Gate would have been lost. Once inside the Meridian Gate the space changes abruptly: the long, narrow oblong of the Street of Heaven opens up into a huge courtyard and the open-galleried buildings surrounding it also assume a different appearance from those outside the palace. These structures are all built on a running terrace that is almost the same height as a human being, causing them to appear even more imposing and making the person feel insignificant in contrast. At the same time, the eye is immediately attracted to the five-arched flying dragon bridges with marble balustrades spanning the Golden River in front. Despite the immense area of the square, anyone entering the Forbidden City will invariably be attracted to the river and the bridges in the centre of the square.

Entering the square of the Gate of Supreme Harmony, one is struck by the magnificence and elegance of the Hall of Supreme Harmony, the climax of the Forbidden City plan. The majesty of the hall lies not only in the height of the building. The hall and terraces measure 2,377 sq. m. with a height of 26·93 m., not much higher than an eight- or nine-storey building. Even though it is the grandest structure in the entire palace complex, covered by the highest ranked double-eaved roof, much of its grandeur would be lost without the three-tiered terrace to set it off. Inside the vast courtyard and in front of the huge palace, one cannot help but feel small. The emperor seated on the imperial throne and looking down on the great mass of people in the square below would have shown himself majestically as the 'Son of Heaven'.

Although similar in style to the three front halls, the three rear palaces are much smaller in scale and their courtyards are half the size of the square facing the great halls. However, the major difference lies in the ingenious disposition of this dividing courtyard. In order to distinguish between the important complexes of the three front halls and the palaces behind them, both of which have oblong courtyards which are orientated north–south, an expansive courtyard, horizontal in plan, was laid east–west across the central axis of the city. Combined with the walls, decorated with green, orange and red glazed tiles, leading funnel-like towards the two sides of the Gate of Heavenly Purity, this differentiation in spatial arrangement seems to mark the end of one type of imperial group of buildings and beginning of another which is quite different in essence – the Inner Court.

The Inner Court differs from the Outer Court mainly in the use of the contrasting method of spatial arrangement, and not just in the scale and size of the buildings. While the front halls may be characterized by their expansiveness, the rear halls are packed close together, emphasizing the less ceremonious, more intimate nature of the Inner Court. In short, the spatial composition of the Forbidden City represents a combination of both expansive and tightly packed forms, interlocking verticals and horizontals and rising and falling elements, and is the concentration of the essential components of classical Chinese architecture.

Decoration

Good ornamentation in classical Chinese architecture invariably satisfied practical as well as aesthetic needs. It was only when these two needs were met that the highest standards were achieved. Architectural decoration in the Forbidden City was followed generally according to this principle, and decoration was applied where it was structurally needed. Looking at the ornamentation in the Forbidden City we find several examples of this kind of practice.

First, the rows of gilt bosses that adorn the imperial gates impress one with a sense of the wealth and solemnity of the imperial palaces beyond. Both halves of each of these double gates bear eighty-one gilt bronze bosses in rows of nine which act as simple but effective decoration. In fact, historically the studs were used to secure firmly the door planks to the cross-timber framework. Such a construction can be seen at the Southern Chan Buddhist Temple. As there are

Fig. 9 Door bosses

Fig. 10 Section through the main buildings lying north–south along the central axis of the Forbidden City.

Hall of Supreme Harmony Gate of Supreme Harmony Meridian Gate N

five lateral timbers on the backs of each gate (called *fu* during the Song dynasty (960–1279)) there are, therefore, five rows of capped large iron bolts.

Second, on important buildings the two ends of the horizontal top ridge and the ends of the sloping ridges were all adorned. A large 'gaping dragon', *da wen*, is found at the junction of the horizontal and sloping ridges serving a structural function as well as an ornamental purpose. Since the upper sloping ridges were built at a sharp angle, they presented a weak link at a vital point in the construction and could easily slide free. To solve this problem, in the construction iron bars were inserted at the lower end of each ridge to strengthen the structural member and ornamental animals were then stuck onto the ridges to hide the protruding ends of the bars. The silhouettes of these rising and falling figures also serve to break the sense of monotony of the rooflines.

A third example can be seen in the treatment of eaves. The rafters are the main support, carrying the weight of the roof. In modern architecture most rafters are hidden, but in traditional Chinese wooden structures the rafters were fully exposed and decorated with different designs and patterns at the eaves. The ends of most of the round rafters in the Forbidden City are painted with the patterns such as 'the dragon-eye precious pearl', 'the tiger-eye precious pearl', or the Chinese character of longevity stylized in a circular pattern. Squared-ended eave-rafters were generally decorated with Buddhist swastikas or jasmine flower patterns. In key buildings, the undersides of the eave-rafters were decorated with gilt *ling zhi*, the fungus of immortality, which added to the splendour of the buildings. These patterns can also be found on the upturned eave-rafters of the Three Great Audience Halls and the Three Rear Palaces.

Finally, the lavish stone carvings of the three-tiered terrace followed this principle of practical use combined with considerations of decoration. The marble balustrades on each layer of the terrace safeguard pedestrians from falling over the edge. The carved hornless dragon heads, *chi*, which stretch out from the base of the balusters direct muddy rainwater away from the terrace and prevent it from spoiling the pure marble below.

It is characteristic of the decorative art of the Forbidden City that craftsmen not only dared to expose the underlying structures but they also freely embellished the structural members and turned them into works of art. Therefore, drainage at the three-tiered terrace was not achieved by hidden trenches, but by water spouts in the form of a thousand dragons. It was this kind of planning that met both the most simple and complex requirements of function and decoration.

THE PRINCIPLES OF *YIN* AND *YANG* AND THE FIVE ELEMENTS IN ARCHITECTURAL DESIGN

The theories of *yin* and *yang* and the Five elements have a long continuous history in Chinese civilization. The Chinese classic on medicine, *Huang di nei jing*, says that '*yin* and *yang* is the way of heaven and earth', meaning that everything can be divided into the two mutually opposing and independent elements of *yin* and *yang*. For example, the pairs of above and below, front and back, odd and even, positive and negative numbers, were classified as follows: above, front, odd and positive belong to *yang*, whereas below, back, even and negative are associated with *yin*. It is believed that all things on earth consist of the unity of opposites. This is why the *Inner book* (*Nei jing*) regarded *yin* and *yang* as the 'cardinal principle of all things'.

The architectural design of the Forbidden City directly reflects the principles of *yin* and *yang*. Of the two sectors of the Forbidden City, the Outer Court signifies *yang* while the Inner Court embodies *yin*. This being so, odd numbers dominate the design of the Outer Court, which is known as the system of 'the three halls and five gates'. In the Inner Court, even numbers prevail: for example, there are two palaces, the Palace of Heavenly Purity and the Palace of Earthly Tranquillity (the Hall of Union was a later construction), and six residential palaces – the six east and west residences.

The ideas of the '*yang* of *yang*' and the '*yang* of *yin*' are also embodied in the *yin–yang* principle. The Hall of Supreme Harmony is considered the '*yang* of *yang*', while the Palace of Heavenly Purity is seen as an expression of the '*yang* of *yin*'. Thus the two buildings have certain similarities, but differ in other respects. For example, both have double-eaved roofs, with one horizontal and four sloping ridges; the centres of the interior ceilings have sunken panels, and a sundial and an ancient measure appear on the terraces outside, both of which are approached by the Imperial Way. There are also differences between the Inner and Outer Courts. For example, the terrace of the front half of the Palace of Heavenly Purity, in the Inner Court, has white marble balustrades while the terrace in the north is made entirely of green lantern-shaped bricks.

In addition to the principles of *yin* and *yang*, ancient Chinese architecture also followed the theories of the Five elements, *wu xing*. The phrase *wu xing* appeared as early as in the *Shang shu*, Book of History. The *Zhou shu*, Standard history of the Zhou covering the years 557–581 B.C., explained the nature of the Five elements and listed them in order – water, fire, wood, metal/gold (having the same written character, the meanings are inseparable), and earth. The 'Five elements' represent the five different kinds of matter that people constantly come in contact with. But it is the essences of the elements, rather than the elements themselves which, in combination, cause each other, as well as all other things to occur; in the wrong combination they are mutual-

earth is the origin of all things. Because the colours of yellow and gold symbolize wealth and honour, the costumes of the emperor and empress were mostly gold and yellow. During the Qing dynasty, the 'yellow mandarin jacket' was bestowed as the highest honour to meritorious officials. This also explains the reason for the vast majority of the palace roofs being covered with yellow-glazed tiles.

1 Southern Gate (Front Gate) of Inner City
2 Gate of the Great Qing Dynasty
3 Gate of Heavenly Peace
4 Gate of Uprightness
5 Meridian Gate
6 Gate of Supreme Harmony
7 Hall of Supreme Harmony
8 Hall of Preserving Harmony
9 Palace of Heavenly Purity
10 Palace of Earthly Tranquillity
11 Gate of Martial Spirit
12 Pavilion of Eternal Spring (on Prospect Hill)
13 Gate of Earthly Peace
14 Drum Tower
15 Bell Tower
16 Hall of Complete Harmony
17 Gate of Heavenly Purity
18 Hall of Union
19 Gate of Earthly Tranquillity
20 Hall of Imperial Peace

Fig. 17 Arrangement of the main structures along the central north–south axis of Beijing.

紫禁城主要建築

MAIN STRUCTURES
OF THE
FORBIDDEN CITY

城池

THE CITY WALLS AND MOAT

Solidly built on a rectangular plan, the Forbidden City measures 961 m. from north to south, and 753 m. from east to west. The entire palace complex occupies an area of more than 723,600 sq. m. A continuous wall pierced by gates with lookout buildings constructed above them and corner watchtowers combined with a wide moat and numerous guard houses to form an impregnable and enduring defence system.

The ramparts of the Forbidden City are 7·9 m. high, 8·62 m. wide at the base, and 6·66 m. broad at the top. Crenellated parapets make up the upper part of the outer wall and drains were located every 20 m. along the base to lead off rainwater. Unlike ordinary city walls found elsewhere, the retaining walls of the Forbidden City were constructed of three layers of brick on the inner and outer sides, about a rammed earth core. After the laying of the surface bricks, the interstices were filled with mortar, giving the wall a smooth appearance.

Each surface brick is 48 cm. long, 24 cm. wide and 12 cm. high and weighs more than 24 kg. More than 12 million bricks were used in the construction of the wall. These were the 'settled clay bricks' of the Linqing kilns in Shandong province, which were known for their exceptional strength and hardness. Records from the reign of Jia qing show that the cost of producing one 'settled clay brick' was 0·24 *taels* (1 *tael* = 50 gm) of silver, and another 0·04 *tael* was needed to transport it from Shandong to Beijing, bringing the cost of the surface brick for the wall alone to more than 3 million *taels* of silver. Given the amount of preparation needed for each brick, its weight and so on, a worker could lay only twenty of them a day. It is estimated that two hundred thousand additional working days were necessary to lay these 12 million bricks beyond what it would have taken to lay ordinary bricks for other city walls.

There are four gateways, a walled 'platform', one on the four sides of the city wall, each surmounted by a building forming a gatehouse: the Meridian Gate to the south, the Gate of Martial Spirit to the north, and the East and West Glorious Gates. A mixture of white lime, glutinous rice and alum was used in the construction of the 'platforms' which was strong enough to withstand the ravages of climate and time. A brick gateway cuts through the middle of each watchtower, and on both sides are bridle paths which wind their way up to the top of the city wall.

The most magnificent of the four gate towers is the Meridian Gate. The 12 m. high platform which comprises the lower part of the Meridian Gate is in the form of a 'three-sided rectangle' in plan, its two parallel arms extending south. Piercing the centre of the section connecting these two projections, and itself a part of the city wall, are three arched gateways. The central gate was reserved for the emperor when he visited the Great Ancestral Temple or when he personally led an expedition out of the city. Civil and military officials entered the Forbidden City through the gate on the left while royal princes used the one on the right. There is an armpit doorway on each of the two wings. The gate towers of the Meridian Gate were built in 1420, and renovated later in the Qing dynasty, in 1647, and again in 1801.

The central of the three buildings built on the platform measures nine bays (60·5 m.) along the front by five bays (25 m.) deep. Such a combination of nine and five bays indicates a building of the highest rank. The building has double eaves, with one horizontal and four sloping ridges. The tallest building in the Forbidden City, it measures 37·95 m. from ground level to the ornaments on the horizontal ridge. From the two corner towers, ridge-roofed galleries measuring thirteen bays in length extend southward to the tips of the two wings, commonly known as the Wild Goose Wings. At the two extremities is a double-eaved pavilion with roofs of four equal sloping ridges. Five roofs jutting upwards from the three-sided platform give rise to the collective name for these buildings, Five Phoenix Turrets. There is a large square in front of the Meridian Gate, where officials assembled for audiences with the emperor and when the emperor issued proclamations or bestowed the almanac each year on the first day of the tenth month. Also, after a successful campaign, the emperor would be present at the gate to accept captives.

The Gate of Martial Spirit is the north entrance to the Forbidden City. It was built during the Ming dynasty and given the name Xuan wu Gate, referring to the northern constellations. It was re-named Shen wu Gate (its present name) in the reign of the Kang xi emperor to avoid using part of the personal name of the emperor, who was called Xuan ye. Historically, the written characters of emperors' names were tabooed in this way. The gate tower is composed of five galleries with a double-eaved roof. One of its functions was to serve as the bell and drum tower, where the two-hourly night watches were sounded. Later, in the Qing dynasty, the selection of palace serving girls also took place here.

The East and the West Glorious Gates stand at

18

Fig. 18 Permits for entering and leaving the Forbidden City during the Qing dynasty.

Fig. 19 Coal Hill from the Gate of Martial Spirit (photograph of 1900). Coal and charcoal stored here for emergencies during the Liao dynasty formed the basis of this artificial mound renamed Prospect Hill during the Qing dynasty.

Fig. 20 Meridian Gate, the main gate of the Forbidden City, showing the two Wild Goose Wings extensions.

Fig. 21 Song dynasty painting, 'Yellow Crane Pavilion'.

Fig. 22 Song dynasty painting, 'Pavilion of the Prince of Teng'

the two sides of the Forbidden City. Outside each gate is a dismounting stone, or stele, with the words 'dismount here' carved in the Chinese, Manchurian, Mongolian, Arabic and Tibetan scripts. Officials and cabinet ministers normally entered and left the Forbidden City through the East Glorious Gate. The emperor seldom used this gate, except on the occasions when the imperial coffin and the ancestral tablets were carried past it. When the emperor, the empress and the concubines returned to the Forbidden City from the gardens in the western suburbs of the capital city, they used the West Glorious Gate.

A watchtower was erected on each of the four corners of the city wall. Historically, these turrets functioned as lookout towers along the defensive wall of a city. But the turrets of the Forbidden City served an ornamental rather than a practical purpose. At the centre of each turret is a square pavilion three bays square, with a verandah around all four sides but without exposed pillars. The design of the turrets which boast seventy-two sloping and horizontal ridges is a faithful reproduction of the extremely refined Yellow Crane Pavilion and Pavilion of the Prince of Teng as they appeared in paintings of the Song dynasty.

35

3. The Forbidden City looking south from Prospect Hill.

4. The Forbidden City in 1900.

5. The front of the Meridian Gate.

6. Gallery of one of the Wild Goose Wings of the superstructure of the Meridian Gate.

The Meridian Gate was the main entrance into the Forbidden City and was built in 1420 and renovated in 1647. Two extensions to the wall project southwards to form a three-sided square, hence the name 'Wild Goose Wing'. The superstructure is nine bays wide, double-eaved and flanked by two pavilions on the east and west. The five pavilions gave rise to the popular name 'Five Phoenix Turrets'.

It was customary that after each triumphant expedition, Qing dynasty emperors would ascend the Meridian Gate to accept prisoners of war. It was also stipulated that the emperor should receive memorials on the fifth, fifteenth, and twenty-fifth day of each lunar month. On the day the emperor held court, the princes and civil and military officials paid their tribute in front of the Hall of Supreme Harmony and presented their memorials. If the emperor did not hold court or was absent from the capital, royal princes and high-ranking ministers assembled outside the Gate of Supreme Harmony, and the lesser officials lined up in rank along the two sides of the Imperial Way in front of the Meridian Gate for inspection. In the absence of any further important matters, the princes and ministers would depart through the Meridian Gate, and only then would the remaining officials be allowed to disperse.

7. Inside the Meridian Gate, looking southwest.

The Meridian Gate has five gateways. In the Ming and Qing dynasties these gates each had their special uses: the central gateway was reserved for the emperor, although the empress was allowed to pass through it once on her wedding day, and the three top examination candidates passed through it after they had accepted honours in the palace. Royal princes, civil and military officials used the gates on the two sides, while the two outer gateways were opened only on the days when the emperor held court. On these days, civil ministers would enter through the east gate and military officials came through the west gate. Candidates for the palace examination filed out according to their examination number: those with odd numbers by way of the gate on the left and those with even numbers through the right. When a sentence of beating was handed down to disgraced ministers during the Ming period, this was carried out on the eastern side of the Imperial Way in front of the Meridian Gate.

Gate of Heavenly Peace

Meridian Gate

Golden River Bridge

Gate of Uprightness

Gate of Supreme Harmony

Hall of Supreme Harmony

8. 'The Kang xi emperor's tour of the South.' Detail of the painting by Wang Hui (1632–1717) *et al.* (Horizontal scroll, Palace Museum, Beijing.)

The Qing dynasty emperor Kang xi ruled for sixty-one years and during his reign made six tours of inspection of the Jiangnan region (the area south of the River Yangtze). This painting records the emperor's second expedition during the first three months of 1689. By unrolling the twelve horizontal scrolls, from left to right, the viewer is permitted to become part of the imperial progress, finally re-entering the Forbidden City in this, the twelfth, scroll. The bottom left portion is a continuation of that at top right.

Starting at the top left of the above two sections, we first see the Gate of Heavenly Peace and then, proceeding through the Gate of Uprightness, we encounter four lines of men, stretching all the way to the inside of the Meridian Gate, awaiting the return of the emperor. The two inner rows form the guard of honour and the other two consist of the royal princes together with military and civil officials. From this point, over the Golden River Bridge to the Gate of Supreme Harmony, the deserted expanses of the Forbidden City are emphasized by the inclusion of only a small group of imperial chair bearers and two vigilant bronze lions who silently await the Son of Heaven. Finally, the Hall of Supreme Harmony is shrouded in heavenly clouds above the dragon steps which lead to the terrace on which it so proudly and mysteriously stands.

41

9. Frontal view of the Gate of Martial Spirit.

The Gate of Martial Spirit is the north and last gate of the Forbidden City wall. Built in 1420, it was originally named Xuan wu Gate. It acquired its present name after restoration work carried out during the Kang xi reign era. Originally, a drum and bell were installed in the superstructure, complementing those of the Drum and Bell Towers to the north. After dusk each day the bell in the Bell Tower was sounded 108 times. The night watches, divided into five two-hourly watches, were then begun by beating the drum, and were continued in this fashion until dawn when the bell was struck once more. Officials were sent daily to the gate from the Board of Astronomy to regulate the time periods. In the Qing dynasty, girls selected for service in the imperial palace entered through this gate.

10. Ramparts of the Gate of Martial Spirit.

Two ramps rise inside the gate from its two sides at ground level meeting two more ramps which lead up in a V-shape to the top of the city walls and gate turrets. Including the corner watchtowers of the walls, these formed an important and integral part of

the defences of the Forbidden City. Therefore, for the sake of speed and efficiency, the city wall type of stone slabs were set at an angle, 'saw-tooth' as on either side of the stone steps, in order to provide the maximum grip for hooves and feet when moving horses and soldiers up to their positions. This gave rise to the popular name 'bridle path'.

11. East Glorious Gate.
12. 'Dismounting stele'.

A so-called 'dismounting stele' was erected in front of both the East and West Glorious Gates. They stand about 4 m. high and 1 m. wide. On them are carved the characters 'dismount here' in Manchurian, Mongolian, Chinese, Arabic and Tibetan. There are also 'dismounting steles' in front of the left and right side entrances of the Meridian Gate. On these stones are carved in Chinese, Manchurian and Tibetan: 'Officials and those of like rank dismount here.' Upon reaching the stele, ministers and generals had to dismount from their sedan chairs and horses, and enter the Forbidden City on foot. This was a symbol of the strong fortification of the Imperial Palace as well as the supreme authority of the emperor.

13. Watchtower on the corner of the city wall.
14. Front view of one of the watchtowers.
15. Partial view of the eaves and bracketing.

The complex roof system of the four corner watchtowers of the city walls consists of three main tiers. At the top, two intersecting pitched roofs share the deep eaves and present four opposing gablets. Double-eaved hip and gable roofs are attached asymmetrically at the two lower levels. Unlike most other palace-style roofs in the Forbidden City, however, the overall silhouette is one of a long, downward-sweeping curved pyramid of unequal sides, falling from a central gilt spherical ornament at the apex. Boasting a total of seventy-two ridges, the many 'floating' eaves break the mass of the roof structure giving it an open aerial appearance, which is in direct contrast to the solid simplicity of the walls on which it stands.

16

17

16. The city moat.

Sunset over the city moat looking due west along the city wall at the northern end of the Forbidden City. The Gate of Martial Spirit, the final main exit, lies on the north–south axis with Prospect Hill beyond it (right). The watchtowers are seen at the two corners of the wall.

17. Prospect Hill from the northern wall of the Forbidden City.

In addition to the high city wall and the deep moat enclosing the Forbidden City, Prospect Hill (right and inset) provides a formidable defence at the back. In the Ming and Qing dynasties, the four gates of the city were heavily guarded day and night. Guard posts and rooms were located between the city moat and the outside of the city wall. In the Ming, forty red coloured guard rooms were erected around the city. Late in the mid-Qing, 732 guard rooms in four long buildings were constructed along the edge of the city moat. Apart from the night watches outside the city, the entire palace complex was divided into several sections which were either patrolled regularly, or where hand bells were used to sound two-hour periods of the watches.

外朝

THE OUTER COURT

The emperors of the Ming and Qing dynasties administered their duties and held audiences with ministers in the Outer Court. The broad composition of the Outer Court contains the three front halls lying on a central north–south axis, flanked by the Hall of Literary Glory and the Hall of Military Eminence. Also included in the Outer Court are the Great Vault of the Grand Secretariat, the Imperial Archives, and the Department of Imperial Equipage.

The Hall of Supreme Harmony, the Hall of Complete Harmony, and the Hall of Preserving Harmony, collectively referred to as the Three Great Audience Halls, occupy the main space of the Forbidden City, covering an expanse of 85,000 sq. m. They combine to form the most outstanding palace group in the city, monumental, heroic and grand in scale, rich in ornamentation, and delicate in their attention to detail.

Access to these three halls is gained through the Gate of Supreme Harmony. Measuring nine bays wide and four bays deep, it is the grandest of all the ceremonial gateways in the City. In the Ming dynasty, the emperor on occasion used the gate tower as a place to listen to memorials and issue proclamations: this was known as 'holding court at the Imperial Gate'. When leaving the Forbidden City it was customary for the emperor to be borne first by sedan chair to the Meridian Gate before transferring to the imperial carriage. After assuming sovereignty in China, the first Manchu emperor, Shun zhi, granted the royal pardon here in the ninth month of his first year on the throne (1644).

The Gate of Supreme Harmony is flanked by the Gate of Luminous Virtue and the Gate of Correct Conduct on the left and right. Together with the Gates of Unified Harmony and Glorious Harmony on the east and west, and the Meridian Gate in the south, a courtyard of 26,000 sq. m. is formed by interconnecting ridge-roofed galleries. In the middle of this vast space, the Inner Golden River meanders from west to east, spanned by five arched, *han bai yu* marble balustraded bridges.

The three halls stand on three-tiered terraces 8·13 m. high, each layer constructed in the form of the Buddhist Mount Sumeru, centre of the world and abode of deities, with white marble balustrades, the tops of which are decorated with fine intricate carvings in relief of dragons and phoenixes flying amongst clouds. Stretching out at the foot of each balustrade on the outer edges of the terraces are the heads of hornless dragons (*chi*). On a rainy day, the rainwater from these three and other terraces spills from the mouths of some 1,100 stone dragons, cascading down layer upon layer, creating a spectacular effect.

The three above terraces cover an area amounting to 25,000 sq. m. In front of the Hall of Supreme Harmony and at the back of the Hall of Preserving Harmony are two marble ramps carved with cloud and dragon motifs, running up the centre of two flights of marble steps over which the emperor's chair was carried. The longer ramp at the back of the Hall of Preserving Harmony is made from a single slab of marble 16·57 m. long, 3·07 m. wide and 1·7 m. thick. This slab weighs more than 250 tons. On the terraced area in front of the Hall of Supreme Harmony, among other carved and cast objects, are a sundial, a standard measure, and two pairs of exquisitely wrought bronze incense burners in the form of a tortoise and a crane which were traditionally considered auspicious animals, symbols of the glory and peace of the empire and the longevity of the emperor.

During the Ming and Qing dynasties, the Hall of Supreme Harmony was the centre of court activities. All of the important court ceremonies such as enthronements, imperial birthday celebrations, royal weddings and the crowning of the empress were conducted here. In the design of the hall, attention was placed on drawing the eye from the massive square below upward in stages, over the three-tiered terrace before finally alighting on the distant golden roof which seems to occupy the vast expanse of sky itself. This dramatic device served to heighten the grandeur and elegance of the ceremonies.

The Hall of Supreme Harmony measures nine bays wide (eleven bays including the side verandahs), and the distance between the first and last pillars is 60·01 m. The hall is five bays deep (33·33 m.) and the total area including the terrace measures approximately 2,377 sq. m. The largest and tallest traditionally built timber framed palace-style building in the whole of China, it towers to a height of 35·05 m. The style of its roof is of the highest rank, being double-eaved, hipped, with one horizontal and four sloping ridges. The bracket clusters in the ceiling are single corbel bracket units with three cantilever lever arms, which is one of the most complicated kind of bracket-set construction. In addition, this is the only building in the country which boasts ten instead of the usual nine ceramic animal-shaped ornaments at the ends of the sloping ridges, a monkey having been added to the end of the row. Not only the exterior doors and windows but also the interior fittings of the hall glitter with gold. In the centre is an elevated platform on which sits the imperial dragon throne of carved gold lacquer. Overhead is a large sunken three-tiered panel of a curling dragon holding a pearl in its mouth surrounded by designs of golden dragons covering the panels of the coffered ceiling. Flanking the two sides of the throne platform are six golden pillars, each of which has a flying dragon coiling from the bottom to the top.

Behind the Hall of Supreme Harmony lies the

23

Fig. 23 A 'rank marker'.

The mountain shape recalls the stylized rocks depicted at the bottom of the carved dragon and phoenix slabs laid between terrace steps along the Imperial Way as well as in designs on imperial 'dragon' robes. During the Ming the markers were made of wood but this was changed to bronze during the Qing.

Hall of Complete Harmony. This hall served as a transitional stop for the emperor before he proceeded to the Hall of Supreme Harmony. Here, the emperor read memorials and acknowledged respects from ministers of the Grand Secretariat, the Internal Ministry, the Ministry of Rites, and the imperial guards. The Hall of Complete Harmony is square in shape, measuring five bays wide and deep. It has a distinctive pyramid pavilion roof with four sloping ridges meeting at an apex, in the shape of a golden dome.

The Hall of Preserving Harmony is the last building in the series of the three front halls. In the Qing dynasty, state banquets and the imperial examinations, success in which made scholars eligible for the highest bureaucratic posts in the land, were held here. The designer adopted the Song and Yuan dynasties' method of construction called 'without pillars', which omitted the six golden pillars in front of the throne, thus creating the maximum unobstructed space. The roof is double eaved and of the hip and gablet type. The interior furnishings and decorations are predominantly red, conveying an atmosphere of sumptuous wealth and splendour.

Introduced by the Gate of Supreme Harmony, the visitor is drawn into the progression of the three halls. Their silhouettes rise and fall, creating a variety of dynamic yet harmonious forms. The arrangement of the buildings in the courtyard space is ingenious and skilfully executed. The three halls are surrounded by connecting buildings with ridge-roofed galleries which form three separate rectangular courtyards. At the four corners of each of these are double-eaved two-storeyed buildings. In front of the three halls, exactly half way along, two symmetrical pavilions balance each other to the east and west: the Pavilion of Glorifying Righteousness and the Pavilion of Manifest Benevolence.

The Hall of Supreme Harmony overlooks a huge square. When the emperor presided over ceremonies, no one was allowed into the hall. The royal princes would kneel on the terrace below. Either side of the Imperial Way there stood eighteen pairs of markers (called 'rank marker hills' after their shape) bearing the different civil and military ranks in Manchu and Chinese script where officials knelt and paid their respects. The imperial guard of honour lined up, facing south, in front of the hall in formations that extended out beyond the Gate of Supreme Harmony, the Meridian Gate, and Gate of Uprightness, reaching to the outside of the Gate of Heavenly Peace.

Two smaller groups of buildings were built on the north–south axis outside the main central compound as if to guard the two sides of the three halls. On the left is the Hall of Literary Glory, and on the right, the Hall of Military Eminence. These two halls have single-eaved hipped roofs.

Once a year, in the Hall of Literary Glory, the emperor attended a reading of the classics. Before the day of exposition, he prayed and offered sacrifices before the shrine of Confucius in the Hall of Remitting the Mind located in the eastern part of the complex. In the Ming dynasty, the Hall of Military Eminence served as the place where the emperor could purify himself by fasting and separating himself from his concubines. When Li Zicheng, the peasant leader, occupied Beijing in the late Ming, he ran state affairs from here. Later, during the reign of Qianlong in the Qing dynasty, this hall housed the imperial editing office and printing offices, which printed the 'palace editions' of books.

To the south of the Hall of Military Eminence is the Hall of Southern Fragrance, a repository where portraits of emperors of past dynasties were kept. This small hall retains not only the original wooden structure and the sunken panel ceiling from the Ming dynasty construction, but much of the wall and ceiling painted decorations from the Ming is still preserved to this day.

Fig. 24 Exterior view of the Hall of Literary Glory. The raised interconnecting path between buildings is clearly visible.

Fig. 25 Exterior view of the Hall of Military Eminence.

Fig. 26 Portrait of the first Qing dynasty emperor, Shun zhi (reigned 1644–62). He holds the ceremonial tablet, *hu*, usually made of jade, in his clasped hands.

18. Great courtyard of the Gate of Supreme Harmony and the Inner Golden River Bridge.

The Inner Golden River snakes its way west to east from the symmetrically arranged courtyard between the Meridian Gate and the Gate of Supreme Harmony. Stepping over the marble-balustraded Inner Golden River Bridge, one faces the magnificent Gate of Supreme Harmony. It was originally named the Gate of Serving Heaven, and was later changed to Gate of Imperial Supremacy. Its present name was acquired in the early Qing dynasty. The Gate we see today was rebuilt in the Guang xu era at the end of the Qing period. Measuring 23.8 m. high, it is the largest, tallest and most magnificent of the gates inside the Forbidden City.

19. Gate of Supreme Harmony at dusk.
20. Gate of Supreme Harmony.

It was stipulated in the Ming dynasty that civil and military officials attended court every morning at dawn at this gate, then called the Gate of Serving Heaven. In the Jing tai reign era, a midday court was also held at the eastern gallery of the gate. To the south of the gate are the Cabinet Offices. In the early years of the Qing, the emperor also received audiences in the Gate of Supreme Harmony, and gave banquets there.

21. Painting of the *fa jia lu bu* imperial insignia (painting of the Jia qing era).

Lu bu was the insignia carried before the emperor by the imperial guard of honour. In the reign of the Shen zong emperor of the Song, the imperial guard of honour boasted a force some 22,000 strong. Although greatly reduced in the Qing, the Kang xi emperor still had a guard of three thousand. According to the *Da Qing hui dian, Collected statues of the Qing dynasty*, the insignia of rank of the emperor was called the *lu bu*, those of the empress and empress dowager called *yi jian*, of the high ranking concubines, *yi shang*, and the lower-ranking concubines, *yue jiang*. There were four different types of *lu bu*: the highest ranking was the *da jia lu bu*, followed by *fa jia lu bu*, *luan jia lu bu*, and *qi jia lu bu*, each having its separate function. The morning assembly was the most important of the court ceremonies. Early in the morning before the assembly, the imperial guard would take out the *fa jia lu bu* and display them in front of the Hall of Supreme Harmony. Consisting of more than 500 gold and silver pieces, wooden weapons such as axes, lances, hooks and halberds, and also umbrellas, canopies, and large and small banners, these combined to make a most splendid sight.

The painting shown on the opposite page (p.53), in the form of a vertical handscroll, was executed by court painters in the reign of Jia qing. The *lu bu* procession began at the Gate of Heavenly Peace, passing the Gate of Uprightness and the Meridian Gate, extending as far as the Hall of Supreme Harmony. This section shows the portion between the Meridian Gate and the Gate of Supreme Harmony.

22. Ceiling and exposed beams of the Gate of Supreme Harmony.

The painted decoration is in the so-called *he xi* style which is reserved for the highest order of buildings.

23. Bronze lion in front of the Gate of Supreme Harmony at dusk.
24. One of the two bronze lions in front of the Gate of Supreme Harmony.

The bronze lions displayed in the Forbidden City symbolize not only the splendour of the imperial palace, but also the 'dignity' and 'solemnity' of the emperor. There are altogether six pairs of bronze lions in the Forbidden City: in front of the Gates of Supreme Harmony, Heavenly Purity, Mental Cultivation, Tranquil Longevity, and Spiritual Cultivation, and the Palace of Eternal Spring. Of the six pairs of lions, the one in front of the Gate of Supreme Harmony is the largest. Not an indigenous animal, the lion was introduced to China along with Buddhism and is to be found in pairs, guarding the entrances to temples and palaces probably in the first instance as protection of the Buddhist Law. Its stylized form suggests that the beast was associated with the world of mythical rather than real animals.

25. The Three Great Audience Halls.

The Halls of Supreme Harmony, Complete Harmony and Preserving Harmony, collectively known as the Three Great Audience Halls or Three Front Halls, comprise the central area of the Outer Court with the main attention focused on the Hall of Supreme Harmony and the Hall of Preserving Harmony. Both halls were built on the enclosure principle – a main hall flanked by two side halls forming two courtyards. But because both buildings are constructed at the two ends of a high podium in the shape of an H, with the smaller Hall of Complete Harmony in the centre, the walls are not intrusive and the sense of enclosure, present in other courtyards, is diminished.

The Hall of Supreme Harmony and the Hall of Preserving Harmony are rectangular in plan, while the smaller Hall of Complete Harmony is a square. Apart from this, spatial variation is achieved by different roof shapes and heights. Between the double-eaved hipped roof with upturned corners of the Hall of Supreme Harmony and the double-eaved hip and gablet roof of the Hall of Preserving Harmony is the

lower hipped pavilion roof of the Hall of Complete Harmony with four sloping ridges falling away from a roof pommel at the top. Thus, although subjected to rigorous standardization in design interest is maintained by means of variation and positioning to achieve an overall harmony.

26. Hall of Supreme Harmony.
27. Plaque of the Hall of Supreme Harmony.

Originally named the Hall of Serving Heaven when first built in the Ming, and later, during the Jia jing era, renamed the Hall of Imperial Supremacy, this building came to be called the Hall of Supreme Harmony in early years of the Qing. Not only the largest hall in the Forbidden City, it is also the largest timber-framed construction still standing in the entire country. It was strictly reserved for use on only the most important occasions such as the celebrations held on New Year's Day which was a highlight in the Ming calendar. Before dawn on that day the imperial guards, the court music master, the director of protocol, and the imperial astronomers, together with the master of ceremony and the summoning officers, assumed their various positions. Upon one beat of the drum, about three-quarters of an hour before dawn, all the civil and military officials assembled in position before the Meridian Gate; at two beats, officials from the Ministry of Rites led the procession into the eastern and western part of the square of the Hall of Supreme Harmony. In the meantime, the emperor, wearing ceremonial vestments, would leave his palace in a sedan chair at the first drum beat and assume the imperial chair in the Hall of the Splendid Canopy at the second. When the drum was struck thrice, the emperor ascended the throne in the Hall of Serving Heaven to the accompaniment of ceremonial music. As the music stopped, the emperor cracked his whip three times (the whip was made of silk, and measured about 10 m. in length), while all officials remained standing upright in formations by the appropriate rank markers. Music followed, and all kowtowed to the emperor four times. Then memorials, declarations and speeches were made. Next, all officials tucked their *hu*, official tablets, into their girdles, bowed, knelt down, and shouted 'Long live the emperor' three times. All stood up again, removed the tablets from their girdles, and bowed again. Music was played, and the officials prostrated four times, whereupon the emperor returned to the Hall of the Splendid Canopy.

LAYOUT OF THE THREE GREAT
AUDIENCE HALLS

1 Hall of Preserving Harmony
2 Hall of Complete Harmony
3 Hall of Supreme Harmony

60

28. Stone slab markers for the guard of honour in the great square of the Hall of Supreme Harmony.
29. The bronze mountain-shaped 'rank markers' in front of the Hall of Supreme Harmony. The right-hand column gives official ranks in Chinese characters with their equivalents in Manchu script on the left.
30. Dusk over the Pavilion of Glorifying Righteousness.

Covering an area of over 30,000 sq. m., the square of the Hall of Supreme Harmony, the largest courtyard in the Forbidden City, lies between the Gate of Supreme Harmony and the Hall of Supreme Harmony. The only decorations in this spacious courtyard are the stone-paved Imperial Way running through the centre of the courtyard and the guard of honour stone markers which flank it. The simple flat-tiled paving and the comparatively low-ridged surrounding galleries accentuate the expanse of the courtyard and make the hall in the centre appear even more prominent. This courtyard truly gives rise to the feeling that 'Heaven is high and earth is broad'.

During the Qing dynasty, when important ceremonies were held in the Hall of Supreme Harmony, eighteen rows of bronze rank markers were displayed on the two sides of the Imperial Way in front of it. These seventy-two markers ranged from the first to the ninth rank, marking the positions where the different officials should stand.

Ceremonial objects arranged on the terrace in front of the Hall of Supreme Harmony.

31. Head of bronze tortoise incense burner. When in use, smoke from the smouldering incense, placed in the hollow body, drifts gently from the mouth.
32. Bronze tortoise incense burner.
33. Bronze crane incense burner.
34. Stone sundial.
35. Inscribed gilt bronze standard measure housed inside stone stand in the shape of a pavilion on a stone base.

On the front apron of the topmost terrace of the Hall of Supreme Harmony stand a pair of bronze tortoises at the back, a pair of bronze cranes in the centre, and a stone sundial in the left and right hand corners respectively. Tortoises, turtles and cranes were symbols of longevity. The tortoises' shell and cranes' wings are in the form of lids which could be removed to insert incense made from such fragrant combustible materials as resin, aloeswood, pine and cypress into the hollow bellies. Their hollow necks acted as flues to draw the aromatic smoke up and out through the open mouths and beaks when the lids were replaced. Used during great ceremonies, they added to the mysticism and solemnity of the occasion.

63

Hall of Supreme Harmony

36. Cloisonné incense burner with four elephant heads at the base mounted on baluster-shaped table.
37. One of the four cabinets carved with dragons amongst clouds and waves.
38. Base of carved and gilt dais with mythical creatures and three short flights of steps approaching the throne.
39. Detail of dais showing designs of carved dragons and clouds in the first and third and stylized lotus petals in the second and fourth registers.
40. Interior of the Hall of Supreme Harmony.

64

41. Throne in front of dragon screen.
42. Detail of the dragon head on the back of the throne.
43. Armrest of the throne.
44. Back of the throne.

The area of the Hall of Supreme Harmony measures more than 2,370 sq. m. Of the highest order, the exterior and interior decoration is painted in gilt *he xi* style dominated by confronting golden dragons symbolizing the emperor. Huge dragons coil up the six pillars flanking the throne and a large coiled dragon carved in high relief occupies the central dome of the caisson at the centre of the coffered ceiling. Sets of green brackets resting on the crossbeams become an integral part of the design as they rise to the ceiling.

Placed against a large panelled screen is the ornately carved imperial throne at the centre of the dais. The gilt lacquer decoration of both combine with the caisson above and pillars between ceiling and floor to create a harmonious and integrated design. Incense containers in the shape of bronze elephants stand on tables to either side of the throne and four large incense burners in the form of archaistic bronze vessels on tables are placed between the steps of the dais.

In keeping with geomantic principles, the thrones of the Three Great Audience Halls all lie, one behind the other, on the central north–south axis of the Forbidden City.

45. Base of the throne.

The carved gilt lacquer throne in the Hall of Supreme Harmony comprises three major elements. Reflecting the exalted position of the emperor, three-dimensional long dragons, the most important of the different types are used to form the back and sides or 'armrests'. Clasping one pillar with back claws a body twists and writhes through space so that the front claws grasp the next column and so on, imparting a dynamic, aerial quality in contrast to the solidity of the broad couch. This central part recalls the *kang* brick bed found all over north China on the one hand, as well as the ornate lotus throne of Buddhist iconography on the other. A fretwork design of two confronting dragons about a flaming pearl on a turquoise ground makes up the main decoration. The footrest is placed centrally and like the throne does not possess long legs but relies on a low podium to raise the whole above the third main element, the carpeted dais. This throne arrangement of dais with steps, platform and seat echo, inside the hall, the external arrangement of tiered terraces. From where one stands in the vast square below, the series of layers continues through the open doorways before reaching the peak, like Mount Sumeru, where the emperor sat.

67

46. Section of the painting, 'Wedding of the Guang xu emperor'. (Palace Museum, Beijing)

The marriage of the Guang xu emperor took place in the fifteenth year of his reign (1889). A year before the wedding, his adoptive mother, Empress Dowager Ci xi, who by manipulation was able to become regent, ordered preparations to be made. Qing Kuan, minister in charge of the Imperial Household Department, was ordered to submit a detailed painting to show all the ceremonies, including the procession of the imperial wedding sedan chair and the guards of honour. The scene shown here shows the procession passing through the Gate of Supreme Harmony. According to ancient practice, the titles of officials and names of buildings are written in rectangular cartouches (yel-

low). Traditional bells and stone chimes hang from frames to the right of the gateway respectively. Special decorations include the red coloured Chinese character *xi*, 'double happiness', on the brightly coloured awning on the eaves and on the square bases of the supporting posts around which are coiled brightly coloured dragons. A felt carpet of honour was also laid over the full length of the Imperial Way.

Of the ten emperors of the Qing dynasty, only four – Shun zhi, Kang xi, Tong zhi, and Guang xu – were married after they had ascended the throne and experienced such a lavish, full imperial wedding. The ceremonies were numerous and complex. They included the protracted selection of the future bride and empress, the sending of betrothal presents, the conferring of the title 'empress' on the bride, the welcoming of the bride to the imperial palace, the drinking of the nuptial cup, the receiving of congratulations from the officials and foreign emissaries, and the giving of wedding feasts. The cost of such celebrations was astronomical.

47. Sedan chair in the Hall of Complete Harmony.
48. Hall of Complete Harmony.

The Hall of Complete Harmony was called Hall of the Splendid Canopy at the beginning of the Ming dynasty and changed to the Hall of Middle Supremacy in the reign of Jia jing, and acquired its present name in the early years of the Qing. It is a square building, and served as a transitional stop for the emperor before he proceeded to the Hall of Supreme Harmony.

Every New Year, before offering sacrifices at the various altars, the emperor would inspect the sacrificial elegiac addresses here. In addition, when a title was bestowed upon the empress, the emperor would read the memorials here. During the Qing dynasty it was stipulated that the imperial genealogy should be compiled every ten years, and the ceremony wherein the compilations were presented to the emperor was also held in this hall. The emperor sometimes gave audiences and held banquets here.

49. Throne in the Hall of Preserving Harmony.
50. Hall of Preserving Harmony.

The Hall of Preserving Harmony was called Hall of Respectful Care and Contentment in the early years of the Ming, then altered to the Hall of Establishing Supremacy during the Jia jing era. It acquired its present name at the beginning of the Qing dynasty when the emperors used it as a banqueting hall. After 1789 the imperial examinations, the highest ranking civil service examinations, were held here.

The Gate of Great Fortune at the eastern end and the Gate of the Great Ancestors at the western end of the back courtyard form the first gates to the Inner Court. It was stipulated in the Qing that apart from ministers on duty, or those summoned by the emperor, no one, including the royal princes, was allowed to enter these gates.

內廷

Fig. 27 Imperial bridal chamber in the Palace of Earthly Tranquillity.

The characters shown are those for *xi*, 'double happiness'. The left- and right-hand elements are the character *xi*, 'happiness', written side by side and used for decoration as auspicious symbols and are often incorporated into pierced lattice screens. The geometric shapes are particularly suited to this purpose.

Fig. 28 The Empress Dowager known as Ci xi (1835–1908) from the first two characters of her long title. Selected as a low ranking concubine of the Xian feng emperor she bore him a son in 1856 and, upon the former's death in 1862, as empress–mother was able to act as co-regent for the new young emperor, Tong zhi. Adept in the use of the imperial prerogative of appointment and dismissal she further consolidated her power by offending against propriety, upon the death of her son in 1875, and adopting her sister's son and, again, as co-regent continued to be the power behind the throne, until her death in 1908.

Fig. 29 Imperial concubine Jin.

THE INNER COURT

The rear, northern, half of the Forbidden City, commonly known as the Inner Court, was the residential area of the emperor and imperial household. Whereas the Outer Court boasts grand buildings set in large open spaces, the palace compounds, gardens, kiosks and pavilions of the Inner Court are tightly packed together. A series of ceremonial gateways, walls, galleries and raised walkways between terraces form an intricate, interconnecting complex that is a unique feature of traditional Chinese architectural design.

The Inner Court can be divided into six sections: the Three Rear Palaces, comprising the residences of the emperor and empress; the Six East and Six West Palaces, the residences of the imperial concubines; the Hall of Mental Cultivation, the residence of emperors following the reign of the Yong zheng emperor in the Qing dynasty; the Palace of Tranquil Longevity, the residence of the empress dowager; the residences of the concubines of the previous emperor; and the six residential palace complexes of the princes.

The principal buildings of the Inner Court are the Palace of Heavenly Purity and the Palace of Earthly Tranquillity. Since both were the living quarters of the emperor and empress, they were placed on the central axis. With the Three Great Audience Halls in the Outer Court, these buildings form the heart of the Forbidden City, known as 'the Three Halls and Two Palaces'. During the Jia jing reign period of the Ming dynasty, the Hall of Union, a square-shaped, single-eaved building, was built between these two palaces. Sharing the same stone terrace, they collectively became known as the Three Rear Palaces.

In the Ming dynasty and the early years of the Qing, the Palace of Heavenly Purity, a large, double-eaved, nine-bay structure, served as the residence of the emperor and was renovated many times during this period. Most of the structural members of this palace survive from the reconstruction carried out in 1797 but it retains the original overall design. Forty gates and galleries surround the buildings in this area. In the eastern gallery is the Hall of Accomplishing Uprightness where the emperor's wardrobe was stored. The western galleried buildings house the Hall of Industrious Energy, which functioned as the office and study of the emperor. At the eastern end of the southern galleried buildings was the office of the Han lin Academy where any query by the emperor was answered by the secretaries on duty: at the western end was the southern study, the classroom of the crown prince. In the northern gallery was the imperial apothecary's office, the duty room of the head eunuch, and the office of the treasury. During his reign, the Yong zheng emperor moved his residence to the Hall of Mental Cultivation, and the Hall of Heavenly Purity became the audience hall for receiving foreign emissaries.

The Palace of Earthly Tranquillity is slightly smaller in scale but shares the same design. From the Ming dynasty until the early years of the Qing it was the residence of the empress. In 1656, the Palace was renovated according to the design of the Hall of Purity and Tranquillity in Shenyang, the former Manchu capital from where the Qing dynasty had first been proclaimed in 1636 before the taking of Beijing in 1644. The original Ming latticed doors were replaced by top and horizontal pivot-hung windows, the open work wooden frame of which was pasted over in traditional style, with white paper. Wooden double doors were substituted for the main door at the centre which was removed to the second bay to the east. In the western side room were added a big furnace and a stove for cooking meat: this became a place of worship for the Manchu religion, Lamaism. The eastern side room was used later as the bridal chamber for the emperor. The Kang xi, Tong zhi and Guang xu emperors all spent their nuptial nights here.

The Six East and Six West Palaces where the imperial concubines lived stand to the right and left of the three rear halls. Each palace comprises what can be called a standard compound, about 2 ha. in area, consisting of the formal reception rooms at the front, the side halls and bed chambers. Each compound has intersecting streets and alleys: running south to north are two long streets 9 and 7 m. wide: and running east to west are alleyways 4 m. wide. At the two ends of the streets palace gates and guard houses were constructed. Uniformly laid out, each compound also has side doors on the east and west and doors opening out onto the streets on the north and south. During the years of the Empress Dowager, Ci xi, an extension to the Palace of Eternal Spring and the Palace of Gathering Excellence resulted in the demolition of the Gates of Eternal Spring and Gathering Excellence. The salon-type Hall of Manifest Harmony and the Hall of Manifest Origin were built in their place.

A number of palaces underwent changes during the Ming dynasty:
The Hall of Mental Cultivation, built in the Ming, is on the southern side of the Six West Palaces. It was renovated during the Yong zheng era of the Qing dynasty to be the imperial residence and became the centre of power to the end of the years of dynastic rule. The heated room on the west side was the imperial living room where the emperor sometimes received his ministers. Works by the famous calligraphers Wang Xizhi, Wang Xianzhi, and Wang Shun were treasured in the Room of the Three Rarities, the suite west of this room, during the Qing. From the Tong zhi era onward, the emperor received his ministers in the heated room to the east. It was here that the Dowager

Name in early Ming dynasty	Renamed in fourteenth year of Jia jing	Renamed in late Ming	Remarks
Xian yang	Gathering Essence		Residence of crown prince in early Ming
Eternal Tranquillity	Inheriting Heaven		Residence of imperial concubine
Eternal Peace	Great Benevolence		Birth place of Qing emperor Kang xi
Eternal Yang	Great Yang		Store-room for paintings and calligraphy during Qing
Eternal Peacefulness	Eternal Harmony		One-time residence of imperial concubine Jin Fei
Longevity	Extended Felicity	Extended Happiness	Imitation of the Water Hall of the Crystal Palace
Longevity and Prosperity	Gathering Excellence		Residence of Empress Dowager Ci xi when she was a concubine
Perpetual Peace	Emperor's Assistance		
Eternal Happiness	Nourishing Virtue	Eternal Longevity	
Longevity and Peace	Complete Happiness		
Eternal Spring	Eternal Tranquillity	Eternal Spring	
Wei yang	Initiating Auspiciousness	Hall of the Ultimate Principle	

Empress Ci xi 'administered state affairs from behind the curtain'. Learning how to use the royal prerogatives of appointment and censure of officials she, by virtue of being empress mother of the young Tong zhi emperor, wielded real power. The chamber palace was behind the Hall of Mental Cultivation. The galleries on the two sides of the chamber palace were called the Hall of Manifest Compliance and the Hall of Festive Joy. Here, the emperor summoned his concubines.

In the eastern section of the Forbidden City between the Gate of Imperial Supremacy and the Gate of Tranquil Longevity is a large elegant courtyard surrounded by old gnarled pine trees on all four sides. The two palace buildings standing inside the courtyard, the Palace of Imperial Supremacy and the Palace of Tranquil Longevity, are magnificently built, modelled on the shape and construction of the Hall of Supreme Harmony and the Palace of Earthly Tranquillity. The Palace of Tranquil Longevity is on the site of the former First Palace of the Ming period. Rebuilt in 1689, it was given its present name. When the Qian long emperor further enlarged it in the thirty-seventh year of his reign, with the intention of living there after his abdication, it acquired its present appearance.

To the rear of the Palace of Tranquil Longevity lie the Hall of Spiritual Cultivation and the Hall of Pleasurable Old Age, which are situated in the centre. To the east is a group of buildings for entertainment, including the Pavilion of Pleasant Sounds, the Hall of Celebrating Old Age, and the Palace of Great Happiness. Various delightful garden buildings are scattered in the western part: the Pavilion of Ancient Flowers, the Hall of Active Retirement, the Building of Appreciating Lush Scenery, and the Pavilion of the Anticipation of Good Fortune. The entire complex constitutes a minor inner court.

The residences of the empress dowager and the concubines are in the west of the Forbidden City. These buildings include the Palace of Compassion and Tranquillity, the Palace of Tranquil Old Age, and the Palace of Longevity and Good Health. The Palace of Compassion and Tranquillity was built on the site of the Palace of Benevolence and Longevity in 1536. It was burnt down and rebuilt in the reign of the Wan li emperor. The main hall was at first single-eaved and not very tall. Renovated again in 1769, the roof was altered to its present double-eaved hipped form, resembling a hall for holding court. Filled with Buddhist statues the rear part was also called the Hall for Worshipping the Great Buddha.

The Palace of Longevity and Good Health is to the west of the Palace of Compassion and Tranquillity. Divided into three units, it contains halls which are interconnected for easy access. The Palace of Tranquil Old Age was called the Palace of Complete Peace in the Ming, and the wooden structure of the main hall dates back to that time. Rebuilt in 1771, the palace is connected by buildings to the left and right. Behind the palace are artificial stone hills and covered walkways leading to two pavilions. The two luxuriant Bodhi trees on the two sides of the pavilion give the courtyard a reverential air.

The residences of the royal princes are located behind the Six East and Six West Palaces, the main buildings being the Palace of Doubled Glory and the Palace for the Establishment of Happiness, both having been built during the reign of Qian long; the Palace for the Bringing-forth of Blessings was built after the Jia qing emperor was crowned.

LAYOUT OF THE THREE REAR PALACES

1. Imperial Garden
2. Gate of Earthly Tranquillity
3. Palace of Earthly Tranquillity
4. Hall of Union
5. Palace of Heavenly Purity
6. Gate of Heavenly Purity

51. Courtyard of the Gate of Heavenly Purity, looking west.

The longer sides of this rectangular courtyard bisect the main north–south axis of the Forbidden City in contrast to those preceding it, serving to divide the outer ceremonial and inner domestic courts. A similar layout is repeated in the Inner Court which continues the progress of the Imperial Way on its route through the Hall of Preserving Harmony and down the gleaming white balustraded stone steps (left) via the Gate of Heavenly Purity (right). Bright yellow and orange pomegranates ripen in the short northern autumn on the branches of the potted trees which are arranged along the south side of the courtyard. Many of the large bronze cauldrons, some gilt, in the Forbidden City were used as the first source of water for the ever-present threat of fire.

52. Looking north towards the Gate of Heavenly Purity from the terrace at the back of the Hall of Preserving Harmony.

The Gate of Heavenly Purity is the main entrance to the Inner Court from the Outer Court. During the Qing period, this was where the emperor held court, normally beginning at eight or nine o'clock in the morning. He would sit on a throne temporarily installed at the centre specially for the occasion and the different officials would stand in their allotted places presenting memorials, according to rank, in turn. In matters of grave importance, members of the Han lin Academy, the supervising officers and the attendants withdrew from the scene. The grand secretaries and the sub-chancellors of the Grand Secretariat ascended and knelt on the terrace, then a Manchu chancellor read out the petitions. After each petition, the emperor's edict would be proclaimed through these secretaries. Of all emperors, Kang xi held court most frequently, and many important decisions were made in this way. But after the Xian feng era the practice was discontinued.

53. Side view of the Three Rear Palaces, looking east. From left to right, the Palace of Heavenly Purity, the Hall of Union, and the Palace of Earthly Tranquillity.

The Three Rear Palaces were the domiciles of the emperor and the empress. Although smaller in scale the layout and design echo that of the Three Front Halls. As the 'Son of Heaven' the desire of all emperors, steeped in traditional beliefs, was that heaven and earth should co-exist in peaceful harmony. Hence, the choice of names for the two palaces reflects this wish and is further underlined by naming the building between them the Hall of Union. It was through the emperor, at the pinnacle of the earthly hierarchy, that men expressed their fears and desires. It is interesting to note that the names of the Three Rear Palaces remained unchanged from the beginning of the Ming to the end of the Qing dynasties.

54

55

57

56

76

54. Square Pavilion of the Gods of Land and Grain in front of the Palace of Heavenly Purity.
55. Sundial in front of the Palace.
56. Gilt bronze censer in front of the palace.

The lower part of the censer is in the form of an archaistic bronze ceremonial vessel *ding* tripod. The removable pierced cowl served to diffuse the aromatic smoke.

57. Palace of Heavenly Purity.

This was the residence of the emperors and empresses in the Ming dynasty. Concubines were also summoned here to wait in attendance upon the emperor.

When the Manchus took over the reins of power, the palace was renovated but although it remained the residence of the emperor, it changed its function many times. Both the Shun zhi and Kang xi emperors summoned officials and received foreign envoys here. It also served as the emperor's office and study. After the Yong zheng emperor had removed the imperial residence to the Hall of Mental Cultivation, this became the foremost hall for holding Inner Court ceremonies and receiving officials and foreign emissaries. As in the courtyard of the ceremonial gateway to the palace, tubs of dwarf pomegranate trees line the Imperial Way.

58. Dais in the Palace of Heavenly Purity.
59. The throne.

Each year on the first and fifteenth days of the New Year, the Dragon Boat Festival, Mid-Autumn Festival, Double Ninth Festival (on the ninth day of the ninth month), Winter Solstice, New Year's Eve and the emperor's birthday, the emperor received congratulations from his officials and held banquets here.

In the sixty-first year of the Kang xi (1722) and fiftieth year of the Qian long (1785) reign periods, two special banquets called the 'thousand old men banquet' were held in the palace to which the emperors invited men who were sixty years of age and over. Three thousand people were invited to the first of these including ministers, officials, soldiers, craftsmen and commoners. Every one of the guests received presents amongst which were staffs traditionally used by the old.

According to dynastic precedent, the emperor's eldest son by his legal wife was assumed to be the heir to the throne, and succeeded the emperor when he died. There were, however, occasions when the emperor appointed an heir on his death bed. Seeing the weakness of such a system, the Yong zheng emperor devised a new system whereby the emperor secretly made two copies of the name of the chosen heir, carrying one on his person and depositing the second copy in a box stored behind the horizontal placard bearing the characters *zheng da guang ming*, 'upright and pure in mind' (right to left), above the throne in this hall. Upon the death of the emperor, the appropriate ministers inspected both copies and only after verification in conjunction with other ministers could the successor be declared. Towards the end of the Qing dynasty, however, in the Xian feng, Tong zhi and Guang xu periods, the practice fell into disuse because there was only one or even no son.

The Palace of Heavenly Purity also temporarily housed the emperor's body after death while the ritual observances were carried out. After the appropriate period of mourning, it would be moved to Prospect Hill to await a fixed time for a state funeral before being taken to the Qing dynasty imperial tombs.

The dais, throne and dragon screen in the Palace of Heavenly Purity are comparable in design and arrangement to those in the Hall of Supreme Har-

59

mony. However, the examples here are more ornate, with many more twists and turns of the dragons' bodies forming the back and sides of the throne and gilt caps to the balustrades of the dais. Hanging couplets by the hands of the Kang xi and Qian long emperors, both renowned connoisseurs and calligraphers, together with characters carved into the panels of the screen, dominate the sumptuous decoration. Chinese characters, written with a brush pen, together with landscape painting were the embodiment of a man's intellectual powers and strength of character and are often incorporated into Chinese architectural decoration and landscape garden design. In the Forbidden City the equivalent in Manchu script was added vertically to the right of the Chinese characters.

Apart from the incense containers and censers placed on the dais a pair of cranes flanks the throne. Symbols of longevity, they hold lotus leaves with projecting spikes to take candles in their beaks.

60. Hall of Union.

The Hall of Union was built in the Ming dynasty. During the Qing period, on the three main festivals of the year, the court paid their respects to the empress in this building. On these occasions, the imperial concubines, the royal princesses, wives of royal princes and wives of ministers who were of second rank and above performed ceremonies first, to be followed then by the royal princes. Its external appearance and positioning follow that of the Hall of Complete Harmony, the main difference being in the absence of a pillared verandah.

61. The throne in the Hall of Union.
62. Copper clepsydra housed to the right of the throne.

The Qian long emperor initiated the practice of storing the twenty-five imperial seals in the Hall of Union. The use of these seals was overseen by the Grand Secretariat and they were kept in the hands of the Director of Palace Affairs. The Grand Secretariat had to obtain the emperor's consent before they could be requested for use. Seals were used for the authentication of documents from a very early date in China. Their origins probably lie in the breaking of identically inscribed objects which, when brought back together, fitted perfectly, thus forming a tally. Usually made from semi-precious stone or ivory, the owner's name is carved in 'seal script' characters on the base which, when having been pressed against a mixture of cinnabar (red mercuric sulphide) and oil leaves a red impression when applied to the document. These seals, or more correctly seal impressions, are most commonly to be seen on Chinese paintings. Imperial and state seals were frequently very large and made from metal or jade.

Calligraphy by the Qian long emperor, concerning the name given to the hall, forms the main decoration in the panel behind the throne together with the two characters *wu wei*, conveying the philosophical principle of non-interference or 'non-action' in administration. The upper panel contains imperial dragons about a central pearl on which is written the character *sheng*, 'divine wisdom' or 'imperial'.

The water clock, or clepsydra, was also used in the past in China. However, after the reign of the Qian long emperor the clepsydra shown here ceased to be used and it was supplanted by a large striking clock. It stands in the bay to the right of the throne and employs three copper tubs, with a fourth reservoir surmounted by a kneeling figure. Water drips at a regulated rate from one tub to the next as each fills up. The mechanism is housed in a large model of a traditional palace-style structure which incorporates faithfully reproduced architectural elements. A spout finally emerges from the series of petal panels along the base of the projecting apron at the front.

63. Bridal chamber in the Palace of Earthly Tranquillity.
64. Palace of Earthly Tranquillity.

The Palace of Earthly Tranquillity was the domicile of the empress in the Ming dynasty. In the Qing it continued to be the official residence of the empress in name although she did not in fact live here. The palace was turned into a place for the observance of religious festivals and worship of the Buddha and the many Chinese and Mongolian gods. Sacrificial animals were slaughtered and prepared on the spot and sacrifices performed in the presence of the emperor and empress to the accompaniment of music. The cooked dishes were then served and eaten.

Both the interior and exterior decorations of the palace are of a different style from the other palaces, as this palace was rebuilt according to the Manchurian taste during the early Qing. In contrast to the more formal rooms of state the ceilings and walls consist of large flat areas between beams and cased pillars and have only a little decoration.

82

65. Bed in the bridal chamber in the Palace of Earthly Tranquillity

The east warm chamber, i.e. a heated room, in the Palace of Earthly Tranquillity was the imperial bridal room. The Kang xi, Tong zhu and Guang xu emperors spent their nuptial nights here, as did Xuan tong after the 1911 Revolution. After three nights, the empress would move to one of the Six East or West Palaces. The walls of the room were painted red, and lanterns bearing the character *xi*, 'double-happiness', were hung from the ceiling.

The marriage bed is constructed in an alcove bordered by a suspended or openwork timber curtain screen. Multicoloured embroidered silk curtains may be drawn over the open side which depict one hundred children playing (*bai zi tu*), a traditional theme. When presented as a gift the implicit wish was that the recipients should have numerous progeny.

66. Room for offering sacrifices to gods or ancestors of Manchu Lamaism in the Palace of Earthly Tranquillity.

67. View towards the Imperial Garden from the Palace of Earthly Tranquillity.

At the back of the palace is the Gate of Earthly Tranquillity. The galleries surrounding the courtyard housed the palace pharmacist and the duty rooms of the imperial physicians and the eunuchs. The gate of this palace opens directly onto the Imperial Garden, the tree-tops of which can be seen rising above the rooftops. In the early years of the Ming, the Gate of Earthly Tranquillity was not located here but behind the Hall of Imperial Peace. It was moved to its present position in the reign of Jia jing. The Imperial Garden was at that time part of the Three Rear Palaces and thus was known as *Gong hou yuan*, 'Garden behind the palaces'.

68. From the Inner Right Gate looking north along the First West Long Alley.

The First West Long Alley is on the western side of the Three Rear Palaces. The long alley runs alongside the walls of the Hall of Mental Cultivation at its southern end and the Six West Palaces to the north. The pavilion visible in the distance sits on the top of Prospect Hill.

内右門

69

70

86

LAYOUT OF THE HALL OF MENTAL CULTIVATION

1 Hall of Festive Joy
2 Hall of Manifest Compliance
3 Hall of Mental Cultivation
4 Gate of Mental Cultivation
5 Imperial dining hall of the Inner Court
6 Grand Council

69. The inscribed plaque of the Gate of Mental Cultivation seen through the hole in the centre of the jade tablet.
70. The jade tablet outside the gate showing five-clawed, imperial dragons pursuing the flaming Buddhist pearl amongst the clouds which they inhabit.
71. The Gate of Mental Cultivation through which can be seen the steps to, and doors of, the palace.
72. East duty room outside the Gate of Mental Cultivation.

The Hall of Mental Cultivation was built in the Ming dynasty and renovated during the reign of the Yong zheng emperor of the Qing. Before this period the residence of the emperor had been in the Palace of Heavenly Purity. When the Kang xi emperor died, his son, Yong zheng, was unwilling to move into the palace where his father had lived for more than sixty years. He did not move even after he had completed the prescribed period of mourning and the hall thus became his residence and office and continued to be the official residence of succeeding emperors.

The hall is in the shape of an H in plan with interconnecting galleries between the front and back halls which surround the courtyard and form a compact unit. The emperor had his office in the front hall and his bedchamber in the rear hall. This palace was close to the Grand Council, making it convenient for the emperor to summon his advisors. The low buildings outside the courtyard were the duty rooms of the eunuchs. Officials also waited here for imperial audiences. The side halls on the east and west sides are Buddhist chapels.

In front of the hall is the dining hall of the Inner Court (that of the Outer Court was outside the Gate of Great Fortune). There was no fixed dining room. The emperors had food brought out to wherever their movements took them but as they usually attended to state affairs after eating, the Hall of Mental Cultivation, the Hall of Heavenly Purity and so on were the most conveniently placed buildings within the Inner Court for this.

73

74

88

73. Courtyard of the Hall of Mental Cultivation.

A screen wall blocks the view through the Gate of Mental Cultivation (left) into the courtyard of the hall (right). The front part of the hall has a roof of the rolled pitched type which curves smoothly over the ridge, lacking the prominent line of ridge tiles over the ridge pole.

74. Screen wall inside the Gate of Mental Cultivation.

Standing across the pathway through the Gate of Mental Cultivation is a screen wall, or more properly doorway, of the type which is found in traditional Chinese domestic courtyard construction. Malevolent spirits can travel only in straight lines and so one of its purposes was to deflect them and prevent them from entering the family home and disturbing its peace. Another, more practical reason for erecting screen walls was to prevent prying eyes from observing activities beyond it whether they were those of an unwelcome visitor or passers-by, as many town courtyards opened directly onto the street.

75. Bronze censer in the form of three cranes joined together.

The heads of the cranes turn back over their bodies to preen their feathers and the second foot of each bird is tucked up under the wing. Chinese texts such as the *Shan hai jing, Classic of mountains and seas*, abound with descriptions of strange composite animals.

89

Room of the Three Rarities | Main hall | East warm chamber (*i.e.* heated by *kang*)

Fig. 30 Sectional drawing showing the arrangement of partition rooms and furnishings in the Hall of Mental Cultivation.
(Numbering refers to colour plates.)

76. Corner of the main hall.
77. The main hall.

The hall is divided into three main bays. At the centre is the 'throne room' which retains the classic coffered ceiling and exposed bracket system above the imperial seat and desk. Two bookcases line the north wall flanking the lacquer screen which has two ceremonial peacock feather fans standing in front of it.

Cased books and cloisonné objects, such as the tripod vessel and jade ornaments arranged on the side tables, impart a businesslike and less ceremonial atmosphere than any counterpart in the Outer Court.

78. The east chamber where the Empress Dowager Ci xi 'administered state affairs from behind the curtain'.

Ci xi acquired power in 1861 after a palace *coup d'état*, and held effective power throughout the reigns of the Tong zhi and Guang xu emperors for a total of forty-eight years. As Empress Dowager she conveyed her decisions on state affairs, from behind the yellow curtain shown, to the infant emperor sitting on the throne chair in front.

(Curtain raised showing Ci xi's seat.)

79. Side view of the chamber.

In the east partitioned bay of the palace traditional decoration was rejected in favour of plain, flat walls and ceilings. From the Yong zheng period the emperor summoned his ministers to discuss state affairs in this section.

(Curtain lowered with Ci xi's seat partially visible.)

79

80

81

80. Ante-room on the northern side of the east bay of the hall.
81. Central partitioned room in the west bay of the hall.
82. Room of the Three Rarities, in two partitioned sections in the west bay.
83. *Trompe l'oeil* painting reproducing the interior of the front section of the Room of the Three Rarities by the court painters, Giuseppe Castiglione, the Jesuit, and Jin Tingbiao.

The eastern side room of the east bay was the bedchamber of the emperor while he fasted before religious ceremonies. The west bay was where emperors from the Yong zheng to the Xian feng often summoned the Secretaries of the Grand Council to discuss state affairs.

The Room of the Three Rarities, which is formed by two small adjoining rooms each 4 sq. m. in area divided by a *nan mu* partition with lattice doors. Both rooms are elaborately decorated. The floor of the front room is covered with blue and white ceramic tiles in geometric patterns. The Qian long emperor at one time kept rare examples of calligraphy by Wang Xizhi of the Jin period, Wang Xianzhi and Wang Shun here, thus giving rise to the name Room of the Three Rarities. The horizontal board bearing the characters *San xi tang* and the *San xi tang ji*, 'Account of Three Rarities', written by the emperor still hang on the wall today. The painting on the wall opposite by Jin Tingbiao depicts the story of the three Wangs. This room still retains much of the original appearance of the Qian long period.

On the wall opposite the entrance door hangs a full-length painting executed by Giuseppe Castiglione and Jin Tingbiao in 1765. The lattice window frames and floor tiles in the painting are exact reproductions from the interior of the chamber. With the use of perspective the painting appears to be an extension of the room.

84

84. Inner imperial apartments behind the main Hall of Mental Cultivation.
85. East side chamber of the Hall of Manifest Compliance at the back of the Hall of Mental Cultivation.

North of the front hall of the Hall of Mental Cultivation is a covered corridor which connects the front and back halls. The back hall comprises the imperial suite which is made up of five rooms. A *kang* (heated brick seat) was built in the middle of the central room. In the east side room is a throne chair and a long desk made of sandalwood. In the west side room there are a sandalwood wardrobe carved in cloud and dragon pattern and a *kang* couch. The outer east and west rooms each have a heated *kang* bed (commonly referred to as 'the dragon bed'), a heated *kang* seat, a desk and other furnishings. The layout of the five rooms is symmetrical with minor variations and the present arrangement has been made according to that of the Guang xu period at the end of the Qing dynasty.

The Hall of Manifest Compliance on the east of the imperial suite was the bedchamber of the empress whenever she stayed with the emperor in the Hall of Mental Cultivation. To the west is the Hall of Festive Joy, the waiting room of concubines and palace maids called upon to wait on the emperor.

LAYOUT OF THE SIX WEST PALACES

1 Palace of Gathering Excellence
2 Hall of Manifest Harmony
3 Palace of Emperor's Assistance
4 Palace of Eternal Spring
5 Hall of Manifest Origin
6 Hall of the Ultimate Principle

Six West Palaces.

86. Palace of Gathering Excellence.

87. Bronze dragon in front of the palace. The imperial five-clawed dragon, one of many types, was of the highest order of *long* dragons. Inhabiting the sky as well as watery places they may be depicted flying amongst clouds or in association with waves, as here. Because of their powers connected with fire and rainfall they were regarded as protectors of man's destiny.

88. Bronze deer in front of the palace.

Several different species of deer were native to China. In Taoist mythology, it is the one animal capable of searching out the *ling zhi*, 'fungus of immortality' (Sika deer), and is often portrayed with a stylized version of the fungus in its mouth. It therefore represents longevity.

89. Interior of the Palace of Gathering Excellence.

The Palace of Gathering Excellence is one of the Six West Palaces, originally named the Palace of Longevity and Prosperity. It was built in Yong le 18 (1420), and acquired its present names in 1535. It was restored several times during the Qing period. In 1884, to celebrate the fiftieth birthday of Empress Dowager Ci xi, it was completely refurbished at a cost of 630,000 *taels* of silver. She moved in on her birthday in the tenth month of that year and occupied it for ten years. The palace of today retains the shape of that renovation.

The palace has a single-eaved hip and gablet roof and is five bays wide. In front of the palace is a spacious courtyard, where two gnarled old cypresses grow. On the two sides in front of the terrace are a pair of bronze dragons each holding a pearl in their claws, and a pair of bronze deer. These were also placed in position at the time of Ci xi's fiftieth birthday. The coloured decorations on the outer eaves of the palace are of the soft-coloured Suzhou style paintings, which employ birds, flowers, fish, insects, vegetables, antiques, animal and human figures and mythological motifs. The outer decorations include *nan mu* timber lattice windows.

The interior decoration of the Palace of Gathering Excellence is exquisite. At the back of the main room is a *nan mu* screen with mirror panels. This is placed on a wooden platform. In front of the screen are the imperial throne, sidetables, ceremonial fans and incense burners. It was in this hall that Empress Dowager Ci xi held audiences and received salutations. On the eastern and western sides of the throne are partition doors of rosewood carved with bamboo and magnolia designs. The upper glazed panels contain paintings on silk of orchids and bamboo, by senior officials.

Behind the partition to the west is a side room, with a couch beneath the windows on the north and south sides. This served as the sitting room of the Empress Dowager. To the west of the side room was her bed-chamber. It is separated from the side room by a large mirror set into a pierced wood screen carved with the characters for 'longevity' and 'good fortune'.

大同

90. Openwork sandalwood partition with octagonal opening in the Palace of Gathering Excellence.
91. Furnishings and decorations in an east side room of the Palace of Gathering Excellence.

The lattice work of the window is formed from the Buddhist swastika and a circular motif created from the stylized character *shou* and bat motif; all are symbols of longevity. Two traditional lacquered frames of asymmetrical compartments to hold antiques and monuments stand adjacent to the pierced or hanging timber partition. An ornamental imperial sea-going 'dragon' boat, often seen in Ming dynasty woodblock prints, is placed on a table in front of the window.

92. West side room. A bedroom in the Palace of Gathering Excellence.
 Two sets of curtains reveal the bed, and a carved wood partition with hanging bosses surmounts the alcove entrance. The inner embroidered satin curtain is made with multicoloured brocade made in Suzhou: the quilts are embroidered with dragon, phoenix, flower and plant motifs.
93. West side room. Couch with low table in the Palace of Gathering Excellence.

94. *Wan shou wu qiang fu. Fu*, prose poem, 'Long life without end'. Engraved stone tablet set into the gallery wall of the Palace of Gathering Essence.

This eulogy was composed by a minister to flatter Ci xi on her fiftieth birthday. Such engravings were made by applying the paper on which the original characters were written to stone with a light paste, tracing their shapes directly onto the surface and then chiselling them out. In this way a true copy of the original is obtained. 'Negative' impressions of such calligraphic and figurative compositions called ink squeezes, which can date back many hundreds of years, are produced by dabbing an inked pad over paper which has been moistened and applied to the surface. This may have been one of the first forms of printing in China.

95. View of the Palace of Eternal Spring from the theatrical pavilion in the courtyard.

The Palace of Eternal Spring was originally the residence of Concubine Li of the Tian qi emperor during the Ming dynasty. When Empress Dowager Ci xi became the regent of the Tong zhi emperor at the end of the Qing dynasty, she made it her residence. Plays were performed for her in the theatrical pavilion in the courtyard. The palace was also the residence of the concubines of the Guang xu emperor and Pu yi, the last, child, emperor of China.

96. Throne of the Palace of Eternal Spring. The *ru yi* sceptre lying on the chair is made of jade. Above the lower part of the right-hand lantern is decorated with the octagonal diagram of the eight trigrams, *ba gua*, while that on the left bears a design of auspicious bats.
97. Mural depicting scenes from *Hong lou meng, Dream of the Red Chamber*, on the surrounding corridor in the courtyard of the Palace of Eternal Spring. Detail.
98. Mural, *Hong lou meng*. Detail.
99. Mural, *Hong lou meng*. Detail.

Painted on the walls of the corridors around the courtyard of the Palace of Eternal Spring are a series of more than ten paintings of scenes from *Dream of the red chamber*, a well-known novel written during the Qing dynasty about the fortunes of a large, wealthy family. It is rare to find wall paintings using this theme in such a grand style. Apart from the many and varied types of patterned decoration on timber members of the palace there are many small paintings of landscapes, birds and flowers as well as figure paintings and portraits.

This series of wall paintings was probably executed during the Guang xu reign period. Skilful and meticulous in style, the paintings are so fine that even the single blades of grass can be clearly seen. Interestingly, the painter has made full use of the principles governing perspective and applied them to a traditional Chinese style of painting so that corridors, towers and pavilions appear to be part of a scene outside the palace.

105

100. Interior of the Hall of Great Supremacy.
101. A table carved with pine, bamboo, and plum inside the Hall.

The Hall of Ultimate Principle is one of the Six West Palaces. At first, it was called the Palace of Infirmity. In 1535 the palace was renamed the Palace of Initiating Auspiciousness in memory of the emperor's father who was born there. Later in the Qing dynasty, the name was changed to the Palace of the Ultimate Principle. A huge screen wall covered with glazed tiles stands in front of the hall which, together with its east and west sidehalls, forms a spacious courtyard with an atmosphere of serenity in the cool shade of the trees growing there.

102. Interior view of the Studio of Fresh Fragrance.

The stools in the shape of ancient drums recall those made of stone in the gardens of the Forbidden City.

103. Verandah of the Studio.

104. Palace of Great Benevolence.
105. Stone screen in front of the Palace of Great Benevolence.
106. One of the four carved animals supporting the stone screen.

The Palace of Great Benevolence is one of the Six East Palaces. The Kang xi emperor, third son of the Shun zhi emperor, was born here during the Qing dynasty. The Qian long and Dao guang emperors also lived here as heirs-apparent. Zhen Fei, a favoured concubine of the Guang xu emperor who met her demise at the hands of the Empress Dowager, also lived here at one time.

107. Bird's-eye view of the layout of the Palace of the Bringing-Forth of Blessings.

The traditional compound courtyard method of layout and construction was employed in the building of homes at all levels of the social hierarchy. From the earliest times, stockades or tamped earth walls around natural or artificial earth terraces had guarded the inhabitants against the vulnerability of attack from across the massive flat north China plain. Later, individual walled dwellings also shielded families from the strong desiccating winds and shifting mud produced by torrential rainfall. In the case of smaller dwellings, such a layout was of the utmost practicality. Courtyards and buildings could be added as sons brought in wives and set up home, thus contributing to the family wealth.

The classic layout shown demonstrates admirably the orientation of the important buildings, bisecting the main north–south axis, with the side buildings joined together and forming the characteristic open galleries and verandahs as a direct consequence of such planning. Enclosed by high and lower walls, held in common with neighbours, living areas were formed which were individual, semi-independent elements of a much larger and integrated whole. Fairly tightly packed dwellings were as much a characteristic of the less ceremonial parts of the Outer Court and domestic Inner Court in the Forbidden City as they were of the cities and towns of the rest of China.

The Palace of the Bringing-Forth of Blessings was the living quarters of the heirs-apparent in the Qing dynasty.

LAYOUT OF THE SIX EAST PALACES

1 Palace of Gathering Essence
2 Palace of the Great Yang
3 Palace of Inheriting Heaven
4 Palace of Eternal Harmony
5 Palace of Great Benevolence
6 Palace of Prolonged Happiness

108. Door plaque of the Palace of the Bringing-Forth of Blessings.

Ornamental plaque above the doorway of the Palace of the Bringing-Forth of Blessings giving the name in Chinese (left) and Manchu scripts (right).

109. Palace of Compassion and Tranquillity.
110. Guardposts at one end of the East Long Alley.
111. The long tube-like alley running north–south in the east of the city.

To the west of this walled alley lies the eastern group of palaces of the Inner Court, to its east is the eastern wall of the Palace of Tranquillity and Longevity. All the buildings in the area of the Palace of Tranquillity and Longevity were renovated and reconstructed during the reign of the Qian long emperor who intended to live there when he retired. This, in fact, never happened and he lived in the Hall of Mental Cultivation instead. Empress Dowager Ci xi, on the other hand, stayed in the palace before and after her sixtieth birthday.

112

113

114

LAYOUT OF THE PALACE OF
TRANQUIL LONGEVITY

1 Gate of Spiritual Cultivation
2 Palace of Tranquil Longevity
3 Hall of Imperial Supremacy
4 Gate of Tranquil Longevity
5 Gate of Imperial Supremacy

northward and join up with the rear hall to form a large courtyard of more than 5,000 sq. m. Two short walls were built between the two flank or gable end walls of the Hall of Imperial Supremacy and the side galleries, by which the main courtyard is divided into two smaller courtyards.

112. Gate of Tranquil Longevity.
113. Hall of Imperial Supremacy.
114. West galleries forming the boundaries of the courtyard of the Hall of Imperial Supremacy showing part of the 'hanging flower' roofed gate and coping roof of the short wall which cuts the courtyard on both sides of the Palace of Imperial Supremacy.

Balustraded stone steps lead up to the platform on which stands the Gate of Tranquil Longevity. A walkway paved with white stone continues at the same level beyond the gateway, 1·6 m. above ground level across the centre of the courtyard. It measures 30 m. long and 6 m. wide. This pavement leads directly to the platform of the Hall of Imperial Supremacy, dividing the front courtyard into an eastern and western section. The entire platform is flanked by white marble balustrades with carved dragon and phoenix designs. The Hall of Imperial Supremacy is nine bays wide, and has a double-eaved hipped roof; it is architecturally lower in rank than the Hall of Supreme Harmony. The galleries to the east and west of the Hall are considerably lower, which accentuates the loftiness of the main hall. Decorations on the inner and outer eaves of this hall reproduce those of the Hall of Supreme Harmony. Behind stands the Palace of Tranquil Longevity. The two are similarly linked by a wide stone pavement. From the plan of the complex, it can be seen that though the Gate of Tranquil Longevity, the Hall of Imperial Supremacy, and the Palace of Tranquil Longevity are separate buildings they are, in effect, brought into architectural harmony and unity by the connecting pathway bisecting the three parallel terraces at right angles. The running-eaved galleries on either side of the Gate of Tranquil Longevity travel

115. Central bay and entrance to the Hall of the Spiritual Cultivation.

The Hall of Spiritual Cultivation is situated north of the Palace of Tranquil Longevity. Its structure and design is modelled on the Hall of Mental Cultivation. This hall was intended as the living quarters for the Qianlong emperor when he retired.

115

116. Hall of Pleasurable Old Age.
117. Upper gallery in the Hall of Pleasurable Old Age. The Empress Dowager Ci xi lived in this hall after her sixtieth birthday.

興和氣游

座右圖書娛畫景

敬勝齋法帖第二十一
御臨鍾繇力命帖

臣繇言臣力命之用以無所立帷幄之
謀而又愚耄聖恩低個待以殊禮天下
之帥土欣戴唯有江東當少留思既
與上公同見訪問昨日讜見復蒙遣及
雖緣詔令陳其愚心而臣所懷膝之事
昔先帝嘗以事及臣遣侍中王粲杜襲
就問臣所懷未盡異益絲髮乞使侍中
與臣議之臣不勝愚款懷之情謹表
陳聞

120

118. Inscribed stone tablets mounted in the wall of the west gallery of the Hall of Pleasurable Old Age.
119. Ink rubbings were taken from the fine examples of Chinese calligraphy, written with a brush pen and transferred to the stone tablets (fig. 119), leaving the characters reserved in white against the black ink ground. These were used as models for copying.
120. 'Zhen Fei well.'

When the Allied Forces forced their way into Beijing in 1900, the favourite imperial concubine of the Guang xu emperor, Zhen Fei, the 'Pearl Concubine', secluded at that time at the north court of the Pavilion of Great Happiness, was drowned upon the orders of the Empress Dowager in this well. The concubine was only twenty-five. Her body was retrieved and the well stopped up after the Empress Dowager returned to the palace from Xi'an in 1901. Consequently, it has been known as the 'Zhen Fei well'.

園林

GARDENS

The gardens in the Forbidden City are an integral part of the halls and palaces of the Inner Court. The four main gardens are the Imperial Garden, the garden of the Palace for the Establishment of Happiness, the garden of the Palace of Compassion and Tranquillity, and the garden of the Palace of Tranquil Longevity. These gardens, which link one palace building to another, are very different from other landscape gardens found in the city of Beijing, in that they do not possess the elements of natural scenery, space, and surface water which are available in, for example, the Garden of the Three Seas (now parks with large lakes running north–south on the west side of the Forbidden City), the Yuan ming Garden (*Yuan ming yuan*), and the Summer Palace. While the total area of the four palace gardens amounts to only 30,000 sq. m., each equivalent to the size of a small- to medium-sized private garden, they nonetheless possess all the character befitting a garden.

The Imperial Garden was called the 'Palace Rear Garden' in the Ming dynasty. Built at the same time as the Ming palaces and halls, it still retains its original character even after many renovations. Many of the buildings, trees and stones in this garden have survived from the fifteenth century. The garden measures 80 m. from north to south, and 140 m. from east to west. The main building in the garden, the flat-roofed, double-eaved Hall of Imperial Peace, is situated on the central axis of the Forbidden City, with nearly twenty buildings arranged symmetrically to the east and west. As most of the buildings are set against the palace walls, the garden looks very spacious.

Four pavilions flank the left and right of the Hall of Imperial Peace. Slightly to the north are the Jade-Green Floating Pavilion and the Pavilion of Auspicious Clarity. Both are square pavilions set over a pond, with covered open corridors on their southern sides. Stepped and uniform in plan the other two pavilions stand to the south: the Pavilion of Ten Thousand Springs and the Pavilion of One Thousand Autumns. These two exquisitely wrought, multi-faceted pavilions have a conical roof above a many covered single-eaved roof over a stepped square base. Symmetrically placed on the east–west axis, these buildings are the centres of attraction in the garden.

The stone mountain built against the north palace wall is called 'Piled Excellence', a precipitous artificial pile of rocks with steep paths winding to the top. On top is the Pavilion of Imperial Prospect where the emperor and empress celebrated the Festival of the Double Ninth each year (i.e. on the ninth day of the ninth month). Many of the flowers and trees here, such as the old cypress and the Chinese scholar trees, date back to Ming times. Stones of fantastic shapes on white stone stands and miniature trees of different kinds decorate the garden. Coloured pebbles are set along the borders of the paved pathways with the characters for 'happiness', 'fortune', and 'longevity' as well as in figurative motifs and flower patterns.

The garden of the Palace of Compassion and Tranquillity was rebuilt in the Qian long era based on the original Ming dynasty layout. An artificial 'mountain' constructed just inside the gate forms a wall of piled stones which although providing interest in itself creates an element of suspense for the visitor just entering the garden, for behind the hill, perched over a pond, is the Pavilion on the Brink of the Brook, flanked by the Study of the Embodiment of Purity and the Hall of Extended Long Life, on the east and west, making the Pavilion on the Brink of the Brook the delight of the southern section. The Xian ruo Buddhist building in the northern part is the principal building of the entire garden. To the north is the Building of Compassionate Shelter, to the east the Building of Buddha's Features and to the west the Building of Auspicious Clouds. These three are long buildings with raised verandahs. They form a semi-enclosed courtyard, creating a visual barrier in the northern part of the garden which makes the lower buildings in the western section seem more intimate and more human in scale.

The ordered, symmetrical layout of the pavilions and courtyards within the compound, amidst the surrounding ponds, hills and rockeries, throw into sharp relief the park-like atmosphere of the garden with its plantings of *wu tong* (Chinese parasol tree; *Sterculia platanifolia*), gingko, cypress, and other flowering trees. Here, the visitor can appreciate the seasonal beauty of each in its turn during all four seasons.

The garden of the Palace for the Establishment of Happiness, or the West Garden, was built in 1740. The gate to this garden opens behind the Pavilion of Favourable Breezes of the palace. Inside is a quiet enclosed courtyard consisting mainly of the Pavilion of Quiet Harmony and the Building of Wisdom and Sunlight. Because of this transitional arrangement of elements, the courtyard in the west, with the Pavilion of Prolonged Spring as its principal building, seems much more open by comparison. Against the palace wall to the north and west of this pavilion are the Building of Auspicious Clouds, the Study of the Respect of Excellence, the Azure Gemstone Kiosk, and the Hall of Crystalline Splendour. Not only do these lavishly appointed buildings relieve the monotony of the high palace wall, the asymmetrical, deliberately informal, arrangements of the buildings and galleries provide a lively contrast to the loftiness of the Pavilion of Prolonged Spring. To the south lies a stone hill with caverns, steep twisting paths, peculiarly shaped stones, and old plants.

Fond of the design and arrangement of the West

Garden the Qian long emperor later used it as the model for the West Garden he built in the Palace of Tranquil Longevity. Unfortunately, the garden was ravaged by fire on the eve of Emperor Pu yi's (the last emperor of the Qing dynasty) departure from the Forbidden City. All that remained was the Pavilion of Favourable Breezes and scattered rocks of the artificial hill.

The garden of the Palace of Tranquil Longevity was built between 1771 and 1776. The garden is rectangular in shape, measuring 160 m. from north to south, and 37 m. from east to west. Altogether there are four courtyards, each with a character of its own.

Going through the southern roofed gateway, the path winds round the edge of a piled stone hill before the full open vista presents itself. Occupying the central position to the north, the Pavilion of Ancient Flowers is the main building of the garden. Stones and pavilions decorate the eastern side of the courtyard, making up an open ensemble of elements. A unique 'cup-floating stream' was built into the floor of the Pavilion of the Ceremony of Purification, held in the spring and autumn, to the west. The galleries which occupy the southeastern corner form a courtyard within this courtyard. Following the traditional northern system of compound courtyard construction for dwellings, there is a second entrance providing access to a second courtyard through the Hall of Active Retirement. Decorated with only a few isolated stones, it is a setting to wonder at and in which to enjoy peace and tranquillity. The Building of Appreciating Lush Scenery in the third section of the garden is a two-storey building. The courtyard contains a stone hill, on which was built the Pavilion of Towering Beauty. Before passing into the final part of the garden one finds the Pavilion of the Three Friends nestling among the rockeries to the east. Entering the last section of the garden, one comes upon the Pavilion of the Anticipation of Good Fortune. This, the most ornate of the buildings here, has a curving stone hill before it and is linked to the Fasting Lodge at the back by ridged galleries, creating a totally different atmosphere. Capping the main peak of the hill in the front is the Pavilion of the Jade-Green Conch Shell, a distinctive and unique, small plum blossom-shaped pavilion, in plan built with five pillars and five ridges, and colourfully decorated with plum blossom motifs.

More than twenty buildings of different size, shape and character decorate the garden. Some buildings, following the lie of the natural shape of the landscaping, were placed asymmetrically, creating an air of lightness and playfulness amidst the overall solemnity of the palace construction. Like the pavilions, the stone hills in the garden, recalling a natural mountain landscape, also express this sense of informality. In each of the sections, stone hills were created in fantastic shapes. Some stand alone and have single peaks: others have multiple peaks, steep cliffs, and caverns. The principle behind this kind of landscaping was the desire to achieve harmony with the surrounding architecture.

The grand, external beauty of the garden buildings is complemented by the fine, ornate decoration of their interiors. All make full use of the arts of carving and inlaying. Filigree and cloisonné set the tone of the interior of the Pavilion of the Anticipation of Good Fortune. The Building of Extended Delight with ceramic inlays, and the enamel-inlaid pictures in the Building of Appreciating Lush Scenery are executed with the highest quality of craftsmanship. The moon door inside the Pavilion of the Three Friends is composed of woven bamboo strips, the plum trees at both sides are carved from sandalwood, and the plum blossoms and bamboo leaves from jade. The interior decorations of the Study of Peaceful Old Age are even more delicate. Here, the decoration on the horizontal boarding of the surrounding mezzanine consists of fine, woven strips of bamboo with jade inlays. The deep skirting panels on the four sides are a carved picture of 'the one hundred deer'. The central sections of the open partitions are comprised of breathtaking double-sided translucent embroideries.

The layout of gardens in the Forbidden City varies in the selection of the type of naturally arranged but artificial landscape and the location of each garden. When a garden was situated on the central axis of the main halls, principles of symmetry were applied. Such is the case with the Imperial Garden, where one can see the symmetrical disposition of the Pavilions of One Thousand Autumns and Ten Thousand Springs, the Pavilion of Auspicious Clarity and the Jade-Green Floating Pavilion, the Hill of Piled Excellence and the Pavilion of Prolonged Sunlight, and the Pavilion of Red Snow and the Study of Spiritual Cultivation. The garden of the Palace of Compassion and Tranquillity also lies on the central axis of the palace which it occupies.

If the garden, on the other hand, lay to the side of the principal halls, instead of on the central axis, the arrangements could be more flexible and informal. Walking in such gardens, one comes upon a different view at every turn along the winding path. This can be seen in the gardens of the Palace for the Establishment of Happiness and the Palace of Tranquil Longevity, which share characteristics of private as well as imperial gardens.

The pavilions, lodges and belvederes in the imperial gardens were chiefly pleasure spots for the imperial family. There were also halls, buildings and pavilions which served as places for Buddhist worship, fasting for purification before ceremonies, and retirement, as well as libraries and studies.

Fig. 31 Cross-section through the Hill of Piled Excellence in the Imperial Garden.

Fig. 32 Selecting palace maids outside the Pavilion of Prolonged Sunshine in the Imperial Garden during the Qing dynasty.

Fig. 33–34 The garden of the Palace for the Establishment of Happiness after devastation by fire.

Fig. 35 The 'cup floating stream' (photograph of 1900).

位育齋　延暉閣　集福門　順貞門 ❸
玉翠亭　　　　　　　　　　　承光門 ❺
澄瑞亭 ❹
欽安殿 ❼
千秋亭 ❽
四神祠 ❿
天一門 ⓫
養性齋 ⓬
瓊苑西門 ⓮
　　　　　　　　　　　　　　⓯
　　　　　　　　　　　　　坤寧門

1. Pavilion of Imperial Prospect on top of the Hill of Piled Excellence. (See Plate 143)
2. Gate of Prolonged Harmony. (See Plate 141)
3. Gate of the Pursuit of Truth, the inner rear gate of the imperial city.
4. Pavilion of Auspicious Clarity bridging a large pool and thus forming two smaller pools on either side.
5. Gate of Inherited Light flanked by two gilt bronze elephants. (See Plate 142)
6. Jade-Green Floating Pavilion, sitting above a pool, balanced symmetrically by the Pavilion of Auspicious Clarity.
7. Hall of Imperial Tranquillity set on the central north–south axis of the Forbidden City.
8. Pavilion of One Thousand Autumns, formally balanced by the following.
9. Pavilion of Ten Thousand Springs.
10. Temple of the Four Gods. (See Plate 133)
11. First Gate of Heaven lying across the central north–south axis of the Forbidden City. (See Plates 121–3)
12. Studio of Spiritual Cultivation. (See Plate 134)
13. Pavilion of Red Snow
14. West entrance
15. Gate of Earthly Tranquillity; entrance to the Imperial Garden.
16. East entrance
 - tree
 - two trees, or trunks, grown to form an arch
 - rock piles
 - strange natural rock formations set on bases

Apart from the above, other features of the garden include bamboo groves, as in the northeast and northwest corners, and formal ornamental geometric flowerbeds with pathways such as those around the Pavilion of One Thousand Autumns and the Pavilion of Ten Thousand Springs.

Fig. 36. Plan of the Imperial Garden

121. First Gate in Heaven, looking north.
122. A giant incense burner, in front of the First Gate in Heaven, the middle in the form of an archaistic bronze tripod vessel with handles, *ding*. The cowl is shaped like a double-eaved conical temple roof and the base a lotus throne pedestal.
123. Detail of leg of the incense burner, showing an archaistic form of the glutton monster, *tao tie*, mask.

Made from finely ground bricks, the First Gate, an arched gateway on the central axis of the Forbidden City, is the main entrance to the Hall of Imperial Peace. In front of the gate are a pair of gilt bronze mythical animals, *qi lin*, and another pair of stone ornaments resembling meteorites. There is a silk tree inside the gate. A giant incense burner stands between the First Gate in Heaven and the Gate of Earthly Tranquillity.

122

123

125

124–131. *Pen jing* in the Imperial Garden.

Rocks of fantastic shape mounted on carved stone plinths are placed all over the Imperial Garden. The term *pen jing* means 'bowl landscape' and is usually composed of a small natural rock which imitates a mountain landscape or particularly beautiful peak, on which grow seedlings or mosses, mounted on a flat container, often of clay, sometimes filled with a small amount of water. Just as these are often included in a small courtyard garden as a way of importing a piece of natural, much larger, scenery, so too were these relatively larger rocks selected for the Imperial Garden. However, the one bearing the title, 'Zhuge Liang paying his respects to the meteorites of the Big Dipper' (Plate 131) is not noted for its naturally craggy surface but for the way in which its silhouette resembles a man bowing with knees bent. Another, prized for its strange yet natural appearance, is the 'sea cucumber' *pen jing* which stands in front of the bronze goat on the eastern side of the Imperial Garden. It consists of a pile of fossilized sea cucumbers which, having a pliant textured appearance, seem to writhe and squirm naturalistically (Plate 125). Facing the Pavilion of Red Snow, a piece of petrified timber is mounted on a hemispherical carved stone base (Plate 126). From a distance it looks like a real split piece of timber, long exposed to sun and rain with thousands of holes bored by insects. But it gives out a clear sound when struck and genuinely is stone. On one side of it there is an inscription by the Qian long emperor with a cyclical date corresponding to 1766.

127

128

129

130

131

132. Pavilion of Ten Thousand Springs.

The Pavilion of Ten Thousand Springs was rebuilt in 1536. In plan the lower eaves' roof is basically a square. Fish-tail shapes are cut away at each corner, producing the distinctive three-pointed eaves' corners. This pavilion forms a pair with the Pavilion of One Thousand Autumns, differing only in the unique umbrella-shaped top to the ornate roof pommel.

133. Temple of the Four Gods.

This temple is an octagonal pavilion surrounded by an open verandah. It faces north, and stands opposite the Pavilion of Prolonged Sunshine.

134

134. Studio of Spiritual Cultivation.

The Studio of Spiritual Cultivation is a seven-column platformed building situated in the southwest corner of the Imperial Garden. It is balanced by the Pavilion of Red Snow and the two would seem to be complementary interlocking shapes in plan; that of the former is basically recessed while that of the latter is protruding in shape.

135. Pavilion of Auspicious Clarity.

This pavilion is symmetrically balanced by the Jade-Green Floating Pavilion and is constructed on a bridge, with water beneath and to either side of it. A hipped pavilion roof merges on the south side with a rolling pitched roof covering an open timber frame that has no filler or wall on any of the sides.

136. Pond over which stands the Pavilion of Auspicious Clarity.

135

136

137. Stone pathway in the Imperial Garden, bordered by inlaid pebble pictures.
138–140. Designs along the edges of the paved pathway in the Imperial Garden.

Pavement pictures in the paths of the Imperial Garden are created with different coloured pebbles. Nine hundred mosaic designs, no two of which are alike, lie in the walkways of the garden. The themes and motifs of the patterns are multifarious, ranging from people and animals, landscapes, and flowers, to historical subjects. The three patterns above are entitled respectively, 'Spring time in the Summer Palace', showing the bridge and bronze bull there, 'Swordfight between Guan Yunchang and Huang Zhong (of the Three Kingdoms)' in Peking Opera costume, and 'Heron, goat, crane and deer enjoying spring time'.

133

141. Gate of Prolonged Harmony.

The highly decorated Gate of Prolonged Harmony is the eastern entrance to the Imperial Garden. Part of the roof of the Pavilion of Imperial Prospect and base of the Hill of Piled Excellence are just visible behind the gate.

142. Gilt bronze elephant inside the Gate of Inherited Light.
143. Hill of Piled Excellence showing the upper and lower cave-like entrances. A fountain spurts a thin stream of water on the left.

The curling dragon relief of the fountain in front of the artificial hill spurts a column of water more than 10 m. high. On top of the hill stands the Pavilion of Imperial Prospect, built on a terrace enclosed by white marble balustrades. There are steps on the east and west sides of the hill leading up to the pavilion. Inside the gate in front of the hill is a stone cave through which the pavilion can be reached by entering the gate and then winding one's way up. Although man-made, the hill recreates the beauty of a natural mountain with deep caves and precipitous cliffs. It is created using the method, which also gives the formation its name, called the 'piled elegance method' by landscape garden planners. This hill was built during the Wan li period of the Ming dynasty, providing a particularly fine vista of the Imperial Garden. From the top of this hill the view stretches out over the Forbidden City and beyond the city of Beijing out to the Western Hills. On the seventh day of the seventh month of the lunar calendar, the Qing court offered sacrifices to the Cowherd and the Weaver Maid Altar in the Imperial Garden. With incense in hand, the emperor made obeisance first, followed by the empress, the imperial concubines of the first rank, the second rank, the third rank, and the fourth rank. It was from this hill also that the imperial family viewed the full moon on the evening of the Mid-Autumn Festival in the eighth month, and celebrated the Double Ninth Festival on the ninth day of the ninth month.

MAIN STRUCTURES

1. Study of the Respect of Excellence
2. Building of Auspicious Clouds
3. Building of Wisdom and Sunlight
4. Pavilion of Serene Tranquillity
5. Hall of Crystalline Splendour
6. Pavilion of Prolonged Spring
7. Gate of Preserving the Spirit
8. Stone *wei qi* chessboard table and seats (See Plate 144)
9. Pavilion for Attracting Kingfishers
10. Pavilion of Favourable Breezes
11. Palace for the Establishment of Happiness
12. Palace of Controlling Time
13. Gate for the Establishment of Happiness
 ⊙ trees
 ⌇ rock piles

Fig. 37 Plan of the garden of the Palace for the Establishment of Happiness.

144. Stone *wei qi* chessboard table and seats in the form of ancient drums in the garden of the Palace for the Establishment of Happiness.

MAIN STRUCTURES

1. Building of Compassionate Shelter
2. Building of Auspicious Clouds
3. *Xian ruo* Buddhist Building
4. Building of Buddha's Features
5. Hall of Extended Long Life
6. Study of the Embodiment of Purity (See Plate 149)
7, 8. West and East side halls
9. Pavilion on the Brink of the Brook (See Plate 147)
10. Pavilions over water wells
 - trees
 - piled rocks

Fig. 38 Plan of the garden of the Palace of Compassion and Tranquillity

145. A bird's-eye view of the garden of the Palace of
Compassion and Tranquillity.

146. A gingko tree (*bai guo shu* or *yin xing*) in the garden of the Palace of Compassion and Tranquillity.
147. Pavilion on the Brink of the Brook.

The Pavilion on the Brink of the Brook is built on a bridge base which spans a rectangular pond surrounded by white marble balustrades. There are screen doors with lattice windows on the four sides of the pavilion, all of which can be completely opened to give a wide vista.

148. Rockery and chequer board pattern pathway of stone and inlaid pebble mosaics in the garden of the Palace of Compassion and Tranquillity.
149. Continuous joined roofs of the Study of the Embodiment of Purity.

MAIN STRUCTURES

1. Gate of Truth and Compliance (outside garden precinct)
2. Study of Peaceful Old Age (See Plates 176–8)
3. Pavilion of the Anticipation of Good Fortune
4. Pavilion of the Jade-Green Conch Shell (See Plates 171–2)
5. Building of Appreciating Lush Scenery
6. Pavilion of Towering Beauty (See Plate 170)
7. Building of Extended Delight (See Plates 167–9)
8. Pavilion of the Three Friends (See Plates 163–6)
9. Hall of Active Retirement (See Plate 161)
10. Hall of the Glorious Dawn
11. Pavilion of Ancient Flowers (See Plates 151–2)
12. Terrace of Receiving Dew, on top of the 'false mountain' (See Plate 153)
13. Pavilion of the Ceremony of Purification (See Plates 155, 157)
14. 'Cup-floating' stream
15. Water well
16. Pavilion of the Carpenter's Square (See Plate 158. Gallery of the pavilion)
17. Gate of Spreading Happiness, main entrance to the garden (See Plate 150)
18. Pavilion over water well

⌂ rock piles
○ trees

Fig. 39 Garden of the Palace of Tranquil Longevity.

150. Gate of Spreading Happiness.

The Gate of Spreading Happiness is the front entrance to the garden of the Palace of Tranquil Longevity. On opening the front door, one is faced with a rockery screen, behind which sway branches of pine trees and cypresses. A winding footpath lies in front of the rockery surface of crazy paving of different colours forming a pattern of 'cracked ice'. This method of blocking the line of vision through an entrance with an object of interest, enticing the observer to explore by means of 'winding paths to penetrate secluded spots' is often used to great effect within the strictly delineated confines of a Chinese courtyard garden. In order to overcome these limitations twisting and winding paths reveal a new vista at every turn.

151. Pavilion of Ancient Flowers.
152. Looking south from the Pavilion of Ancient Flowers.

Facing south and situated on the central axis in the garden of Tranquil Longevity, the Pavilion of Ancient Flowers is an open-sided lodge with a hipped and gabled roof with single, long-pointed upturned eave corners. It is surrounded by a verandah with a low rail forming benches on four sides. The elegant coffered ceiling inside the pavilion has carved *nan mu* hardwood decoration in each square. An old catalpa tree standing in front of the pavilion grew there long before the pavilion was built and was specially retained. Since the flowers of this tree are notable for their exceptional beauty, the pavilion was given the name 'Pavilion of Ancient Flowers'.

153. Terrace of Receiving Dew.
154. Archways of the Buddhist hall below the artificial hill.

The Terrace of Receiving Dew on the main ridge of an artificial hill to the east of the Pavilion of Ancient Flowers is surrounded by white marble balustrades. The terrace is attractively positioned, jutting up through the branches of the pines and cypresses. Beneath the terrace is an entrance between the rocks and there are two sets of stairs leading up to the terrace on the east and west sides. The small cave at the bottom of the artificial hill is in the form of a Buddhist hall which evokes the atmosphere of an ancient Buddhist temple tucked away in some remote corner of a mountain.

145

155. Pavilion of the Ceremony for Purification.

In plan, this building is square with a projecting, smaller square attached centrally with a pointed hipped pavilion roof over the larger area joined to a hip and gablet roof with high, upturned eaves' corners. It is balanced in position by the Terrace of Receiving Dew in the eastern part of the garden. Its name alludes to the famous calligrapher Wang Xizhi, of the Jin dynasty, who wrote a piece of calligraphy celebrating the ceremony of this festival in the Orchid Pavilion.

156. Water storage vats for the cup-floating stream in the garden of the Palace of Tranquil Longevity.
157. 'Cup-floating stream' in the Pavilion of the Ceremony of Purification.

The cup-floating stream in the pavilion is for the enjoyment of 'floating wine-cups on the meandering water'. The stream follows a winding course, along which people would take their seats. When water was introduced into the trench, a cup full of wine was put at the head of the trench and floated on the water. Whenever it came to a stop, the person who sat there would have to compose a poem and finish the cup of wine. The water comes from a well and is drawn into the vats. There is an inlet at the bottom of the artificial hill which allows the water from the vat to flow into the trench. The water then winds its way into a culvert through a northern outlet at the bottom of the artificial hill. Both the inlet and outlet are ingeniously hidden beneath the artificial hill. Such cup-floating streams are also found in the Pavilion of Green Clouds in the garden of Compassion and Tranquillity and in the Zhonghai and Nanhai Parks.

156

157

158. Side view of the Gallery of the Square-Rule of the Pavilion of the Carpenters' Square.

The Gallery of the Carpenters' Square is situated at the southeastern corner of the first section of the garden of the Palace of Tranquil Longevity. This gallery creates a courtyard which is used to break up the monotony of the square plan design, and in addition, achieves a balance with the Pavilion of Dawn Sunlight in the northwestern corner of the garden.

159. Pavilion of Dawn Sunlight.
160. Mountain-Climbing Gallery of the Pavilion of Dawn Sunlight.

The Pavilion of Dawn Sunlight, a three-bay building with a rolled hip and gablet roof, is constructed on the northern slope of the artificial hill. Facing east it catches the rising sun and was, therefore, given the name of 'Dawn Sunlight'.

The Mountain-Climbing Gallery links the Pavilion of Dawn Sunlight at the top of the hill to the Pavilion of the Ceremony of Purification at the bottom. The hill and the buildings together serve to block the palace wall at the back from view.

161. 'Hanging flower' carved timber decorative canopy beneath the roofed gateway facing the Hall of Active Retirement.
162. The 'tiger skin' decorative wall-bases on both sides of the gateway.

The 'hanging flower' gateway in front of the Hall of Active Retirement is to the north of the Pavilion of Ancient Flowers. Beyond this archway lies the second section of the garden. On both sides of the gate are wall facings made from finely ground bricks. The lower part of the wall is made up of a tiger skin-like patchwork of coloured stones. This colour scheme lies in sharp contrast to the red colouring used on most walls in the Forbidden City.

159

161

160

162

149

163. Pavilion of the Three Friends, showing the double top-hinged lattice windows.
164. Sandalwood window carved with pine, bamboo, and prunus designs in the Pavilion of the Three Friends.
165. Partition boards with sandalwood frames inlaid with jade. Sandalwood openwork screen inlaid with jade and mounted with paintings and calligraphy. The lower registers are carved with the interlocking-T pattern incorporating swastika motifs.
166. Moon door in partition covered with woven bamboo bearing carved sandalwood design of (left to right) prunus, bamboo and pine.

The Pavilion of the Three Friends is situated in the southwest corner of the third section of the garden of the Palace of Tranquil Longevity. Its name, decorations and function are all directly related to *san you*, 'the three friends of winter', or pine, bamboo and blossoming prunus. These three have long been appreciated in literature and depicted in art for their abilities to withstand the extremes of the winter climate. They acquired symbolic qualities of correct gentlemanly conduct as well as steadfast friendship in the face of adversity. As the pavilion itself was used by the emperor in the winter, heated *kang* were installed and a high artificial hill constructed to shield the garden from the northwesterly winds.

The moon door inside the pavilion is a particularly fine example of a variation of the more common moon gate, a circular gateway piercing an exterior, garden wall, in which gnarled prunus and pine trunks twist through the aperture. The circumference of the latter is carved as if bamboo stems, some of which are left to grow upwards, have been woven together to form a circle. In keeping with the tone of the decoration, the rear translucent curtains are painted in a less formal style with a design of flowering magnolias and lotuses.

168

169

167. The imperial couch in the Building of Extended Delight.
168. Upper gallery of the building.
169. 'Borrowed view' through an artificial hill in front of the building.

The third section of the garden of the Palace of Tranquil Longevity is mainly landscaped with gnarled rocks forming artificial hills. In the centre of the courtyard are cliffs and caves, interspersed with buildings. At the northwestern corner are the Building of Extended Delight and the Building of Appreciating Lush Scenery. The verandahs of the lower floor connect with the Gallery of the Carpenters' Square, forming a covered walkway for the close viewing of the scenery, while the galleries on the upper floor provide a panoramic view of the artificial landscapes.

170. Snow on the Pavilion of Towering Beauty.

The Pavilion of Towering Beauty stands on the main peak overlooking the rest of the garden. A precipitous cliff, some 10 m. or more high, falls away from the front of the pavilion.

171. Pavilion of the Jade-Green Conch Shell.
172. Small bridge leading to the pavilion.

The Pavilion of the Jade-Green Conch Shell is situated on the main ridge of the artificial hill in the fourth section of the garden of the Palace of Tranquil Longevity. This pavilion is double-eaved, five-columned, and has a pyramidal roof covered with purple-glazed tiles, suggestive of the colour of prunus blossom. In fact, the entire structure, the decorative motifs, and the choice of colour for the roof and the division of the circular roof and eaves by five ridges like petals are all calculated to suggest the prunus and its blossom. Hence it was commonly called the 'Prunus Pavilion'. The stone bridge to the south of this pavilion which connects up to the Building of Appreciating Lush Scenery foreshadows the modern fly-over. This passageway, together with the paths at ground level, forms two criss-cross pathways on the upper and lower levels.

155

173. Pavilion of the Anticipation of Good Fortune.
174. Enamelled square-shaped window inlaid with jade in the pavilion.
175. Carved wood partition screens with translucent silk and inlaid with jade in the pavilion. The strange shaped inedible fruit on the branches is known as Buddha's hand or fingers (*fo shou*).

The Pavilion of the Anticipation of Good Fortune is located in the northern part of the fourth section of the garden. It is a five bay square, two-storeyed building: with its surrounding galleries on both floors and a pyramidal pitched roof, it looks extremely majestic. The covered walkways and low walls which lead to and away from the pavilion on the four sides divide the area around it into several smaller separate but connected courtyards. The ground floor is ingeniously partitioned with gilded carved screens inlaid with jade. Because the many twists and turns often caused the visitor to become disorientated, this pavilion also commonly came to be known as 'the labyrinth'.

157

176

177

158

178

176. Principal room of the Study of Peaceful Old Age.
177. Skirting panel in the lodge with traditional design in carved and inlaid wood of 'one hundred deer'.
178. Imperial couch in the principal room of the lodge showing horizontal woven bamboo frieze above the alcove and jade inlaid in the gallery pelmet and screen partitions.

The Study of Peaceful Old Age lies to the north of the Pavilion of the Anticipation of Good Fortune. The covered corridors on the two sides of the former join up with the two verandahs of the latter to form a small galleried courtyard. From the point of view of design, the Pavilion of the Anticipation of Good Wishes is aesthetically the most pleasing of all the buildings in the garden. The Study of Peaceful Old Age serves as its rear hall. Inside the gallery boards of woven bamboo and openwork partitions covered with silk and inlaid with jade are particularly fine.

159

179. East courtyard of the Pavilion of Great Happiness. A moon gate pierces the wall through to the next small garden.
180. Exterior view of the front of the pavilion.

161

戲臺

THEATRICAL STAGES

Many theatrical stages are scattered throughout the Inner Court of the Forbidden City. Some of them can be found in good condition today, such as the large Pavilion of Pleasant Sounds behind the Palace of Tranquil Longevity, the smaller Pavilion of Peaceful Old Age, the stage in the courtyard of the Studio of Fresh Fragrance in the Palace of Doubled Glory, the small 'Preservation of Culture' stage inside the same building, and that in the courtyard of the Palace of Eternal Spring. There are outdoor and indoor stage pavilions differing in design, size, and grandeur according to the requirements of the type of drama performed there.

The theatrical Pavilion of Pleasant Sounds is a three-storey building which was completed in 1772. It was renovated in 1802 and again in 1891. From top to bottom, the three storeys, connected by staircases, are called the Stages of Prosperity, Good Fortune, and Longevity. On the ground floor, the spacious Stage of Longevity measures nine square bays, about nine times the size of an ordinary theatrical stage. Stage doors are located on the two sides at the back of the stage. Just above the stage doors is a small platform from which the actors could descend to the stage below or reach the Stage of Good Fortune above. Five stage pits are located in the centre and at the four corners of the Stage of Longevity. Covered by wooden planks when not in use during a performance, the stage sets were pulled up from below stage through these holes. For example, when the play 'Golden Lotus Springing from the Earth' was performed, five statues of boddhisattvas on lotus thrones were hoisted up from below. The well in the centre was filled with water in the room below to produce sound effects. There are also three openings in the ceiling through which actors or stage sets could descend by pulley to the stage, such as the set used in the play 'The Arhats Crossing the Sea'.

The Stages of Good Fortune and Prosperity are relatively small. Both were designed according to the angle of vision of the emperor sitting in the room specially reserved for him. This was usually located in the connecting buildings which enclosed the courtyard and stage on three sides. Large doors and hanging windows could be opened out onto the performance directly opposite the stage. When a play such as 'The Imperial Birthday' was performed, hundreds of actors donned the sumptuous costumes of Taoist immortals and Buddhist characters, and created an exciting spectacle when they appeared on all three stages at the same time in well-loved, traditional tableaux. The rear part of the Pavilion of Pleasant Sounds is a two-storey building measuring five by three bays. The roof is attached to the eaves of the Stage of Good Fortune, providing a spacious back stage area.

Inside the west chamber of the Study of Peaceful Old Age, which is located in the northern part of the garden of the Palace of Compassion and Tranquillity, is a small theatrical pavilion where eunuchs sang and performed the *cha qu* (a musical play in question and answer form, which is mainly lyrical and comic in character). This is a square pavilion with a roof drawn up to a point: most of its structural members were carved to resemble bamboo. Bamboo fences acting as partition walls enclose the northern, western and southern sides.

Murals on the three remaining – north, south and west – walls are a flamboyant display of the designer's and painter's ingenuity and skill. They depict the continuation of the rear bamboo fence as well as large buildings and the sky beyond. Combined with a painted trellis of mottled bamboo through which wisteria and creepers grow, the result is a magical *trompe l'œil* effect in which the small pavilion stage appears to occupy an idyllic external setting. The interior construction is quite distinctive from the other red-walled and yellow-glazed tiled buildings of the Forbidden City. The emperor would sit in a recess, above which is a gallery, directly opposite the stage to watch the drama. Contrasted with the arrangement described above for outdoor performances this is a prime example of how maximum pleasure could be derived from those which took place protected from the elements.

When the two western palaces were renovated in the Qian long period, the Studio of Fresh Fragrance in the eastern courtyard of the Palace of Doubled Glory was added. There are two theatrical stages, the bigger one being in the front court of the studio. It has four pillars on each side, leaving a relatively large open space free in the centre. The pavilion is lavishly decorated, with skylights in the ceiling and a double-eaved roof. On New Year's Day, the emperor accepted congratulations from his officials, held banquets, and watched performances here. The small theatre is in the 'Golden Jade' chamber at the back of the building. Here, small-scale performances were put on for the imperial family during family banquets.

The Hall of Manifest Origin was erected in the late Qing at the time when the Gate of Eternal Spring was renovated. At the back of the hall, a three-bay covered corridor extended north to form the theatrical stage of the Palace of Eternal Spring. Spacious, simple, and elegant, it has low wooden rails between the columns around the perimeter which also served as seats for the audience.

Fig. 40 The great three-tiered theatrical pavilion in a courtyard of the Yi he yuan, Summer Palace, northeast of Beijing.

Fig. 41 Theatre programmes.

184. Interior of the top floor of the theatrical Pavilion of Pleasant Sounds.
185. Interior of the middle Stage of Good Fortune.
186. Backstage, corner of the pavilion showing costumes and stage properties used in the drama performed in the Forbidden City.

The Pavilion of Pleasant Sounds was the largest of theatrical stages during the Qing period. It is a three-storeyed building situated at the eastern part of the Inner Court in the vicinity of the Palace of Tranquil Longevity. It was built by decree of the Qian long emperor but, in fact, he seldom visited it because he never took up his residence in the palace nearby. It was only in the latter part of his reign that he went to watch large-scale performances there on such occasions as New Year's Day and the imperial birthday. It was during the reign of Empress Dowager Ci xi that this theatrical pavilion staged the greatest number of plays. She attended performances here on great occasions, accompanied by the emperor, empress, imperial concubines, princes and ministers. On her fiftieth birthday in 1884, operas were staged in the Pavilion of Pleasant Sounds from the twenty-second day to the twenty-eighth day of the ninth month, and again from the eighth day to the sixteenth day of the tenth month simultaneously in the Pavilion of Pleasant Sounds and the Palace of Eternal Spring. The performances lasted for six to seven hours a day. For these performances given in honour of Ci xi's birthday, 10,000 *taels* of silver were spent on buying the costumes and properties for performances at these two theatres. The costumes and stage properties are still preserved in good condition in the Forbidden City.

187. *Yue shi lou*, imperial building for viewing performances; view from the upper levels of the theatrical Pavilion of Pleasant Sounds.

Equivalent to the 'royal box', this building was constructed during the Qian long period of the Qing dynasty. It faces north and stands opposite the Pavilion of Pleasant Sounds. It is a two-storeyed building five bays wide and three bays deep. The emperor would sit here to watch operas. To the east and west of this building are viewing galleries which connect it with the theatrical pavilion. The building was renovated during the Jia qing period and later was a favourite place for Empress Dowager Ci xi to attend operas. She would sit on a couch surrounded on three sides by screens inside the main central doors which could be opened to watch the performance, as could the latticed shutters to either side. Glass panels meant that viewing was also possible through the closed doors.

188–9. Two sections of the painting entitled 'Opera performance at the Summer Palace at Chengde', *Bi shu shan zhuang yan xi tu* (Palace Museum, Beijing).

The painting depicts the Qian long emperor watching a performance from the imperial seat opposite the stage, similar to that of fig. 187, at the Summer Palace of Chengde. A resort was built by the Kang xi emperor in the mountains of Rehe (Jehol, now Hebei province), north of Beijing, to fulfil several purposes. First, situated high above the north China plain, it meant that the court was able to avoid the stifling summer heat. Second, its proximity to the old Manchu homeland and the lands of the other peoples who lived along China's borders meant that it was politically less sensitive than Beijing and thus became an important diplomatic, political and religious centre. In the pursuit of friendly and peaceful relations with Tibetan, Mongolian and other minority peoples, large temples were constructed as well as such facilities for entertainment. Amongst the latter there was a theatrical pavilion called the Pavilion of Clear Sounds, which was similar in design to the Pavilion of Pleasant Sounds in the Forbidden City.

The painting above, recording a grand occasion which took place in 1789, is by official palace artists.

喜在嘉主北有年　　萬添南極應無算

190. A small theatrical stage inside the Study of Peaceful Old Age, mainly used for the performance of *cha qu*.
191. The emperor's seat in front of the stage.

192. Theatrical stage in the courtyard of the Studio of Fresh Fragrance.
193. Ceiling painting above the stage.
194,195. Stage entrance bearing the characters (right to left) *yi wu*, 'ceremonial dancing', *xie yin*, 'harmonious sounds'.

173

聊将山水寄清音

風雅存

196. The small stage inside the Studio of Fresh Fragrance. The nameplate above the stage reads *feng ya cun*, 'preservation of elegance' or 'literary pursuits'.
197. Theatrical pavilion inside the courtyard of the Palace of Eternal Spring.

佛堂、道場及其他祭祀建築

BUDDHIST AND TAOIST HALLS AND OTHER PLACES OF WORSHIP

Many halls and buildings in the Forbidden City served as places of worship for the imperial family. Although Lamaism became the official religion of the country during the early years of the Qing dynasty, Taoism and Confucianism retained their traditional importance.

The important Buddhist halls, buildings and chapels are attached either to the palace of the emperor, that is, to the Palace of Tranquil Longevity or the residences of the empress dowager and imperial concubines, all in the Inner Court – the Palace of Compassion and Tranquillity, the Palace of Tranquil Old Age and the Palace of Longevity and Good Health. For example, there are the Buddhist Building and the Building of the Buddhist Sun at the back of the Palace of Tranquil Longevity, the Hall for Worshipping the Great Buddha behind the Palace of Compassion and Tranquillity, the Pavilion of the Rain of Flowers in the northeastern corner of the garden of the Palace of Compassion and Tranquillity, the Hall of Exuberance standing to the north of the Palace of Tranquil Old Age and the Palace of Longevity and Good Health. The Palace of Earthly Tranquillity of the Three Rear Palaces and the Palace of Inheriting Heaven of the Six East Palaces also housed shrines, Buddhist figures, and articles used in sacrificial rites by the emperor, empress and concubines. Most of the Taoist structures, such as the Hall of Imperial Peace in the Imperial Garden, the Temple of the Four Gods to its southwest, and the Hall of the Treasures of the Sky to the east of the Six East Palaces, were built in the Ming. Places for worshipping Confucius include the Hall of Remitting the Mind to the east of the Hall of Literary Glory, and the Confucian shrine inside the Gate of Heavenly Purity. There were also many large palaces which the emperor used for ancestral worship, as well as places where the emperor fasted and purified himself before offering sacrifices at the Altar of Grain, such as the Hall for Serving Ancestors and the Hall of Abstinence.

The Building of the Buddhist Sun and the Buddhist Building are situated to the east at the back of the Palace of Tranquil Longevity and to the north of the Palace of Great Happiness. They are built against the palace wall. The designs of these two Buddhist buildings are modelled on the Building of Auspicious Clouds and Building of Wisdom and Sunlight in the West Garden of the Palace for the Establishment of Happiness. They stand adjacent to each other and are connected by a roofed corridor on the first floor and share a common staircase. The two halls are filled with statues of the principal Buddhas of Lamaism, accompanied by 10,900 tiny clay images of Buddha. There is also a realistically carved statue of Tsong-ka-pa, the founder of Yellow Sect Lamaism, who sits with an air of composure. On the ground floor are six large, extremely rare and exquisitely wrought cloisonné pagodas.

The Hall for Worshipping the Great Buddha behind the Palace of Compassion and Tranquillity was the place where the Empress Dowager Li xi worshipped the Buddha and 'uttered her sorrows and griefs'. It is of the same width as the palace and is built on the same terrace. During the Qing dynasty a eunuch Lama priest chanted from the Buddhist sutras for twenty-one days from the fifth day of the twelfth month of the lunar calendar in this building. It was usual to hold Lamaistic religious ceremonies on the sixth day of each month. The Hall for Worshipping the Great Buddha in the last section of the garden of the Palace of Compassion and Tranquillity, the Buddha's Features' Building standing at its eastern side, the Building of Auspicious Clouds to its west and Building of Compassionate Shelter to the rear are all places of Buddhist worship. The Buddhas honoured are the Buddhas of the Past, Present and Future (Thatagata, Sakyamuni and Maitreya). The empress and concubines of the demised emperor came here to pray for long life, for aid in their remaining years and to practise asceticism.

The Pavilion of the Rain of Flowers is a finely built, square, two-storeyed building. The roofs of the two lower floors are of blue-, green- and yellow-glazed tiles. The uppermost roof, a hipped pavilion roof above the middle hip and gablet roof, is covered with gilt bronze tiles. Four rare freestanding dragons made of gilt bronze are placed along the four ridges. The Buddhas of the Western Paradise were worshipped in this pavilion and monthly ceremonies, such as chanting from the sutras, were also held.

At the northwest end of the back courtyard of the Pavilion of the Rain of Flowers is the Building of the Ancestors of Brahma, where Manjusri was honoured. Behind the Pavilion of the Rain of

Fig. 42 Hall of Transmission of the Mind to the east of the Hall of Literary Glory.

Fig. 43 Statue of Tsong-kha-pa (d. 1419), the great religious reformer and founder of the Yellow Sect of the Tibetan form of Buddhism, inside the Potala Palace, Lhasa, Tibet.

Flowers was the site of several buildings where large Buddhist and Lamaist sutra-chanting meetings were held. Unfortunately, they were all burnt down in 1923.

The Hall of Exuberance is to the north of the Palace of Tranquil Old Age. It was built in the Ming dynasty, and renovated in 1689 and once again in 1762. The flanking walls of the Gate of Exuberance before it, also built during the Ming, are graced with designs of glazed ceramic cranes. Inside there are paintings of five boddhisattvas sitting on lotus thrones to whom the hall is dedicated and it is here that the empress dowager and empress came to worship during the Ming.

The Hall of Imperial Peace stands inside the First Gate in Heaven at the centre of the Imperial Garden. It was built during the Ming period with double eaves and a flat-topped hipped roof surmounted by a gilt Buddhist parasol, one of the Eight Precious Objects. The balustrades of the terrace and the Imperial Way, the inclined slab of stone running up the centre of the steps of this building, are finely carved. The hall is surrounded by a low wall on the four sides. The God of the Northern Heaven was worshipped in this hall. Every year on the day of the spring, summer, autumn and winter solstices, an altar was set up and the spirit tablets set out, before which the emperor burned incense and performed the rites. During the New Year Festival and from the sixth to the eighteenth day of the eighth month, Taoist priests and followers made sacrificial offerings to Heaven here as well as in the Hall of the Treasures of the Sky.

The Hall for Worshipping the Treasures of the Sky is located to the south of the Six East Palaces. It has a main hall five bays wide and side halls three bays wide on the east and west flanks. The Supreme Deity was worshipped in the main hall. Religious activities here were similar to those which took place in the Hall of Imperial Peace.

Built in 1685, the Hall of Remitting the Mind is to the east of the Palace of Literary Glory inside the East Glorious Gate. Ancestral tablets were raised to the legendary emperors Fu xi, Shen nong, Xuan yuan (the Yellow Emperor), Yao and Shun, as well as to the kings Yu, Tang, Wen and Wu and also to the Duke of Zhou and Confucius. In the eighth month of every year on the day before the exposition of the classics, the emperor made offerings in the hall. Renowned for its fresh, sweet water the Big Kitchen Well, on the eastern side of the front courtyard, was that selected for use in offering sacrifices to the God of Wells from 1651 onward.

Another Confucian hall is adjacent to the Imperial Study, on the southern end of the east gallery inside the Gate of Heavenly Purity. Inside the hall is a tablet written by the Qian long emperor which reads 'Joining Heaven and Earth'. Ancestral tablets were set up here in honour of Confucius, Confucian disciples and men of virtue.

The Hall for Worshipping Ancestors is in the eastern section of the Palace of the Bringing Forth of Blessings. The original structure was built in the Ming dynasty but the present palace is the result of renovations carried out in 1656, 1679, 1681 and 1737. Constructed in an H-shape the palace is nine bays wide, with the high ranking double-eaved, hipped roof. A covered walkway links the front and rear halls and the whole complex is surrounded by high walls. The ancestral tablets to the heirs of Nurhachi, the founder of the Manchu state, were deposited in the front hall and those to his antecedents were placed in the rear hall. Each year on the imperial birthday, the first day of the New Year, and winter solstice (the three great festivals of the year celebrated in the palace), and on state occasions, the emperor would either go personally or send representatives to pay tribute to the ancestors.

The Hall of Abstinence stands to the west of the Palace of the Bringing Forth of Blessings, and south of the Six East Palaces. It was built in 1731 but later removed to a different site, in 1801. During the early years of the Qing, the emperor would stay for one day in the Hall of Abstinence before departing for either one of its counterparts at the Temple of Heaven, in the southern suburbs, or Altar of the Earth, in the northern part of Beijing. Only having first purified himself in this way was he able to perform these important ceremonies, the exclusive preserve of the Son of Heaven. Fasting entailed total abstention from wine, music and hot, spicy foods, as well as onions and garlic.

The Temple to the City God was built in 1726. It is situated in the northwest corner of the Forbidden City.

198. The two-storeyed Buddhist Building near the Palace of Tranquil Longevity.
199. Pagoda inside the Buddhist Building.

The Buddhist Building is situated at the northeastern part of the area of the Palace of Tranquil Longevity. It is a two-storeyed building seven bays wide, and has a verandah in front, and a pitched roof covered with yellow-glazed tiles. Many Buddhist pagodas and statues are kept in this building.

200. Wooden cabinet carved with the Eight Precious Objects of Buddhism and frame with niches containing images of Buddhas and Dalai Lamas set into the wall on the upper floor of the Buddhist Building.
201. Detail of niched frame. The Buddhas sit on lotus thrones and have blue *ushnisha*.

大清乾隆年敬造

202. Carved image of a Buddhist god from the shrine of the Buddhist Building.
203. Lacquered and gilt carved image of Tsong-kha-pa in the shrine of the building.
204. Carved image of a Buddhist god.

183

205. Murals of *lokapala*, or Four Heavenly Kings, on the ground floor of the Buddhist Building.
206. Mural on the upper floor of the Buddhist Building.

207. A corner of the Buddhist shrine inside the Temple for Worshipping Buddhas in the garden of the Palace of Compassion and Tranquillity.

Above is the gilt carved canopy with pendant bosses, embossed plaques of the Buddhas behind and gilt mystic knot in the foreground.

208. Interior of the main hall of the temple.

The five precious objects – two flower vases, two candlesticks and tripod incense burner – which are found on many Chinese altars are arranged on tables at the front.

209. Buddhist images inside the Building of Auspicious Clouds.
210. Pavilion of the Rain of Flowers.

The Pavilion of the Rain of Flowers, a building built specifically within the Forbidden City for the practice of Lamaism, was built during the Qian long period of the Qing dynasty. It has three storeys, the ground floor being surrounded by a covered verandah, the column-heads of which are decorated with animal masks with additional coiled dragons on those of the upper two storeys. The upper pavilion roof has four curving ridges, each bearing a gilt bronze dragon, and is surmounted by an elongated golden roof pommel at the apex.

211. Circular Lamaistic altar in the Pavilion of the Rain of Flowers.
212. Detail of the altar.

213. Altar and carved openwork partitions, through which is visible the roof of the circular altar below, on the first floor of the Pavilion of the Rain of Flowers.

214. Stairway leading to the top floor of the Pavilion of the Rain of Flowers.

215. Buddhist painting in the Hall of Exuberance.
216. Buddhist figures painted on a leaf of the Bodhi tree (*Ficus religiosa*).
217. Rosary of strung beads made from the seeds of the Bodhi tree (shown right).
218. Buddhist text written on a leaf of the Bodhi tree.

Built in the Ming dynasty, the Hall of Exuberance was used for worshipping the Buddhas of the Western Sky. It is five bays wide, three bays deep, and has a single-eaved pitched roof with yellow-glazed tiles. An old Bodhi tree grows in front of the hall, the leaves and seeds of which traditionally have been used to make Buddhist articles.

219. Hall of Imperial Peace in the Imperial Garden.
220. Ceramic tiled oven for the burning of sacrificial offerings in front of the Hall of Imperial Peace. Such ovens are usually found symmetrically placed in courtyards, in pairs.
221. Carved stone pedestal for flagpoles.

The Hall of Imperial Peace is situated in the centre of the Imperial Garden. Built in the Ming dynasty, it is the place for worshipping the Supreme Deity of the Taoist religion. Because Taoist assemblies were often held here during the Ming and Qing periods, it has been preserved in a relatively good condition. The building is five bays wide and is double-eaved and is approached by a flight of steps with a ramp at the centre carved in relief with dragons amongst clouds. The hall stands on a Sumeru stone terrace enclosed by white marble balustrades with dragon and phoenix carvings, all of which date to Ming times. The roof is flat-topped and hipped and surmounted by a large gilt roof pommel. A low wall built on all four sides means that the building is self contained.

220

221

222. Statue of the Lord of the Black (Northern) Pavilions of Heaven (*Xuan tian shang di*), surrounded by Buddhist religious paraphernalia and objects inside the Hall of Imperial Peace in the Imperial Garden. This deity is usually flanked by fourteen images – seven disciples and seven demon kings.

書房、藏書樓

READING ROOMS AND LIBRARIES

The main libraries and reading rooms in the Forbidden City were: the Pavilion of Literary Profundity, the Hall of Literary Elegance, the Hall of Luminous Benevolence, the Imperial Reading Room, the Hall of Luxuriant Foliage, the Study of Lingering Flavours, and the Study of Increasing Knowledge.

Built in the Ming dynasty and located in front of the Hall of Literary Glory, the Pavilion of Literary Profundity, the old imperial library, contained the rare books printed during the Song and Yuan dynasties. Among these old books were the ten categories of ancient books in one hundred cases transported from the imperial library of the Nanjing palace in 1421, and the original manuscript of the Ming encyclopedia, *Yong le da dian*, in 11,095 volumes. Construction work on the new imperial library began on the site previously occupied by the Hall of Ancient Physicians in 1774. After its completion in 1776, the imperial library was linked to the Hall of Literary Glory to form a component of the Outer Court.

The setting of the imperial library was the result of a well-conceived design. Behind the library and on its west side, there are stretches of artificial hills made of stones dredged from the bed of Lake Tai, and pine trees and cypresses are planted throughout the grounds. There is a square-shaped stele-pavilion with a hipped pavilion roof with upturned pointed or flying eaves to the east of the library, reminiscent of southeastern Chinese architecture. Erected in the middle of the pavilion is a stele bearing engraved calligraphy written by the Qing emperor Qian long, entitled 'An account of the Pavilion of Literary Profundity'. In front of the imperial library is a rectangular pool enclosed by white marble balustrades, the crosspieces of which are decorated with aquatic patterns. The source of its water is the Inner Golden River. A white marble arched bridge was built over the pool. Together with footpaths paved with cobble stones and flagstones, these create the serene atmosphere characteristic of a traditional Chinese garden.

The design and decoration of the imperial library are in harmony with the atmosphere of the courtyard. The platform on which it stands is built-up with city-wall bricks covered with smooth stone slabs. The two gable end walls built, unusually, of a smooth stone both possess an arched doorway surmounted by a canopy in the form of a roof of green glazed tiles. In contrast to the preponderance of the ubiquitous yellow tiles of the Forbidden City, the roof tiles are a deep, almost black, green bordered by glazed ridge tiles and decorations in a brighter green. Similarly, the painted decoration is generally in greens and cool colours; the pillars as well as the carved wooden eaves' boards and openwork balustrades between them are all painted deep green. Narrative scenes from literature decorate the upper part of the eaves' boards using similar cool colours in the more lyrical, so-called Suzhou style of painting. The colour scheme of all these elements combines to form a unique feature in the Forbidden City.

The structure of the imperial library was modelled on the First Pavilion in Heaven in Ningbo, Zhejiang province. It is five bays wide, with the staircase on its west wing making it six in all. The building is 34.7 m. long and three bays deep: with roofed corridors at the front and back of the building, it measures 17.7 m. deep. The building appears two-storeyed from the outside but it actually has three floors, with a winding corridor built in between the ground and first floors.

Between the years 1772 and 1782, under the Qian long emperor, some 350 scholars were set the task of reviewing and annotating over 10,000 volumes collected from all over the empire. Based on the definitive imperial library of the Ming dynasty, this resulted in the publication of the *Si ku quan shu*, *Complete library in four branches of literature*, sometimes called the imperial library, comprising 79,030 'sections' (*juan*) bound in 36,000 stitched volumes (*ce*), stored in 6,750 cases (*han*): the four categories comprised the classics, history, philosophy and literature. Two examples of other such huge compilations deposited here were *Si ku quan shu zong mu kao zheng*, *Annotated catalogue of the imperial library* and *Gu jin tu shu ji cheng*, *Synthesis of books and illustrations past and present*. All these books were stored in cedar (*nan mu*) wood boxes which were kept on book shelves on the three floors of the library. Book shelves, used as partitions, created spacious reading rooms between the central bays on the upper and lower floors. An 'imperial couch' was placed in the centre of the reading areas for the use of the emperor when readings of the classics were held here. Only seven complete handwritten sets of the imperial library were made and deposited in important centres such as the Yuan ming Garden, Chengde and Shenyang, but the one stored here is considered the best.

Situated in the Imperial Garden to the east of the Hall of Imperial Peace, the Hall of Literary Elegance is five bays wide. Rows of *Essentials of the imperial library*, *Si ku quan shu hui yao*, were kept here. These books were prepared at the command of the Qing emperor Qian long, who had ordered the official compilers of the *Complete library* to do a summary of its text. Two sets of the *Essentials* were made, the other set being stored at the Study of Lingering Flavours in the garden of Eternal Spring in the Yuan ming Garden. This set was destroyed when British and French troops set fire to the garden in 1860.

The Hall of Luminous Benevolence is on the east side of the Palace of Heavenly Purity. The main hall is three bays wide, with a covered corridor. On two occasions, in 1744 and 1797, the Qing emperors ordered compilations of all the rare printed books of the Song, Liao, Jin, Yuan and Ming dynasties that were kept in the Forbidden City to be placed in the hall.

The Imperial Reading Room is located inside the Gate of Heavenly Purity. Stretching east and west is a row of galleried buildings facing north which adjoin the gate on both sides. Those to the east house the Imperial Reading Room; those to the west, the Office of the Secretaries of the Han lin Academy. The Imperial Reading Room was the study for children of the imperial family: the Office of the Han lin Secretaries was where the Grand Secretaries of the Han lin Academy worked. To the northwest, and on the north wing of the Gate of the Luminous Moon, lies the Hall of Industrious Energy where a large collection of books was stored.

The Palace of Doubled Glory was originally one of the Five East Residences. This hall was the living quarters of the Qian long emperor when he was heir apparent. When he ascended the throne, his residence was accordingly raised in rank. This was also his study when a young boy.

The Palace of the Bringing-Forth of Blessings was the residence of the Jia qing emperor when he was still the heir apparent and the Study of Lingering Flavours and the Studio of Increasing Knowledge were the places where he studied. During his reign, it was the place where a set of the *Complete library in four branches of literature* as well as other titles were kept.

Large collections of books of the various dynasties, in addition, were stored in the Bureau of National History the Great Vault of the Grand Secretariat the utility rooms in the front and rear of the Hall of Military Eminence inside the West Glorious Gate, and the Palace of the Great Yang of the Six East Palaces.

Fig. 44 Facsimile edition of *Si ku quan shu*, Complete library in four branches of literature.

Traditionally bound Chinese books are usually of standard format. Rectangular pages are printed from wooden blocks and folded in half. The cut edges are then stitched together on the right-hand side with the folded edge outermost, forming a 'bag', the term used to describe this method. Relatively thin volumes (*juan*), their text being read from top to bottom and right to left whilst turning the pages from left to right, are placed in sets inside box-like cases, secured by toggles, the best being covered in silk (see fig. 47). The quality of paper and this method of binding has meant that many old books have come down to us in a fine state of preservation.

Fig. 45 First Pavilion in Heaven, Ningbo, Zhejiang province.
Fig. 46 Entrance to the pavilion.
Fig. 47 One cased volume of the Ming dynasty encyclopedia, *Yong le da dian*.

223. Stone bridge in front of the Pavilion of Literary Profundity, the imperial library.
224. The Pavilion of Literary Profundity.
225. Stele-pavilion of the imperial library.
226. The arched gateway at the front verandah of the imperial library.

Built in 1764, the Pavilion of Literary Profundity is where the *Si ku quan shu* is shelved. In structure and in appearance the building is modelled on the famous First Pavilion in Heaven Library in Zhejiang province. The former is six bays wide and has front and rear verandahs. It has a hipped and gabled roof, covered with black-glazed and green edging tiles. The library is a two-storeyed building but has an additional mezzanine floor constructed in between the upper and ground floors. The ridge tiles bear designs of dragons amongst waves. The theme of the beautifully executed paintings on the eaves' boards is of sea-horses, books and manuscripts.

Built at the same time as, and standing to the east of, the imperial library, is a stele pavilion. The stele, an engraved stone tablet bearing calligraphy by the Qian long emperor, an enthusiastic supporter of literature and the arts, was erected in this small building.

224

225　226

衙署及其他

GOVERNMENT OFFICES

Many types of office, guardroom and repository were set up in order to aid the emperor in his management of state affairs in the Forbidden City. Lower in rank, the buildings housing these offices are characterized by a simpler appearance, and most of them are located at some distance from the Outer and Inner Courts. Some of these buildings, though situated in the vicinity of the Three Great Audience Halls and the Three Rear Palaces, only occupy areas of secondary importance, such as the long galleried buildings and the side halls. Their location is determined by the functions they serve. They were divided by function into different departments, the more important ones being the Grand Secretariat, the Grand Council, the main office of the Nine Ministries, the Mongolian Princes' Office, and the Imperial Household Department.

The Grand Secretariat was an institution set up in the imperial palace during the Ming and Qing dynasties to assist the emperors in the management of state affairs. Its major functions were to draft and promulgate edicts, and examine and deliberate on the memorials presented to the emperor by officials. The offices of the Grand Secretariat were housed in different palace buildings according to their function.

The main office of the Grand Secretariat was situated at the east wing of the courtyard in front of the Gate of Supreme Harmony inside the Meridian Gate, consisting of twenty-two galleried rooms on both sides of the Gate of Unified Harmony. Housed in these galleries were the Honorary Titles' Office and the Inspectorate.

Most other sub-offices of the Grand Secretariat were housed in a group of buildings to the south of the Hall of Literary Glory. The main sub-office was the Great Hall of the Grand Secretariat. The eastern section of the hall consisted of the Chinese Registry, the office for readers of the Han lin Academy to draft proposal slips, the office for secretaries of the Registries to copy out formal slips, and the Duplicate Memorial Storehouse. The western section consisted of the Mongolian Copying Office, which was charged with the special task of translating memorials written in Mongolian, Tibetan, Turkish and other foreign languages into Manchu, and kept official records and imperial instructions written in Mongolian. The west building was the Manchu Copying Office, which was responsible for the preliminary examination of memorials written in Manchu, the copying out of documents written in Manchu, the collection and presentation of these documents to the emperor, and the management of the Imperial Archives and the Repository of Imperial Writings. The east building was the Chinese Copying Office, which was charged with the collection and the promulgation of memorials and the translation of various kinds of documents written in Manchu into Chinese.

Housed behind the Great Hall of the Grand Secretariat were the Manchu Registry, Inspectorate and Archives Offices, as well as a hall for the grand secretaries to observe the ceremony of fasting before offering sacrifices. The Archives Offices were divided into a southern and a northern section. The southern section kept the seals used in all correspondence of the Grand Secretariat, received and handled memorials presented to the emperor, and dealt with matters related to the performance of government officials. The northern section, on the other hand, was in charge of the imperial seals and memorials, and kept the endorsed memorials and documents.

The Great Vault of the Grand Secretariat consisted of the Endorsed Memorials' Archive and the Imperial Archive. These two archives are located on the east of the Great Hall of the Grand Secretariat and are both two-storeyed buildings with a total of twenty-two rooms. Precautions were taken against fire damage to such important repositories of documents by facing the outer walls of the timber structure with bricks. Stored in these archives were literary records, maps, and a large number of historical documents of the Ming and Qing dynasties. The veritable records and statutes were stored in the Bureau of National History to the north.

The Grand Council, known previously as the 'Military Council' and the 'State Administration Council', was originally established in 1729 as a

branch of the Grand Secretariat. With more and more highly confidential state papers being passed from the Grand Secretariat to it for handling, the Grand Council, which was then under the direct control of the emperor, assumed an even more prominent position and became the central organ of administration. Only those most trusted by the emperor could be selected to be grand councillors, and all matters concerning government had to be handled by them and presented to the emperor through the Chancery of Memorials. The Office of the Grand Council was located on the west wing of the Inner Right Gate outside the Gate of Heavenly Purity.

When Qing emperors attended to state affairs at the Gate of Heavenly Purity or summoned their officials for audiences in the Inner Court, presidents and grand councillors of the different offices had to gather in the Nine Ministers' Office outside the Gate of Heavenly Purity and wait to be called to his presence, while the Mongolian Princes waited in the Mongolian Princes' Office. Though the Grand Council was only a short distance away, neither the Nine Ministers nor the Mongolian princes were allowed to have any intercourse with the grand councillors, or else they faced severe punishment.

The main office of the Imperial Household Department is situated inside the West Glorious Gate, to the north of the Hall of Military Eminence. It served the numerous and varied needs of the imperial court. The establishment of the Imperial Household Department was divided into a number of offices. Those related to the imperial court are described as follows:

The Imperial Armoury administered four store houses: the Armoury, which was in charge of helmets, armour and weapons; the Blanket Storehouse which was responsible for the provision of arrows, bows, riding boots, and felt blankets; the North Saddle Storehouse which was in charge of saddles, bridles, canopies, tents, mat-awnings, and so on, used by the emperor; and the South Saddle Storehouse where saddles, bridles and other riding accessories for the army were kept.

The Imperial Stable was on the southern side of the Three South Lodges inside the East Glorious Gate. It provided and stabled the horses ridden by the emperor. On the northwestern corner of the Forbidden City is the Temple of the Horse-God. Every spring and autumn, sacrifices were offered to the Horse-God in order to protect the emperor's mounts.

The Department of the Privy Purse supervised six vaults; the Treasury, the Silk Store, the Imperial Wardrobe, the Tea Store, the Fur Store, and the Porcelain Store. These vaults were scattered throughout the Forbidden City; the Treasury was in the Pavilion of Glorifying Righteousness; the Silk Store in the Hall of Manifest Benevolence on the eastern side of the Hall of Supreme Harmony and in the western galleries outside the Middle Left Gate; the Imperial Wardrobe in the galleries south of the Gate of Glorifying Righteousness; the Tea Store in the west galleries inside the Gate of Supreme Harmony and the east galleries inside the Middle Left Gate; the Fur Store in the southwest corner building in front of the Hall of Supreme Harmony and the east galleries of the Hall of Preserving Harmony; and the Porcelain Store in the west galleries in front of the Hall of Supreme Harmony and the west of the Hall of Military Eminence.

The Imperial Medical Department was on the northern side of the East Glorious Gate. It exclusively treated the emperors. Two other Imperial Dispensaries were established at the southwestern corner of the Imperial Garden and in the Five East Lodges. Numerous kitchens were to be found inside the Forbidden City, the largest one being the Outer Kitchen east of the Arrow Pavilion. Another, south of the Hall of Mental Cultivation, served the emperors, provided food for the various palaces and prepared banquets for festive occasions. The Six East and Six West Palaces and the residence of the empress dowager housed their own smaller kitchens.

The Arrow Pavilion was built in the middle of the courtyard outside the Gate of Great Fortune. Five bays wide, enclosed by corridors, and with an encircling verandah and hipped roof with gablets, the Arrow Pavilion was where the military talents of candidates entering the advanced palace examinations were put to the test before the emperor.

Fig. 48 Kneeling mat for Grand Councillors.

Fig. 49 Duty room in the teastore.

231. Office of the Grand Council.
232. Interior of the office of the Grand Council, showing panelled *kang* on which stand low tables. The calligraphy hanging above the table and chairs is by the Xian feng emperor.

The office of the Grand Council was located in the row of galleries in the northwest corner of the courtyard between the Hall of Preserving Harmony and the Gate of Heavenly Purity. To its west is the main office of the Imperial Household Department and to its east, the guardrooms. The Office of the Grand Council, though small and simple in structure, was nevertheless the highest administrative organ of the Qing government. During the 182 years from 1729 to 1911, it lay at the heart of Qing administration.

The wooden structure of the Grand Council was converted during the Qian long period to the much extended tiled building that we see today. This office was close to the Hall of Mental Cultivation, making it easy for the emperor to summon his officials to discuss state affairs. The duty house of the Grand Council was small and simple, with very little interior furnishings apart from some tables and chairs. Hanging on the south wall of the office is a horizontal plaque with the words 'A Roomful of Harmony', written by the Yong zheng emperor. After the suppression of the popular Taiping Rebellion in the Xian feng period, the emperor wrote on a horizontal plaque now hanging on the east wall with the words, 'Joyous the reports of victory with red banners', to celebrate the victory.

233. Office where secretaries carried out their duties.
234. Office of the Nine Ministries.
235. Mongolian Princes' Office.
236. Grand hall of the Grand Secretariat.

The grand hall of the Grand Secretariat is situated near the city walls to the south of the Hall of Literary Glory on the southeast corner of the Forbidden City. Three bays wide, it has the simple pitched roof. The Grand Secretariat was an institution set up in the Qing dynasty to help the emperor to manage state affairs.

237. Gate of Initiating Auspiciousness.
238. Arrow Pavilion.

The Arrow Pavilion is situated on a vast expanse of level ground to the south of the Hall for Worshipping Ancestors. Here, the Manchu emperors and members of the royal family rode and practised horseriding and archery skills. Though termed a 'pavilion', the Arrow Pavilion is actually an independent hall. The building has long upturned eaves' corners, on the hipped and gabled roof. Twenty red painted columns support the eaves' boards of the surrounding verandah, thereby effectively reducing the number of bracket layers in this kind of traditional structure, a practice rarely found in Qing architecture.

建築結構與裝飾

ARCHITECTURAL COMPOSITION
AND DECORATION

臺基、欄杆

TERRACES AND BALUSTRADES

Buildings of timber construction in China consist of three important components: the terrace, the body and the roof. During the Shang and Zhou dynasties, the use of terraces had always been a major feature of palace construction. It is recorded that as early as the period of the Warring States, the lords of the various kingdoms were extremely fond of high terraces and with the passage of time, terraces became more and more sophisticated. Balustrades were added to the edges of the terrace and the two became integrated into a single unit. Directly influenced by Buddhism, the highest ranking buildings were built on elaborate, many tiered, terraces which embodied the concept of Sumeru, the central mountain peak of the Buddhist universe. This 'Sumeru terrace' added greatly to the impact of the overall design. The architectural treatise of the Northern Song period, *Ying zao fa shi, Regulations for use in buildings and construction work*, mentions the method for constructing 'double terraces with ornate balustrades'.

Terrace design in Ming times was exceptionally fine. Three buildings of the highest rank constructed during the years of Yong le – namely, the Hall of Serving Heaven (the present-day Hall of Supreme Harmony), the Hall of Praying for Good Harvest of the Temple of Heaven, and the Hall of Heavenly Favours at the tomb of the Yong le emperor (d. 1424), Chang ling, northwest of Beijing – all stand on a Sumeru throne terrace, the three tiers and steps of which are skirted by stone balustrades which enhance the splendour of the overall design by providing the correct proportions as a prelude to the superstructure. It is not difficult to imagine that if the additional layers of these terraces were removed, the effect would be completely lost. Three different ground plans were utilized for such terraces in order to give full expression to the various requirements and functions of these three palace-style buildings: circular (as in the Hall of Praying for Good Harvest); rectangular (as seen in the Hall of Heavenly Favours); and H-shaped (as seen in the Hall of Serving Heaven). The last design, in particular, accentuated the supreme authority of the emperor.

Building three-tiered terraces with balustrades was not a common practice in ancient Chinese architecture. Most halls and palaces of rank stand on a single wide Sumeru terrace surrounded by white marble balustrades, and protruding from the base of each post of a balustrade is a gargoyle in the shape of a dragon's head. Lying between two flights of steps approaching and leaving the major halls and at the same angle are large carved marble ramps which form part of the Imperial Way. There are three such carved stone slabs at the front and back of the three-tiered terrace on which stand the Three Great Audience Halls. The lowest section of the slab at the rear of the Hall of Preserving Harmony is 16.45 m. long, and 3.06 m. wide. Such slabs are usually carved in low relief and their decoration rarely deviates from a general formula which is found here. Imperial dragons chase flaming pearls through swirling clouds as the main design. When symbolizing the emperor, dragons have five claws and because these buildings are of the highest order, there are nine of them. Nine and its multiples were considered perfect numbers. The lower part of the slab bears rolling waves crashing against stylized mountains. When phoenixes, either alone or in combination with dragons, are found on these stone slabs, or elsewhere in the Forbidden City, they denote the empress.

Terrace balustrades are composed of two main parts: the upright stone posts, and the lintels which fill the spaces between them. Cut from a single slab of stone the lintels comprise the rail, baluster and solid, decorated panel of which the last forms the largest portion. Linear carved designs of crab-apple, bamboo, aquatic animals, an archaistic thunder pattern or interlocking Ts and hooks and the *kui* dragon are the most common motifs found on these panels. One of the finest examples of this art is to be found on the balustrade panels of the Hall of Imperial Peace. A lively pictorial composition is achieved by means of two dragons occupying the main field, one chasing a flaming pearl, the other turning its head back to join in the action, both against a ground of flowers and encased in a border of dynamic, continuous, scroll patterns which unify the design of the whole panel.

The patterns and decorations of the capitals of the posts vary according to the rank of the building with which they are associated. The Three Great Audience Halls are the heart of the palace complex and the symbol of imperial power. Therefore the caps of the posts all utilize the dragon and phoenix motifs, symbols of the emperor and empress respectively. Those which enclose the four corner towers of the Three Great Audience Halls, the buildings being lower in rank, use designs of the twenty-four solar divisions of the lunar calendar. Those which enclose the pavilions and terraces in gardens bear pomegranates, clouds, lotuses, and jointed bamboo stems. Most striking of all are the carvings on the tops of the stone posts on both sides of the Rainbow-Cutting Bridge to the east of the Hall of Military Eminence. Each is formed from the shape of a lotus leaf on which rests a fully opened lotus flower having three layers of petals wrapped around the seedpod. Lions carved in the round sit on top of the seedpods. Each lion assumes a different posture: some play with silk balls; others, lionesses,

50

play with their cubs. The larger of these young lions are only 10 cm. long, while the smaller ones measure no more than a few centimetres. They crawl, roll, tumble, or lie still by the side of their mother, just like spoiled children. These carvings are among the best that have survived in the Forbidden City.

Fig. 50 Hall of Praying for a Good Harvest, Temple of Heaven.

Fig. 51 Dragon and goat designs for the bas-relief carved decoration of balustrades from *Ying zao fa shi*, *Regulations for use in buildings and construction work*.

Fig. 52 Imperial Way carved stone slab in front of the Hall of Supreme Harmony.

Fig. 53 The above carved stone slab showing the lines of the joints made using the curving lines of the cloud motifs to conceal them.

Fig. 54 Facsimile reproduction of the Song treatise on architectural construction, *Ying zao fa shi*, by Li Mingzhong.

239. Three-tiered terraces and their white marble balustrades of the Three Great Audience Halls in the Outer Court.
240. Lower section of the Imperial Way on the rear terraces of the Hall of Preserving Harmony.

The Imperial Way measures 16·57 m. long, 3·07 m. wide and 1·7 m. thick, and weighs about 200 tons. It was made from a large, perfect piece of stone. The main design consists of alternate single and paired imperial dragons chasing flaming pearls amongst clouds with a border design of the classic scroll. Below, rolling waves crash against rocks, symbolizing the earth. To either side, the stone steps bear designs of lions and horses.

241

242

243

244

216

241. Imperial Way running north over the Inner Golden River bridge in front of the Gate of Supreme Harmony.
242. Imperial Way stair slab carved with clouds and dragons on the ramps in front of the Hall of Supreme Harmony.
243. Imperial Way stair slab carved with a geometric pattern. Echoing the pattern a large hexagon envelops a curled dragon and four phoenixes fly in the corners of the slab ramp in front of the Palace of Heavenly Purity.
244. Imperial Way stair slab carved with two phoenixes, symbols of the empress, on a ground of flowers in front of the Palace of Inheriting Heaven.
245. Imperial Way stair slab carved with two dragons in an ogival panel bordered by a key-fret meander in front of the Hall of Supreme Supremacy.
246. Imperial Way stair slab carved with two dragons amongst waves with naturalistic rocks, at the base of the Hall of Spiritual Cultivation
247. Imperial Way stair slab carved with a combination of hexagonal lattice with flowers, a curling imperial dragon in a leaf-framed ogival panel amongst waves and rocks, horses amongst waves, phoenixes and classic scrolls. The hexagon and squares forming the panel recall the central caissons of coffered ceilings.

248. Balustrade of the three-tiered terraces in front of the Hall of Supreme Harmony. Cloud scrolls decorate the post capitals.
249. Balustrade of the pond in front of the Pavilion of Literary Profundity, imperial library, carved with water pattern and aquatic animals.
250. Balustrade with leaf scrolls on a trellis with square pattern on the Pavilion of Ten Thousand Springs in the Imperial Garden.
251. Balustrade carved with an archaistic pattern on the eastern terrace of the Pavilion of Ancient Flowers in the Palace of Tranquil Longevity.
252. Balustrade carved with designs of different kinds of bamboo of the Pavilion of the Ceremony of Purification in the garden of the Palace of Tranquil Longevity.
253. Column base carved with prunus blossoms of the Pavilion of the Jade-Green Conch Shell in the garden of the Palace of Tranquil Longevity.

254. Balustrade carved with dragons and flowers on the terrace of the Hall of Imperial Peace in the Imperial Garden. The capitals are carved with phoenixes amongst clouds.
255. Balustrades carved with panels of dragons amongst waves and dragons amongst clouds on the capitals on the terrace of the Hall of Imperial Peace.
256. Balustrade on the terrace in front of the Hall of Imperial Supremacy.
257. Gargoyle in the shape of a *chi*, hornless dragon, on the front terrace of the Hall of Supreme Harmony.
258. Undecorated terminal panel of balustrade outside the Hall of Imperial Supremacy.
259. Terminal panel stone carved with dragons and *mille-fleurs* of the Hall of Imperial Peace in the Imperial Garden.

219

260. Capital of a corner post carved in high relief with a dragon amongst cloud scrolls outside the Hall of Imperial Peace.

261. Capital of a post carved with a dragon outside the Hall of Supreme Harmony.

262. Capital of a post carved with a phoenix standing on a rock above lappets in the Hall of Imperial Peace.

263. Capital of a post carved with a pomegranate above lotus panels; Gate of Martial Spirit.

264. Capital of a post carved with a pattern representing one of the twenty-four solar divisions of the lunar calendar; Gate of Unified Harmony.

265. Capital of a banister carved with banana-leaf pattern with *ru yi* lappets; Pavilion of Auspicious Clarity, Imperial Garden.

266–267. Two of the many lions carved in the round, all different, forming the capitals of the balustrade posts on the Rainbow-Cutting Bridge.

268. Capital of a banister carved with lotus-leaf patterns by the side of the pond in front of the Hall of Literary Profundity.

263

264

265

266

267

268

221

梁架

TIMBER CONSTRUCTION

The external appearances of the halls, palaces, temples and other buildings in the Forbidden City are closely related to their internal structure.

By the Ming dynasty, the timber construction of official buildings had reached a degree of uniformity in terms of standards, design and specifications. The whole of the Forbidden City was constructed under the direct supervision of the Board of Works and so not only does it provide examples of official, palace-style architecture but also methods of construction.

For the most part, there were three methods of timber construction employed in China: post and beam construction, column and tie construction and log cabin construction. The first of these methods was the one most commonly used and is to be found in all the buildings throughout the Forbidden City.

In general, Chinese timber structures were designed, depending upon the size and orientation of the building, by erecting circular wooden columns on stone plinths. Beams are placed between these columns resting on their tops. Shorter columns (queen posts) are placed some way in from the two ends which are also joined by a beam. By stacking tiers of these frames one on top of the other, a rising line of steps is produced. When the point of each step is joined together the pitch and silhouette of the roof shape is formed. This method is known as 'column and strut construction' or the 'post and lintel method'. The superstructure is tied together between bays by a horizontal beam joining the upper ends of the centre columns. Purlins parallel to the superstructure are then placed on the heads of the beams and the centre column. Rafters are nailed to these purlins to support the weight of the roof boards. This completes the complex interlocking structure.

The roofs of buildings in the Forbidden City are of many different types, the most complex part of their structure being the flank walls of the two side walls when viewing the building straight on. If these gable walls follow the line of the slopes of the pitched roof in a triangular shape it is referred to as *ying shan ding*, 'firm (pointed) mountain (shape) roof'. The pitch and point at which the angle of the roof changes, is determined by the number of 'stacked frames' employed in the construction of the gable wall. Middle and lower ranking buildings in the Forbidden City such as *er fang*, or smaller extension or 'ear' buildings, side galleried buildings and the Great Hall of the Grand Secretariat employ this method. This type may be termed the pitched roof (see fig. 56.5).

Slightly higher in rank than the *ying shan* roof is the *xuan shan*, or 'overhanging mountain' roof. Similar to the former, the main difference lies in the extension to one or both slopes of the pitched roof to form a pillar-supported verandah. Roof tiles are laid on the roof boards which in turn are placed on the extended rafters resting on the projecting eaves' purlin. Most of the minor palaces in the major courtyards of the Forbidden City were built with this type of roof. They include the side halls of the Hall of Literary Glory, the Hall of Military Eminence, the guard houses to the east and west of the Gate of Martial Spirit, and the guard houses inside and outside the West Glorious Gate.

In contrast to pitched roofs, high ranking buildings have hipped roofs of differing types. As a general rule they have one horizontal and four double pitched sloping ridges. Prior to the Song and Yuan dynasties they were known as *si a shi*, 'four slope style', or *si zhu ding*, 'four (faces) flowing water roof', because of their ability to carry rainwater quickly down and away over the gently upturned projecting eaves, which thereby provided a protective verandah. This is called *dan yan wu dian ding*, 'single-eaved great hall roof', or single-eaved hipped roof (see fig. 56.1). However, such roofs are found as early as the so-called Yangshao neolithic period of China. Vestiges of the post holes found on the south bank of the River Jin at Baoji in Shaanxi province attest to a thatch-covered dwelling supported by main posts. Although simple, such constructions were the forerunners of the magnificent official-style buildings of later periods. The oldest example of this hipped roof, later called *wu dian ding*, 'veranda great hall' roof, surviving today is that of the *Fo guang si* (Temple of the Light of Buddha's Halo) dating to the Tang dynasty. However, majestic as it was, this type of single-eave roof was never used for the most important halls but found on the group of buildings next in rank to them, such buildings as the Hall of Exuberance, the Palace of the Great Yang, the front hall of the Palace of Complete Happiness, and the rear hall of the Hall for Worshipping Ancestors.

In order to enhance further the splendour of such halls, a lean-to roof was added below the eaves of the hipped roof. Following the lines and design of the eaves above, it skirts the four walls forming what is known as *chong yan wu dian ding*, 'double eaved verandah roof', and may be called a double-eaved hipped roof. Such roofs are incorporated into the construction of only the highest rank of buildings such as the Hall of Supreme Harmony in the Outer Court, the Palace

Fig. 55 Temple of the Light of Buddha's Halo, *Fo guang si*, A.D. 857, Wutai shan, Shanxi province.

of Heavenly Purity, the Palace of Earthly Tranquillity and the Hall of Worshipping Ancestors in the Inner Court, and the Hall of Imperial Supremacy and the watchtowers at the four corners of the Forbidden City walls (see fig. 56.2).

Slightly lower in rank than the above type of roof is the *xie shan ding*, 'cut-off mountain roof'. Mentioned in the *Gong cheng zuo fa*, *Construction methods*, of 1734 it is a form which combines the pointed gable and pitched roof described above (*ying shan ding*), placed over a hipped roof (*wu dian ding*). In this way the 'cut-off mountain', a small gable, or gablet, is formed, on the sides of the building, above the two flanking walls. The overall result is a hipped roof with gablet, or a gambrel roof. Because four ridges fell at a steep angle from the main horizontal ridge ends at the top and in turn connected with four other ridges sloping away to form the eaves at a shallower angle on the lower part, it was originally referred to as *jiu ji dian*, 'nine ridge hall (roof)' (see fig. 56.3).

In the case of tall and important buildings such as the Gate of Heavenly Peace, Gate of Uprightness, Gate of Supreme Harmony, Hall of Preserving Harmony, Palace of Tranquil Longevity, and Palace of Compassion and Tranquillity, a verandah roof skirts the buildings forming double eaves (see fig. 56.3). Amongst the various different methods of construction, the most common was to form a symmetrical stepped frame by piling up successive layers of short queen posts and beams of diminishing lengths on a graduated scale, all resting on a base formed by the main beam of the lower eaves, as already described above.

The hip and gablet roofs are known to have been in existence in a simpler form during the Western Han dynasty. But the earliest prototypes probably consisted of a pitched roof and separate awning roof, and only later during the Eastern Han dynasty were the two roofs connected together as an integrated unit to form the 'nine ridges' type of roof. The front hall of the South Chan Buddhist Temple, a large-scale timber framed building dating to 782, is the oldest building still surviving in China that possesses such a roof.

Two paintings of the Song period, 'The Yellow Crane Pavilion' and 'The Ming huang emperor travelling in Shu', show a variation of this type of roof in which the two roofs intersect presenting four gablets (see fig. 21, p. 33). The possibilities were taken even further in the Ling xing Temple built in 1052 at Zhengding in Hebei province, and in the multifaceted watchtowers with three levels of eaves in the Forbidden City.

These corner watchtowers imitate the buildings in Song paintings and the palaces of the Great Inner Court of the Yuan dynasty capital. In each case, six hip and gablet roofs are joined to form one entity boasting twenty-eight eaves' corners, ten decorated gablets and seventy-two ridges. A rare feature of the building lies in the complete absence of interior columns; nor can a single beam end be seen on the outside. Although projecting in so many directions the disposition of the eaves is such that they present a unified whole.

Special styles of roof tend to be reserved for a garden setting in the Forbidden City. Small-scale hipped pavilion roofs with four equal double pitched faces fall pyramid-like from a central point.

Sitting atop a piled rock formation, the Pavilion of Imperial Prospect possesses just such a roof and resembles a much grander building nestling some way off in the mountains. Chinese gardens demanded such illusions and the relative simplicity of the style is particularly suitable for such use as it is also when used in smaller 'connecting' buildings as part of a sequence. Two such examples are the Hall of Complete Harmony between the stately Hall of Supreme Harmony and the Hall of Preserving Harmony, together with the Hall of Union lying between the Palace of Heavenly Purity and the Palace of Earthly Tranquillity. Here, it fulfills a similar role in the spatial arrangement of buildings. The gilt sphere hovering at the apex symbolizes heaven over the square plan of the roof symbolizing earth. Called *si jiao cuan jian ding*, 'four corners gathered to a point roof', hipped pavilion roofs may also be double-eaved, such as the corner towers of the Meridian Gate. In other cases, the eaves are multi-pointed as in the Pavilion of the Jade-Green Conch Shell which has five and the Hall for Worshipping Ancestors which has eight. Another variation is seen in the curving 'bell-shaped' ridges of the stele pavilion in the precincts of the Hall of Literary Glory. Pavilions built above wells have roofs with tiles on four sides and an opening to the sky left in the centre.

There is also a type of roof which resembles a case in which imperial seals in ancient China were kept, and this became known as the 'seal-case roof', *lu ding*, consisting of a flat top and four sloping ridges. Associated with the grandest of official halls, the Hall of Imperial Peace and the 'Seal Case Roof Hall' of the Yuan palace belong to this category.

1 *Dan yan wu dian ding*. Single-eaved pitched roof.
2 *Chong yan wu dian ding*. Double-eaved hipped roof. May also be single-eaved.
3 *Chong yan xie shan ding*. Double-eaved hipped roof with gablets. May also be single-eaved.
4 *Lu ding* 'sea-case roof'. Half-hipped, flat-topped roof.
5 *Ying shan ding*. Pitched roof.
6 *Xuan shan ding*. Pitched roof with overhanging eaves.
7 *Juan zha ding*. Rolled pitched roof.
8 *Yuan zuan jian ding*. Conical roof.
9 *Si jiao zuan jian ding*. Hipped pavilion roof.

Fig. 56 Nine different types of roof shape used in the Forbidden City.

269. Model showing timber structure of the Palace of Gathering Essence.
270. Palace of Gathering Essence.
271. Structure of the 'seal-case' roof, *lu ding*, of a well pavilion in the western part of the Imperial Garden.
272. Double-eaved hipped roof of the Hall of Supreme Harmony.
273. Double-eaved hipped roof with gablets of the Hall of Preserving Harmony.
274. Hipped pavilion roof of the Hall of Union.
275. Double-eaved half-hipped flat-topped or 'seal-case' roof, *lu ding*, of the Hall of Imperial Peace in the Imperial Garden.
276. Rolled pitched 'coping' roof of the Gate of Gathering Essence.
277. Single-eaved hipped roof of the Palace of the Great Yang.
278. Conical roof of the Pavilion of Ten Thousand Springs in the Imperial Garden.
279. Pitched roof showing gable.

272

273

274

275

276

277

278

279

225

280

281

282

283

226

280. Beams and columns of the Gate of Supreme Harmony.
281. Roof beam structure of the Gate of the Great Ancestors.
282. Roof beam structure showing rafters and roof boards of the Gate of Luminous Virtue.
283. Roof beam structure of the Rear Right Gate.
284. Roof beam structure of the back stage of the Theatrical Pavilion of Pleasant Sounds.
285. Column head brace or bracket with carved and gilt dragon in the Hall of Imperial Supremacy.
286. The large and small tie beams and column head brackets of the Hall of Supreme Harmony.
287. Main structure of the covered verandah of one of the city wall watchtowers.
288. Corner cantilever end inside a watchtower.

斗栱

BRACKETING

One of the main developments in the history of Chinese official timber framed architecture lies in the methods employed in supporting the large, elegant roofs. Basically, full advantage was taken of the lever action of transverse members or cantilevers. First, a square-shaped wooden block, *zuo dou*, the lowest bearing block, is placed on a flat crossbeam above the top of a pillar. Square brackets, called *gong*, the two ends of which are curved upward in a cup shape, are let into the cushion or seat, *zuo dou*. The two ends of the bracket have similar *dou* which take the next set of brackets. Layer upon layer of brackets may be piled upwards in this fashion in order finally to support the roof and eaves' purlins. Horizontal members with beak-shaped ends, called *ang*, may be inserted into the construction. These projecting members are relatively long in order to spread the load as they carry the brackets upward and outward to support the characteristically deep eaves. These, too, make use of the cantilever in which a load is borne on a horizontal element behind a fulcrum.

The *dou gong* bracket system was developed very early in Chinese history. The earliest example is found in relics of buildings which date from the Eastern Zhou dynasty. The system was developed and used extensively in the Han, being used not only as supports for eaves and balconies of wooden buildings, but also, in the Eastern Han dynasty, in the construction of stone watchtowers and tombs. By the Tang period, the dimensions of the *dou gong* had increased because of the use of multiple layers to create deeply projected eaves. During the Song dynasty and after, the brackets decreased in size. In the Ming and Qing, the span of each bay was enlarged and the number in each bay increased accordingly. The central bay of the Hall of Supreme Harmony is built up with eight bracket sets. Those of both the upper and lower eaves are gilded. This is the highest ranking bracket set to be used in construction.

Depending on the number of layers, there are several types of bracket sets, their use being determined by the size and rank of the hall or building. In large halls they are complex and multi-layered. In the Hall of Supreme Harmony, the brackets supporting the lower eaves consist of four tiers, while the brackets used for the upper eaves are piled in five layers. This is the only extant example where so many layers of bracket sets were used. There were some halls and palaces which used considerably less *dou gong*. For instance, the majority of the side rooms, galleries, corridors and duty rooms use only a single-layer bracket set. The kind of arrangement was not only appropriate from the point of view of a well-balanced structure but was also based on structurally sound principles. Different bracket arrangements were, however, used to bear the much greater weights of the roofs of large halls or the relatively lighter skirting lean-to roofs of verandahs, and the much less

Fig. 57 Model of corner bracketing of the Palace of Gathering Essence.
Fig. 58 Model of bracket sets resting on beam plates, the two ends of which meet over the centre of the column head, in the Palace of Gathering Essence.
Fig. 59 Bracketing system at upturned corner eaves of the Shrine of the Saintly Mother (*Sheng mu dian*) at the Jin ci temple, Shanxi province.

heavy roof-covered walkways beween pavilions.

Bracket sets rest upon the capitals of eave columns, crossbeams and flat beams' boards. In large-scale halls, upturned cup-shaped brackets were used under the eaves. The shape of this kind of bracket is symmetrical from all sides. Looking at it from the side, its shape resembles the successive layers of the written character 品 *pin*, giving rise to the traditional name *pin*-shaped brackets. Apart from supporting the upper crossbeams, columns and the ceiling, *dou gong* also act as the junctures which relieve the tension between the upper and lower parts of large wooden structures.

In relation to girders and beams, the function of the *dou gong* resembles the leaf spring used in the suspension system of automobiles. Even though the materials are not the same, the method of building up successive layers of ever-increasing length in order to support projections is similar. Particularly when many small wooden members are joined together, the strength of the wooden structure as a whole is greatly increased. The roof of the Hall of Supreme Harmony weighs more than 2,000 tons and the distance from the ridge course to the ground is 35·05 m. Two 3·4 m. high, 4·3 ton acroteria, or gaping dragons, are attached to the ridge. But even during strong earth tremors the roof of this palace has never been damaged or shifted; on the contrary, it was the roofs and the walls of the smaller buildings which collapsed, an indication of the tremor-resistant nature of the bracket-set method of construction.

In traditional wooden structures, because the eaves of a roof were projected deeply, the dead weight of the eave portion was enormous. In order to maintain the balance between the inside and outside areas of the roof structure, apart from using brackets between the column ends and girders with multiple fulcrums, the beam was lengthened and extended to distribute the load as described above. Another type of structural member has its tail end suspended in air. Making use of the upward thrust of the tail end, this bracket set effectively supports the excessive load of the eave portion of the roof. This type can be found on the eaves of the Gate of Literary Glory and the Hall of Great Supremacy.

The total number of members used in a timber framed structure can be anything from one hundred to in excess of one thousand, depending on the size of the building. These members are all fitted together with tenons and mortises. However, in palatial structures, apart from using the direct links provided by the tenons and mortises, the bracket sets were used as indirect, transitional links which lent special strength to the structure, equivalent to adding extra roof beams. The brackets also increase the bending strength, shearing strength and compressive strength of the structure, as well as increasing its ability to withstand strong earth tremors.

58

59

230

290

291

292

293

294

295

289. Bracketing resting on beam plate at base and supporting coffered ceiling lath with tail end (interior) of long member, *ang*, cantilever in the Hall of the Ultimate Principle.
290. Gilded brackets in the Hall of Supreme Harmony.
291. Bracketing showing the Chinese written character *pin* shape between crossbeam and ceiling inside the Gate of Supreme Harmony.
292. Eaves' bracketing between beam and eaves' purlin showing circular rafter ends of the Hall of Imperial Supremacy.
293. Gilded, interior tail end of cantilever members, *ang*, inside the Gate of Literary Glory.
294. Gilded corner eaves' bracketing and cantilever tail ends of the Gate of Martial Spirit.
295. Gilded corner bracketing supporting caisson inside the Pavilion of Ten Thousand Springs in the Imperial Garden.

231

屋面裝飾

ROOF FORMS AND THEIR DECORATION

Traditional architecture in China paid careful attention to the aesthetics of constructional design, considering the contour and outline of the roof as well as its decoration. The flowing curve of the roof is gentle, the corners of the slightly upturned eaves giving the structure the appearance of a pheasant in flight. Many kinds of glazed objects became integral parts of roofs, for practical purposes as well as for decoration contributing to the beauty and magnificence of the building as a whole.

Most of the large and small palaces, halls, pavilions, galleries and corridors in the Forbidden City are covered with coloured glazed tiles. The shape of the roof was determined by the function and the rank of the building. And the choice of the type of ridge and the ceramic figure tiles that would decorate them was dictated by the form of roof chosen. Roof tiles are of two types: 'flat' and 'cylindrical'. The former are slightly curved and somewhat wider than the latter. They are laid overlapping one another vertically down the roof slope to form rows. The cylindrical tiles, which are, in fact, semi-cylindrical, are laid end to end overlapping the two sides of each row of flat tiles forming ridges. The roofs are decorated with different types of glazed ceramic objects. At the junction of the main, top, ridge and the sloping ridges is placed a gaping dragon, while immortals and small creatures line up in procession towards the eave corners.

The Hall of Supreme Harmony was the main audience hall of the emperor. The main top ridge is decorated with a pair of huge gaping dragons which are swallowing the two ends of the ridge. Their tails are raised and a double-edged sword is implanted in their backs. The treatise *Regulations for use in buildings and construction work, Ying zao fa shi*, refers to these composite dragons as *chi*, 'owl-like', *wen* 'lips'. According to the *Important documents of the Tang dynasty, Tang hui yao*, 'After the Hall of Bo Liang of the Han was destroyed by fire, a shaman of Yue had told of a fish that lived in the sea, its tail resembling an owl's, which churned up such huge waves that heavy rains would fall immediately afterwards: so its image was placed on the roofs to protect buildings from fire.'

The nature of the mythological animals seen filing down the sloping ridges of palace-style buildings is almost impossible to define precisely. However, it seems certain that animals could be selected in strict order from a specified list from the Ming dynasty onwards. The sequence is usually as follows: dragon, phoenix, lion, winged or celestial horse, sea-horse, scaled lion *suan ni*, *ya yu*, the fire-eating *xie zhai*, *dou niu*, and *xing shen*. All are composite animals embodying propitious and protective qualities acquired down the centuries and should occur only as an odd numbered set.

During the Ming and the Qing dynasties, the shape, type and size of roof ornaments were also decided according to the rank of the building. The gaping dragons on the main ridge of the Hall of Supreme Harmony are made up of thirteen separate pieces each. They are 3.4 m. high overall and 4.3 tons in weight. Ten smaller animals sit astride the ends of the sloping ridges. The Palace of Heavenly Purity was the residence and office of the emperor, its rank being second only to the Hall of Supreme Harmony. Accordingly, the glazed roof ornaments are smaller and nine instead of ten decorate the sloping ridge (without the *xing shen*). The Palace of Earthly Tranquillity was the chamber palace of the Ming empresses. In the Qing, it was used as the imperial bridal chamber and a place for sacrifice and worship. Here, the decorations are even smaller and only seven small animals stand on the sloping ridge end (with the *xie zhai*, *dou niu*, and *xing shen* missing). The Six East and Six West Palaces were the concubines' residences and boast only five small animals. Other side halls and gates used smaller and fewer ceramic ridge animals according to their status. Correspondingly, the smallest figures were used on the smallest and least important buildings and gateways where only one and sometimes none at all are found. The standardization of glazed ceramic roof ornaments enabled construction work to be carried out more quickly and can even be seen as reflecting the rationalization of the complicated bureaucratic and aristocratic hierarchy that flourished during the Ming and Qing periods.

The decoration of the roofs of halls and buildings in traditional Chinese architecture, whether in terms of roof shape or glazed ceramic constructional elements, came to be considered as a prescribed and integral part of the entire structure. Taking the Three Great Audience Halls in the Outer Court as an example: the Hall of Supreme Harmony has a double-eaved hipped roof, the Hall of Preserving Harmony is of the double-eaved type, with a hipped and gablet roof over a lean-to verandah roof, and between these two buildings stands the Hall of Complete Harmony with a hipped pavilion roof. Dominated by their roofs, which are the climax of the first two stages – the platforms and the bodies of the buildings – the surrounding side buildings and towers, by careful spatial arrangement, create massive courtyards. It is in the harmony achieved between structure and courtyard that traditional, palace-style architecture succeeds or fails.

To this end, one of the greatest burdens falls upon the design and variety of roof shapes, in the need not only to distinguish between primary and secondary buildings, but also to convey the desired solemn and formal coherence as well as a moving sight imbued with interest.

296. Gilt bronze roof pommel of one of the city watchtowers.
297. Gilt bronze roof pommel of the Hall of Union.
298. Glazed ceramic roof pommel of the Jade-Green Floating Pavilion in the Imperial Garden.
299. Roof pommel of the Ru Pavilion in the garden of the Palace of Tranquil Longevity.
300. The glazed ceramic roof peak of the Pavilion of One Thousand Autumns in the Imperial Garden.
301. The glazed ceramic roof peak of the Pavilion of the Jade-Green Conch Shell in the garden of the Palace of Tranquil Longevity.

234

Glazed ceramic mythological animals and immortals on the lower sloping roof ridges of the Hall of Supreme Harmony.

302. *Wen* or *chi wen* gaping dragon placed at the two ends of horizontal roof ridges.
303. The above zoomorphs in series.

Close-up views of the above.

304. Immortal (possibly the tyrant Prince Min of Qi) riding a hen.
305. Dragon.
306. Phoenix.
307. Lion.
308. Celestial horse.
309. 'Sea-horse' (horse that frolics in waves), *hai ma*.
310. 'Scaled lion', *suan ni*.
311. *Ya yu*.
312. Fire-eating *xie zhai*.
313. *Dou niu*.
314. *Xing shen*.
315. Dragon (variation of *chi wen* but with bushy tail).
316. Detail of roof tiles of the Hall of Mental Cultivation showing cylindrical imbrex and circular antifix end tiles with an impressed dragon design; crescentic tegulae with ogival, triangular end tiles, also bearing dragon designs, for carrying water out and away; and ceramic bosses or caps on the final imbrex for concealing the pin which secured the tile against the downward pressure of the preceding tiles.
317. Hornless dragon-shaped head encasing a corner member of the Hall of Imperial Peace in the Imperial Garden.
318. Zoomorphic series on a ridge of the guardroom inside the Gate of Martial Spirit.
319. Zoomorphic series on a ridge of the Pavilion of Gathering Flowers.

235

內外簷裝修

INNER AND OUTER EAVE FITTINGS

In traditional Chinese architecture, fittings are divided into two types: inner eave fittings and outer eave fittings, or, interior and exterior features.

The term 'outer eave fittings' includes the many different types of doorways and windows, which can be seen from the outside of buildings in the Forbidden City. There are partition, plank and wind shelter doors, and screen doors between inner and outer courtyards, as well as assorted windows. Important palaces and halls invariably used partition doors and silled windows. The upper part of a partition door (*ge xin*) consists of a 'lattice window' of ornate open timber work, the inside of which may have been covered with paper. The lower portion (*qun ban*, 'skirt-board') is composed of a solid panel or panels which usually bear carved decoration or applied ornamental features. So-called silled windows lack this decorated lower skirting panel built as it rests on a horizontal member, or sill, which is part of the wall construction.

As with other architectural features of the Forbidden City, decoration of outer eave fittings are subject to a hierarchy of rules. The variable so-called trellis pattern occurs on the lattice windows of partition doors. Complex geometric patterns are formed by placing four- or six-pointed petals of a flower tip to tip. In this way, the two tips of each petal become the centre of a flower as well as the focus of an imaginary circle drawn around the circumference of the petals. Thus, circles add a further dimension to the design. Intersecting parallel lines form a 'rhombic lattice'; these lines may cross twice or three times. This gives rise to such terms as 'double-crossed six curved water chestnut blossom pattern' in Chinese. Patterns of the highest order would seem to be the double and triple-crossed and double ball-shaped lattice. Doors and windows of the Hall of Supreme Harmony all utilize the triple crossed design. The lower portions of the doors and windows have gilt panels of carved coiled dragons amid scudding clouds. Such gilded doors and windows add much beauty and luxury to the palaces. Outer eave fittings in the residential quarters of the empress and imperial concubines became more varied after the introduction of large-sized glazed tile frames and casement windows, often top pivoting. The lattice patterns include the lantern frame, cracked ice, coin, the Buddhist swastika and circular patterns. The skirting panels and fanlights of the partition doors in the Palace of Gathering Essence in the Six East Palaces area are carved in bamboo patterns which harmonize with the surrounding galleries, canopies, and screen doors to make the palace a three-in-one type residential courtyard.

The inner eave fittings of screens and other partitions are used to separate the interior spaces of the buildings. They are of many kinds. There is some especially fine interior partition work found in the chamber palaces of the empress and concubines. Partition doors, board walls, shelves for antiques, and bookshelves were often used to divide rooms into separate but interconnecting compartments. By far the most common type of partition used, however, is a suspended or openwork curtain screen. Extremely ornate fretwork panels, commonly of red sandalwood or rosewood, they are suspended across the ceiling and down the walls to form an open, airy semi-partition. Similar to drawn drapes, they break up the interior open space with brocade-like patterns of winding stems, leaves, flowers, scallops and geometric shapes providing a general spatial interest as well as a more specific interest in their own intrinsic qualities. Similarly exquisite decoration is to be found on the partition doors of the Six West Palaces. The majority of these have lantern frame-patterned lattices on the centre section of which are set glass plates or gauze screens which bear paintings of flowers or fine Chinese calligraphy. A combination of lanterns, ornamental hangings, pillar couplets and vertical scrolls lends a studious atmosphere to the room. Every kind of craftsmanship is shown at its best here. This is seen too in the partition work in the buildings of the garden of Qian long. The partitions there utilize such crafts as double-sided embroidery, in which perfect compositions appear, with no finishing stitches visible, on both sides, as well as inlays of jade, mother-of-pearl, cloisonné, and many other jewel-like materials.

Originally outer eave fittings were intended to be used merely to protect the interior of the building from wind and rain, to shield it from heat and cold, or for lighting purposes such as the openwork, paper-backed lattice windows. However, once fittings had passed through the hands of palace artisans, they took on the second yet equally important and necessary role of palace decoration which, manifestly, attained the highest artistic standards.

Fig. 60 Bird's-eye view of a typical courtyard with buildings constructed along all four walls in Beijing.

Fig. 61 'Waterchestnut' trellis pattern lattice work.

322

323

324

325

320. Doors inside the Gate of Heavenly Purity. Comparable with the stone doors of the imperial Ming dynasty tombs, these doors are studded with nine lines of nine bosses. The chased metal plates at top and bottom, decorative escutcheons and ring handles, are also gilt.
321. Doors inside the heated room of the Palace of Heavenly Purity surmounted by elaborately carved canopy with hanging bosses.
322. Decorative *pu shou* gilt escutcheon in the form of an animal mask from inside the Gate of Tranquil Longevity. The lower half is usually in the form of a ring hanging from the animal's jaw.
323. Decorative *pu shou* gilt animal head escutcheon holding a plate and ring in its mouth, from the Gate of Spreading Happiness inside the garden of the Palace of Tranquil Longevity.

324. Pair of decorative *pu shou* gilt escutcheons with hanging ogival ring and crescent with gilt door bosses in the Palace of Heavenly Purity. Unusually, the features resemble a human mask.
325. Gilt *pu shou*, cymbal-shaped gilt door handles of the doors of the Palace of Tranquil Longevity.

Archaistic decorative escutcheon and ring handles, called *pu shou* or *men pu*, are usually in the form of an animal mask, usually a lion, with an ogival ring, more or less defined, hanging from its jaws with another crescentic plate below. They are usually of chased gilt bronze and bearing lively designs of dragons.

326. Coin pattern carved openwork lattice doors with carved and gilt *ru yi* shaped moulding on the lower panels, of the Hall of Mental Cultivation.
327. Waterchestnut-blossom pattern carved openwork doors with ogival panels carved with dragons mounted on the lower halves in the Hall of Supreme Harmony.
328. Dragon and phoenix carved panels on the lower halves of partition latticed doors in the Hall of Union.
329. East screen door of the courtyard of the Studio of Fresh Fragrance.

328

329

241

330. Trellis or circle patterned openwork lattice doors of the Hall of Imperial Peace in the Imperial Garden.
331. Openwork lattice partition of the west gallery of the Hall of Imperial Supremacy.
332. Waterchestnut-blossom patterned partition door and curtain rails of the Pavilion of Ten Thousand Springs in the Imperial Garden.
333. Lattice window of the Middle Left Gate.
334. Lantern pattern lattice windows in the Pavilion of Prolonged Sunshine.
335. Lower panels carved with bamboo designs of doors in the Palace of Gathering Essence.
336. Lattice window of the Pavilion of Glorifying Righteousness.
337. Door with carved decoration of auspicious bats (the Chinese character for 'bat' is a homophone of the character for 'happiness') around the stylized character in circular form *shou*, 'longevity', in the Pavilion of Red Snow.

334

335

336

337

243

338

339

340

341

338. 'Double bracket' door plates and ring handles in the Hall of Union.
339. Door plates and ring handles in the Gate of Martial Spirit.
340. 'Double bracket' door plate and ring handles in the Palace of Earthly Tranquillity.
341. Door plates and handles decorated with the 'five blessings' (longevity, wealth, health, virtue and to finish the allotted span). Bat motifs, also associated with this scheme, alternate with the stylized character for longevity; Palace of Emperor's Assistance.
342. Lower panels decorated with *ru yi* moulding on the doors of the Hall for Worshipping Ancestors.
343. Lower panel decorated with *ru yi* moulding on a door of the Palace of Tranquil Longevity.
344. Carved panels of gilt dragons' design on a door of the Hall of Imperial Supremacy.
345. Carved panels of gilt dragons' design on a door of the Palace of Heavenly Purity.

245

346

347

346. Coin pattern lattice fanlight on the lower level of the terrace to the east of the Pavilion of Ancient Flowers in the garden of the Palace of Tranquil Longevity.
347. Windows of various shapes of the Ru Pavilion in the garden of the Palace of Tranquil Longevity.
348. Lattice window in the west chamber of the Hall of Pleasurable Old Age.
349. Design of the traditional theme known as the hundred antiques of the Studio of Fresh Fragrance.

350

350. Partition doors inlaid with enamels inside the Hall of Pleasurable Old Age.
351. Horizontal inscribed plaque, lantern pattern lattice window and partition door at the back of the Studio of Fresh Fragrance.

352

353

352. Openwork hanging curtain partition with a design of intertwined lotuses, inside the Studio of Fresh Fragrance.
353. Detail of the openwork partition inside the Studio of Fresh Fragrance.
354. Openwork hanging curtain partition inside the Palace of Emperor's Assistance.
355. Detail of the openwork hanging curtain partition inside the Palace of Emperor's Assistance.

藻井、天花

CAISSONS AND CEILINGS

Caissons, were used in the ceilings of the most important halls of the city, such as the Hall of Supreme Harmony where the emperor carried out grand ceremonies, the Hall of Mental Cultivation where he had his offices and conducted state affairs, the Hall of Abstinence where he would stay before going to offer sacrifices at the Temple of Heaven, the Palace of Imperial Supremacy where the Qianlong emperor prepared for his enthronement and the Hall of Imperial Peace where the Supreme Deity was worshipped. Such places as the lower ranking Six East and Six West Palaces did not have sunken panels in the ceiling.

The construction of caissons involves an extremely complex process, with even richer ornamentation than the surrounding ceiling. Most of those still remaining in the halls and palaces of the Forbidden City are made up of an upper, middle and lower section, their being round at the upper section and square at the lower section. To take the caisson in the Hall of Supreme Harmony as an example: the lower portion is a 5·94 m. square pendentive 50 cm. high. Around the four sides are seventy-six bracket sets supporting the weight of the upper sections. The octagonal drum in the centre is the intermediate portion which supports the upper portion. It is 57 cm. high, with a diameter of 3·2 m. A number of crossed beams divide this section into triangles and rhombuses containing carved dragons and phoenixes. The dome at the top is 72·2 cm. high, with a diameter of 3·2 m., and supported by a circle of twenty-eight small bracket sets. A writhing dragon, holding a pearl in its mouth, occupies the centre of the dome, an exact replica of every twist and turn of the carved gilt dragon of the imperial throne below.

Apart from this, the Pavilion of One Thousand Autumns and the Jade-Green Floating Pavilion in the Imperial Garden carry their own unique style of sunk panels because of their different rank and surroundings.

These intricately carved caissons of the Ming and Qing periods are carefully and precisely constructed. The choice of colour is predominantly a cool green, and always against a lavishly gilt background, with highlights added in splendid complementary colours.

Most of the ceilings in the Forbidden City palaces were built during the Ming or Qing dynasties. There were two basic methods used in their construction: one is the coffered ceiling, the other, the *ruan*, 'soft', ceiling.

Coffered ceilings are formed by means of parallel wooden laths intersecting at right angles, thereby making square-shaped caissons, the sunken panels of which are usually painted green or blue. Medallions of dragon, phoenix or flower motifs occupy the centre while triangular cloud patterns fill the four corners. Their colour is complementary to that of the circle at the centre. If green is used for the circle, blue would be used as the main colour for the triangles and vice versa. At the point of intersection of the wooden laths is painted a cruciform design with 'swallow-tail' ends made up of a 'lotus seedpod wheel' concealing the pin at the centre, and lappet motifs.

The framework of a 'soft' ceiling is made of wooden laths and bamboo strips. It is then covered with hempen cloth and paper and painted to reproduce the coffered ceilings already described. Such ceilings occur mostly in lower ranking palaces of the Inner Court, especially in the Six East and Six West Palaces where the concubines lived. Polychrome ceiling decoration of the palaces utilizes many themes. The dragon and phoenix pattern is, naturally, to be found in the Three Great Audience Halls and in the Palace of Heavenly Purity, Hall of Union, and the Palace of Earthly Tranquillity of the Inner Court. Residences of the empress and concubines and the garden pavilions, halls and religious buildings are, by contrast, given slightly less rigid although no less symbolic and traditional themes and motifs, as can be seen in the example of the paired cranes in the Palace of the Great Yang, the orchids, peonies, narcissi and magnolias of the Jade-Green Floating Pavilion in the Imperial Garden; the lotuses in the Temple of the Four Gods: and the golden lotus and pondweeds of the imperial library. Making use of the inherent qualities of *nan mu* timber, the ceilings of the Hall of Pleasurable Old Age and the Pavilion of Ancient Flowers are not painted but carved in a pattern of intertwining vegetation which harmonize with the surrounding interior decorations. Perhaps the most exuberant of all the ceilings in the Forbidden City still in existence, however, is that discussed already in the Study of Peaceful Old Age. Here the illusion of sitting beneath a wisteria-covered bamboo trellis in a garden painted on the walls and ceiling is a far cry from the symbolic ceilings, evoking the power and magnificence of the dynasty found elsewhere in the imperial city.

357

356. Caisson in the Hall of Supreme Harmony.
357. Caisson in the Hall of Union.
358. Caisson in the Hall of Mental Cultivation.

Caissons, large sunken panels, are constructed above imperial thrones, or as special decorations in the middle of the ceilings of Buddhist temples. Their history can be traced back to the Han dynasty. The caisson of the Hall of Supreme Harmony is located in the middle of the ceiling, directly above the front of the imperial throne. In keeping with the usual method of construction the upper part is round and the lower square. It is divided into an upper, middle and lower section: the lower basal part is square, measuring about 6 m. square; the middle part is octagonal and the upper part is circular. The depth of the three layers

358

totals 1·8 m. A system of bracketing carries each level up and inward. The main compartments consist of designs of lively dragons, pearls and phoenixes, the whole dominated by a large coiled dragon holding a pearl, which hangs independently, at the centre. This caisson is entirely covered with two-tone gold matching the imperial throne below. Together with the towering columns carved with gilded, curling dragons at the two sides of the throne, they give the hall an atmosphere of sumptuous grandeur not equalled elsewhere.

359

360

256

359. Caisson in the ceiling of the Hall of Southern Fragrance.
360. Caisson in the Hall of Abstinence.
361. Caisson in the Pavilion on the Brink of the Brook in the garden of Compassion and Tranquillity.
362. Caisson in the Pavilion of Auspicious Clarity in the Imperial Garden.

258

363. Dome caisson of the Pavilion of Ten Thousand Springs in the Imperial Garden. Here a drum formed around short, thick pillars is used instead of bracketing to increase the height, as well as to afford light by means of square lights.
364. Dome caisson carved with a dragon inside the Gate of Piled Excellence at the foot of the Hill of Piled Excellence in the Imperial Garden. Stone block domes, vaults and arches are not unknown in Chinese traditional architecture and are best seen at the imperial tombs of the Ming and Qing dynasties. The central coiled dragon is also of carved stone.

365.

365. Section of the coffered ceiling decorated with forward-facing dragons, inside the Gate of Supreme Harmony.
366. Section of the coffered ceiling decorated with forward-facing dragons, inside the Hall of Preserving Harmony.
367. Section of the coffered ceiling decorated with paired dragons rotating about a flaming pearl, inside the Hall of Southern Fragrance.
368. Section of the coffered ceiling decorated with paired dragons rotating about a flaming pearl, inside the Gate of Heavenly Purity.

These coffered dragon ceilings possess several common features: the square panels are decorated with a central roundel with cloud motifs in the four corners; swallow-tail cruciform designs consist of lappet or *ru yi* shapes around the central lotus petal bosses at the intersection of each lath.

366

367

368

261

369. Section of the coffered ceiling decorated with intertwined lotuses in the Temple of the Four Gods in the Imperial Garden.
370. Section of the coffered ceiling decorated with flowers and fruits including peonies, lotuses, peaches and pomegranates arranged diagonally in the Jade Pavilion inside the Imperial Garden.
371. Section of the coffered ceiling decorated with fruits and flowers including Buddha's hands (top centre), *fo shou*, peaches, chrysanthemums and lotuses in the Jade-Green Floating Pavilion in the Imperial Garden.
372. Section of the coffered timber ceiling with applied carved openwork flowers and grasses inside the Pavilion of Ancient Flowers in the garden of the Palace of Tranquil Longevity.
373. Section of the coffered timber ceiling with applied carved openwork flowers and leaf scrollwork in the Hall of Pleasurable Old Age.

Similar to the disposition of motifs in the more formal dragon coffered ceilings, those employing motifs from the repertoire of the traditional hundred flowering plants confine the decorative elements to the same roundel within the square panel with triangular sections at each corner and swallow-tail crosses made up of lappets about a central lotus petal boss.

374. Central prunus petals-shaped section of the wooden ceiling carved with flowering branches of prunus blossoms in the Pavilion of the Jade-Green Conch Shell in the garden of the Palace of Tranquil Longevity.
375. Section of the ceiling in woven fret-pattern, incorporating swastikas and interlocking-T motifs, of the ceiling in the Pavilion of the Carpenters' Square in the garden of the Palace of Tranquil Longevity.

376

377

378

379

264

380.

376. Section of the ceiling decorated with twin phoenixes in the Palace of Inheriting Heaven.
377. Section of the ceiling decorated with a repeated flower motif in the Pavilion on the Brink of the Brook inside the garden of Compassion and Tranquillity.
378. Section of the ceiling with a repeated pattern of paired crane motifs inside the Palace of the Great Yang.
379. Section of the ceiling decorated with Sanskrit characters on the lotus petals and centre inside the Pavilion of the Rain Flowers.
380. Ceiling decorated with floating cloud motifs around a square caisson with dragon decoration of the theatrical stage in front of the Studio of Fresh Fragrance.

Apart from the theatrical stage ceilings, these, generally lower ranking, less formal ceilings, bear the hallmarks of imperial coffered ceilings. The coffering here, however, is painted decoration only.

彩畫

PAINTED DECORATION OF STRUCTURAL MEMBERS

One of the unique features of traditional Chinese palace-style architecture lies in its use of polychrome painted decoration. Perhaps its greatest achievement was the fact that it successfully combined the dual role of preservation of the valuable timber components with that of enriching an already impressive structure.

Initially, a monochrome coating had been used simply to protect the wooden structure from the extremes of the Chinese climate and wood-boring insects. Paints were composed of plant and mineral pigments. But with the passage of time, a concern with past golden ages of Chinese civilization and the development of coloured paints, the designs themselves became part of the regulations to which palace construction was subject. By the Ming and Qing periods these decorations had become an integral part of architectural planning.

With the complete destruction of the Yuan dynasty capital it was found that very few plans existed for its reconstruction. In an attempt to expunge the memory of Mongol rule, the new Ming dynasty set about rediscovering its pure Chinese heritage and in the process laid down rules governing the use, application and design of painted decoration. The Qing, an alien dynasty, continued this process according to its own Manchu taste. During the Ming, sumptuary laws stipulated that 'polychrome decoration of the houses of the common people is forbidden' and even the decoration of buildings in the Forbidden City was clearly classified according to their status. It is not difficult to discern the differentiation today.

The most important buildings in both the Inner and Outer Courts employ the so-called *he xi* style of decoration. Designs are divided into three main sections *fang xin*, 'heart, centre of the beam', *zao tou*, and *gu tou*, 'girdle', and 'encircle'. The *gu tou* occur at the two outermost sections of the composition on the beam, comprised of circular motifs within a broad band encircling the beam. The *zao tou* consists of motifs encircling the beam in a band with lotus panels on one side and ogival shapes on the other. Side by side, these two later degenerate into straight-edged parallel zigzag lines. The central and longest part of the decoration, *fang xin*, runs along the length of the middle section of the beam, and consists of elongated panels, terminating at both ends in the ogival or zigzag shapes mentioned. Occupying the most prominent position, these registers abound with dragons or phoenixes in varied and lively postures. Any spaces between these three main areas are interspersed with floral and other motifs which, combined with the gilding and mainly blue coloration, produce a vivid and stately effect. The regulations prescribed that if blue was used for the upper structural timbers in one bay then the colours should be reversed for the next bay, and so on.

The so-called *xuan zi* style was immediately subordinate to the *he xi* style of decoration and was mainly employed in secondary buildings. For example, *he xi* painting is found in all of the Three Great Audience Halls while the Arrow Pavilion, remote from the city centre, is decorated in the *xuan zi* style. Although similar in spirit the main difference between the styles is the *zao tou* section which in the case of the *xuan zi* style is called *hua xin*, 'flower heart' or 'centre'. Two or three petal whorls of each main motif are surrounded by 'curls' which join with its neighbour to form long meanders, thus giving rise to the term: *xuan* means 'whorl, curl'. The proliferation of curls and spirals found in the Qing dynasty designs are most probably the result of simplification of rolling wave patterns found from the Tang dynasty onward. Once formed, these shapes could be easily incorporated into another favoured motif such as the lotus or other flower shapes. Compared with the *he xi* style, the overall impression of this *xuan zi* decoration is one of simplicity underlined by the alternate use of green and blue bands of less complicated design. The central panels on the

beam are sometimes left without the addition of fussy motifs and enriched by judicious use of gilding, also especially evident at the centre of flowers.

According to the amount of gold used and the application of different colours, *xuan zi* decoration can be divided into eight types which were used in accordance with the rank of individual buildings.

Most of these *xuan zi* paintings are of the Qing period, except for those on the structural members of the inner eaves of the Palaces of Gathering Essence and Eternal Spring, and those found on the inner eaves of the Hall of Southern Fragrance, which were painted during the Ming.

The *xuan zi* style decoration was the type most commonly used for the interiors of Ming dynasty palaces. The rich, lively painting was inherited by the Qing who developed traditional patterns and developed them further still. In addition, for the convenience of design and application, patterns were all standardized. Perhaps not unexpectedly, the decoration of garden pavilions, kiosks and covered walkways is in a much lighter vein. The so-called Suzhou style, although not completely divorced from the overall structure of the two other types of decoration discussed, finds its individuality in the *fang xin*, or central section, of an architectural member. Falling into two broad categories, the *fang xin* is either, as in the two other styles, bounded by a long panel or, more uniquely, large semi-circular panels painted at the centre of one, two or even three tie beams where they are laid one on top of the other. A border of folding lines, similar to an Elizabethan ruff, is obtained by shading to give a three-dimensional effect. The *zao tou* sections often bear panels in fan, gourd or other shapes. These apart, the truly unique character of Suzhou-style decoration lies in the repertoire of subjects and motifs as well as the lyrical style in which they are executed. Amongst the formal patterns associated with the other two styles appear naturalistic sprays of prunus, narcissi, bunches of pomegranates, mountain landscapes, mythical animals and many other favourite subjects from Chinese tradition. Narrative scenes, such as from the *Journey to the west*, *Xi you ji*, decorating the central panels of the tie beams under the walkway along the lakeside at the Summer Palace, provide special points of interest and are more in keeping with the relaxation and pleasure associated with a traditional Chinese garden.

The majority of the Suzhou-style coloured paintings date to the middle of the Qing period and later, such as those found in the Qian long garden and the Imperial Garden. During the later years of the Qing, the structural members of the Six East and Six West Palaces of the Inner Court were also covered with this kind of coloured decoration.

The *he xi* style, *xuan zi* and Suzhou-style polychrome decorations as well as the 'dragon brocade' designs (using dragon and brocade motifs) all use blue and green as the predominant colours. They are not only useful in distinguishing primary from secondary buildings, but also enrich the already magnificent imperial buildings.

Scale reproductions of *he xi* style polychrome painted decoration.

381. Interior beam decoration of the Hall of Supreme Harmony. The highest ranking of buildings, the decoration is dominated by gilt dragons and ornate ogival lotus panels.
382. Exterior beam decoration, including bracketing, of the building in the northeast corner of the courtyard of the Hall of Supreme Harmony. The lotus panel shapes are formed with smooth gilt lines. Finely gilt dragons and flower motifs fill the first band and the Eight Buddhist Emblems or Precious Things, the second; the third register shows, diagramatically, the bracketing, with cloud scrolls in the fourth band.
383. Interior beam decoration of the Palace of Longevity and Good Health. Gilt scrollwork is employed to fill the *gu tou* section next to the pillar, while the sets of panels joined together form zigzag bands with gilt phoenixes and dragons, symbolizing the emperor and empress, as the main motifs.
384. Interior beam decoration in the central bay of the Palace of Tranquil Old Age. The outer band around the central dragon roundel is filled with flames, one of the Twelve Symbols, next to a band of lappets, all of which recall the decoration on imperial robes. The roundel replaces the long panels which usually form the *gu tou* central section of beams.

He xi style decoration, reserved for only the most important halls, consists of a strictly regulated set of motifs placed within rigid bands of panels, similar to variations of the lotus panel.

383

384

He xi style polychrome painted decoration.

385. Beam and coffered ceiling in the Hall of Supreme Harmony.
386. Beam and coffered ceiling in the Hall of Preserving Harmony.
387. Exterior decoration of column capitals, eaves' boards and braces including exposed round and square-ended rafters of the Hall of Supreme Harmony.

388. Exterior eaves' boards and brace of the Hall of Imperial Supremacy.
389. Carved and gilt dragon panels between paired dragon and phoenix, *fang xin*, panels and the square and circular ends of exposed rafters under the outer eaves of the Palace of Tranquil Longevity.
390. Decoration on internal beams and brackets of the Hall of Imperial Peace in the Imperial Garden.
391. Exposed round and square-ended rafters decorated with the stylized character *shou*, 'longevity', and Buddhist swastikas outside the Hall of Imperial Peace. Above are the circular and triangular ends to the roof tiles.

Scale reproduction of *xuan zi* style polychrome painted decoration. (Ridge pole, purlins, roof boards etc. shown in section.)

392. Beams supported by brackets on cushion blocks forming the frame inside the Palace of Eternal Spring.
393. Detailed decoration on the interior eaves' purlins of the side room in the Palace of Gathering Essence.

Xuan zi style decoration is second in order only to *he xi* decoration. While retaining the strict division into the three main longitudinal areas of decoration, *gu tou*, *zao tou* and *hua xin* (*fang xin*, of the *he xi* style) and rigid repertoire of motifs, it is characterized by a freer curl or whorl shapes, from which it takes its name, around a central stylized flower.

394. Gilt decoration on interior beams and bracketing inside the Hall of Southern Fragrance.
395. Embossed gold leaf decoration on interior beams of the main hall of the Hall for Worshipping Ancestors.

A characteristic motif, apart from the flower and whorl, is the square or lozenge formed around a cross at the centre. The square, resembling the swastika lozenge, is echoed above, intruding into the lambrequin pattern.

396

397

398

274

Xuan zi decoration

396. Decoration of beams below a coffered ceiling inside the Gate of Compassion and Tranquillity.
397. Decoration on outer eaves' boards and column capitals of the Hall for Worshipping Ancestors.
398. Gilt decoration of crossbeams inside the Gate of the Great Ancestors.
399. Gilt decoration of eaves' boards and brackets outside the Hall of Imperial Supremacy.
400. Gilt decoration on the eaves' purlins and beams of the outer eaves of the watchtower on the northwest side of the city.
401. Decoration on the eaves' purlins and beams of the outer eaves of the east duty rooms inside the Gate of Martial Spirit.
402. Decoration on eaves' boards and braces of the Gate of Unified Harmony.

The Suzhou style is the third order of the three main types of decoration of timber members in the Forbidden City. In contrast to *he xi* and *xuan zi* decoration, its main characteristic is of a painterly style, reproducing favourite themes of traditional brush and ink landscape painting and bird and flower paintings, for example. A curled neck ruff pattern, meticulously painted in three tones from dark to light, often borders the central, *fang xin*, panel, which is usually a partial or full circle.

403

404

405

Scale reproductions of Suzhou style polychrome painted decorations.

403. Decoration of the outer eaves of the Pavilion of Dawn Sunlight in the Imperial Garden employing a type of aerial perspective in the central band.
404. Gilt decoration on the purlins, beams and brace brackets on the outer eaves of the Hall of Manifest Harmony.
405. Central, *fang xin*, segment panels bordered by the three-tone ruff pattern on the beams of the main, side and end rooms in the Hall of Manifest Harmony. Those at left and centre are details of Plate 404.
406. Decoration employing dragon and diaper silk embroidery patterns on eaves' purlins and beams of the outer eaves of the Building of the Buddhist Sun in the garden of the Palace of Tranquil Longevity.
407. Decoration on the purlins and beams of the Pavilion of the Jade-Green Conch Shell. The pink prunus blossoms above are offset by the twisted branches and gilt blossoms below.
408. Decoration on the front verandah of the Pavilion of Red Snow in the Imperial Garden. The design comprises painted green and brown spotted bamboo cane motifs.

409

410

411

278

Suzhou style decoration

409. Decoration on the tie beams of the east side gate of the Studio of Fresh Fragrance. Butterflies and bats form the outer sides of the central designs.
410. Decoration on the purlins inside the gate leading to the Palace of Gathering Essence. The central design shows half of the diagram of the eight trigrams (*ba gua*).
411. Decoration on the beams of the covered corridor of the Palace of Great Happiness. The landscape panels are judged as being in harmony with the landscaping of the courtyard.
412. Decoration on the beams in the corner corridor of the Palace of Gathering Excellence.
413. Decoration on a beam in a coffered ceiling inside the Palace of the Great Yang. The centre, *fang xin*, instead of a curved panel, employs the edges of two of these panels to form the decoration.
414. Decoration on the tie beam of the Pavilion of the Ceremony of Purification in the garden of the Palace of Tranquil Longevity.
415. Decoration on corner girders and beams of the inner eaves in the theatrical pavilion of the Studio of Fresh Fragrance.

琉璃裝飾

GLAZED ORNAMENTS

In the Forbidden City, wall gates leading to the hall and palace complexes in the Inner Court and walls and gates of individual courtyards, screen walls, as well as flower beds in the gardens, have an abundance of glazed ceramic ornaments. The choice of the designs for this type of decoration was determined, as for many other things, by the status and function of the building. The glazed ornaments on buildings used by the emperor all employ dragon motifs, as in the case of the Palace of Doubled Glory where the Qianlong emperor lived as heir-apparent. The Six East and Six West Palaces were the residences of the empress and the concubines, and their glazed ornaments have motifs of birds and flowers. In secondary courtyards, only monochrome glazed tiles without further decoration are found.

More durable than timber and more immediately appealing than stone, clay possessed many advantages as a medium for use in decoration. Advances in the control of polychrome glazes during firing as well as mass production techniques and organization from the Yuan dynasty onward meant that as many bright and shining tiles as were thought necessary to improve the appearance of the palace complex could be requested and used. In terms of spatial arrangement, they were used to great effect at the boundary line between the Inner and Outer Courts. A wide street-like courtyard straddles the main north–south axis at this point underlining this division. Not content with this, the designer made use of a 'funnel-like' arrangement of two walls leading to the Gate of Heavenly Purity which in contrast to the grandeur of the platforms and halls immediately preceding it is on a smaller scale. Green and bright yellow wall tiles applied to these screens combine with all the above considerations to herald a change and draw the beholder towards the more intimate and domestic atmosphere of the Inner Court.

Inner Court wall and courtyard gates are often decorated with glazed ceramics imitating their timber counterparts. These include the roof tiles, the brackets beneath the eaves, and the flat coloured tiles imitating eaves decorated in *xuan zi* style. On each side of the gate, a lower screen wall was constructed, in some cases on a 'Sumeru base' forming an interesting 'triple gateway' but having only one entrance. At the centre of the screen wall is a composite ceramic design of animals, birds and plants with a triangular floral design at the four corners. A fine example of this is to be found inside the Gate of Mental Cultivation. Glazed ceramic decoration is lavishly used here: the upper part of the gateway from the stone base and the two screen walls are all covered with glazed tiles. The frames of the two flanking walls are composed of yellow tiles, and green tiles are used over the main ground. At the centre of the wall is an ogival panel encasing white egrets, green lotus leaves, yellow lotus flowers, and blue water. A different type of gateway, called *pai lou*, was selected for construction in the high wall which surrounds the courtyard complex of the Palace of Tranquil Longevity. Normally a high, freestanding ceremonial triple-gateway with coping roofs, this example has been scaled down in size by applying ceramic substitutes for normally timber-made architectural members directly to the wall. With three scalloped gateways piercing the wall, the tiles produce the desired, splendid effect.

An even more attractive way of utilizing glazed ceramic tiles is to be seen on the so-called 'Nine Dragon screen' south of the Gate of Imperial Supremacy. Monumental in size, this screen wall stands 24.9 m. long and 3.5 m. high on a stone Buddhist 'lotus petal, Sumeru base'. Nine composite designs of lively dragons in different postures are built up from tiles modelled in high relief and covered in golden yellow, purple, blue and white coloured glazes. Each chases a flaming pearl amongst a stylized design of rolling waves and overhanging rocks below a ceramic imitation of traditional roof construction supported by brackets and a decorated eaves' purlin. Dragons chase pearls through waves along the elaborate series of ridge tiles.

Just as dragons are used symbolically here so, too, other screen walls, such as those of the First Gate in Heaven and Gate of Exuberance use composite ceramic tile panels of Taoist- and Buddhist-associated motifs respectively.

Apart from the glazed ornaments of screen walls, there are some low palace walls which are covered with glazed tiles and the Sumeru bases of some flower beds and balustrades in the gardens also bear this kind of decoration.

Evidence exists of the use of clay water pipes and roof tiles, for example, in architectural construction from the Qin dynasty onward. But it is only with the great leap in production and improvement in firing techniques during the Ming and Qing dynasties that polychrome glazes were used on such a large scale. A general shortage of the more common building materials and an abundance of clay in north China played no small part in the development of the technical processes that made possible the widespread use of glazed ceramics in the Forbidden City.

416. Glazed tile screen wall inside the Gate of Following Righteousness.
417. Glazed tiled screen wall inside the Gate of Mental Cultivation.
418. Triple gateway with ornamental glazed tile roofs and eaves' boards imitating timber structures on the Gate of Imperial Peace, which is set into the high courtyard wall.

419

420

282

419. Detail of the glazed screen wall in front of the Gate of Imperial Supremacy.
420. Glazed screen wall in front of the Gate of Imperial Supremacy; Nine Dragon Screen.

This screen wall, popularly referred to as the 'Nine Dragon Screen', was erected in 1771 when the area around the Palace of Tranquil Longevity was being rebuilt. It is completely clad in coloured tiles which form the composite design of nine moulded dragons. It is surmounted by a squat hipped coping roof and stands on a white marble Sumeru throne base.

From ridge to base the wall measures 3·5 m. high and 29·4 m. long. Nine dragons pursue flaming pearls against a background of rolling waves and clouds swirling amongst mountain tops, their natural habitats. Four five-clawed, horned dragons, each in a different, lively posture, pursue a flaming pearl on either side of a central, forward-facing yellow dragon. Although they are divided into four compartmentalized pairs, the fifth, containing the dominant central dragon, angular hanging rocks and the dynamic design of the rushing, stylized waves, lends unity and completeness to the overall composition.

The dragons are moulded in high relief, the thickest part at their foreheads, standing 20 cm away from the surface. The main composition consists of 270 glazed tiles, which attests to the high standards achieved by ceramicists of the time.

The three dragons at the centre of the screen wall are on the same south–north axis as the Gate of Imperial Supremacy, the Gate of Tranquil Longevity, the Hall of Imperial Supremacy, and the Palace of Tranquil Longevity. In succession, with the dragon-carved Imperial Way in front of the Hall of Imperial Supremacy and the 'nine dragons' horizontal tablet hanging below its eaves, the screen dragons seem to form a unifying path which leads along this line. The fixed stare of the central dragon pierces straight through the gateway to the hall, arresting the attention as one looks southward from the terrace in front of the Hall of Imperial Supremacy.

Altogether there are three 'Nine Dragon Screens' in China. One, located in the city of Datong, Shanxi province, was erected during the Ming dynasty. The other, standing in Beihai Park, Beijing, was constructed during the Qian long era of the Qing dynasty. Of the three, the one in the Forbidden City is the most refined and beautiful.

421

422

423

424

425

284

421. Glazed tile relief of clouds and twin cranes on the screen wall of the First Gate of Heaven in the Imperial Garden.
422. Glazed tile relief of a pair of egrets amongst lotuses on the screen wall inside the Gate of Mental Cultivation.
423. Flanking 'funnel' wall of 'hanging flower' gateway of the Gate of Doubled Glory.
424. Glazed tiled ogival panel in moulded floral relief on the screen wall inside the Gate of Heavenly Purity.
425. Glazed tile triangular corner relief on the screen wall.
426. Moulded glazed tile terrace and balustrades of the elevated flower bed in front of the Pavilion of Red Snow in the Imperial Garden.
427. Glazed tile decorations of floral *xuan zi* patterns on the 'hanging flower' Gate of Doubled Glory.
428. Glazed decorations on the apron wall of the Pavilion on the Brink of the Brook in the garden of the Palace of Compassion and Tranquillity.
429. Glazed Sumeru throne base of the screen wall inside the gate of the Hall of Abstinence.
430. Glazed bricks with decorative honeycomb and flower geometric pattern inside the Hall of Supreme Harmony.

其他設施 SERVICES

橋梁、涵洞

BRIDGES AND CULVERTS

The Forbidden City is surrounded by a moat, commonly known as the 'Tube River'. Its source lies in the Jade Spring Mountains, from where it runs into the Water Storage Pool in the northwest of the capital. One stream of this river skirts the North Lake, then winds its way eastward to the west wall of Prospect Hill, and flows into the northeastern corner of the moat. Here it disappears below the city wall, and is directed along culverts beneath the Forbidden City, finally emerging as the Inner Golden River. A second branch flows from the Middle and South Lakes eastward to the Altar of Earth and Grain (present-day Zhong shan Park), then southward to the Gate of Heavenly Peace, where it is known as the Outer Golden River.

The Golden River was already in existence during the Yuan dynasty. It is written in the 'Waterways' section of the *Yuan shi, Standard History of the Yuan dynasty*, that 'the source of the Golden River is at the Jade Spring Mountains in the county of Wan ping. Its water flows through the South Water Gate at the Gate of Harmony and Righteousness into the capital, hence the name "Metal" or "Golden"' (metal is associated with south according to the Five elements). The Gate of Harmony and Righteousness is the present-day West Straight Gate and the original site of the South Water Gate is located about 120 m. south of the West Straight Gate. It is recorded in the *Gu jin shi wu kao ji, Verified notes on things past and present*, that 'emperors usually built a Golden Water River inside their capitals to symbolize the Milky Way. This practice has been handed down from the period of the Zhou dynasty'. When the Yuan emperors built their Great Capital, Dadu, present-day Beijing, they too dug a river according to the established system, and called the water which flowed through the palace grounds 'Golden Water'. Though the course of the Golden River was shifted a little during the Ming and Qing dynasties due to the change of the sites of the palaces, it remained more or less the same as it is today.

The moat of the Forbidden City was excavated during the Ming dynasty. It is 52 m. wide; its two vertical sides are constructed with large pieces of two kinds of flat-faced rock, with low walls built along its banks. Moats were constructed originally for purposes of defence, but during the later imperial period they had lost this function and were dug only in accordance with tradition when around imperial palaces. The water reflected the trees planted alongside it as well as the watch towers at the four corners, all of which provided a broad, serene vista. Combined with the beauty of lotuses planted in the water during the Qing, this enhanced the external appearance of the imperial city.

The Inner Golden River flows via the underground ditches at the northwestern corner into the Forbidden City and continues on its southward course along the western side of the city, passing the Hall of Military Eminence, across the front of the Gate of Supreme Harmony and past the imperial library. From there, it flows out from the Forbidden City at the southeastern corner. Its entire course is more than 2,000 m.

The flow of the Golden River, which is from northwest to southeast, is determined by geomantic principles and ritual regulations. But its design is not purely based on aesthetics; water supply and drainage were given special consideration. For instance, outbreaks of fire were a constant threat to the timber-framed buildings. Liu Ruoyu, in his historical *Zhuo zhong zhi*, records that 'this Golden Water River is not for enjoying the swimming of fish among the water plants, nor is it deliberately made to meander in order to waste materials. It can be used to prevent fire and accidents. The fire that burnt down the galleries of the Six Departments in the fourth year of the Tian qi era (1624), and the fire caused by the combustion of paint from the Hall of Military Eminence in the sixth year, for instance, were put out by water from the Golden Water River . . . The two fires that broke out in the Singing Phoenix Palace during the Tian qi era (1621–7) were also put out by water from the river. How could these two fires have been put out if only well water had been available?' While the Golden River served as a source of water for dousing fires, it also supplied water for mixing mud and mortar when such great buildings as the Hall of Imperial Supremacy and the Hall of Supreme Harmony were built.

There is a criss-cross network of underground waterways in the Forbidden City, forming several main arteries, all of which converge into the main stream of the Golden River. The drainage of water is so smooth that even with the heaviest downpour, the Forbidden City was never flooded.

Whenever the river meets a building on its course, the river goes underground through culverts. That is why it is said that 'the Inner Golden River is sometimes visible and sometimes invisible, but it nevertheless is one river'. Rivers and bridges go hand in hand. Over its entire course, the river is spanned by more than twenty large and small bridges, and there are more than ten points at which it disappears into culverts. By far the most majestic of these bridges is the Inner Golden River Bridge, just in front of the Gate of Supreme Harmony, composed of five small bridges. The rest are different in design and style. There are single-arched bridges, and those juxtaposed in groups of three single bridges.

The oldest as well as the most exquisite bridge is the Rainbow-Cutting Bridge over the Golden River at the eastern end of the Hall of Military

Fig. 62 Culvert where the moat enters the Forbidden City.

Eminence. It is 18·7 m. long and 9·2 m. wide. It has a single arch, the curved surface is paved with large stone flags and carved white marble balustrades. Engraved with fine floral patterns, the stone panels connect twenty-four upright posts each crowned by a lion carved in the round in varying postures. Built during the Ming dynasty it has never needed major repair and is still as solid as ever.

In addition, flat bridges were built over the river in front of the Gate of Martial Spirit, the East Glorious Gate, and the West Glorious Gate, connecting them with the main avenues outside the Forbidden City.

431. Inner Golden River bridges in front of the Gate of Supreme Harmony.
432. Inner Golden River bridges formed by five separate spans.

The Inner Golden River in the Forbidden City is a masterpiece of architectural and structural engineering. The river widens, narrows, emerges and disappears under the courtyards according to the topography of the land; and in each section along its course, the river assumes a different appearance. In the places where the river flows above ground, its sides and bed are uniformly lined with pisolite and darkish stone, but as it twists and turns away and down they are treated differently. The Golden River is widest in the area of the Gate of Supreme Harmony, measuring 10·4 m., narrowing at its eastern and western ends where it empties into culverts to 8·2 m. At its narrowest it is only 4–5 m. wide. The banks of the river are decorated with white marble, *han bai yu*, balustrades along the section passing through the square of the Gate of Supreme Harmony. Other sections of the river have low walls constructed of brick.

The winding section of the Inner Golden River which runs across the front courtyard of the Gate of Supreme Harmony was designed to be, aesthetically, the high spot of this watercourse. Five bridges were built here, the middle one, measuring 23·15 m. by 6 m. wide, being the largest. The two bridges either side of it are slightly smaller, each measuring 21 by 5·4 m. wide. The two outer bridges each measure 19·5 by 4·8 m. wide. All five bridges are single-arched structures paved with marble and enclosed by carved white marble balustrades. Forming part of the Imperial Way, the balustrade capitals of the middle bridge are carved with dragons and clouds. The four bridges to the left and right were used by princes and officials and have post capitals of torch-shaped carvings of the so-called 'twenty-four solar divisions of the lunar calendar'.

433. Looking west towards the Rainbow-Cutting Bridge.
434. Culvert at the east end of the Inner Golden River.
435. Rainbow-Cutting Bridge.
436. Watercourse east of the Gate of Literary Glory.

435

436

給水、排水

WATER SUPPLY AND DRAINAGE

Wells supplied most of the water for the imperial palaces during Ming and Qing times. Legend has it that when the Ming built the palaces, seventy-two wells were dug so as to make them represent the seventy-two stars symbolizing the earth. Liu Ruoyu, when writing on the palaces during the Ming period, mentions wells on several occasions and more specifically that the side halls of the Palace of Compassion and Tranquillity, the Palace of Compassion and Good Luck, and the Palace of Heavenly Purity, were supplied with their own wells, an indication that the location of the wells had been given special consideration during the planning stage of the Forbidden City. However, it is difficult to ascertain whether or not the number was exactly seventy-two. Almost all the halls in the Inner Court, and some courts, kitchens and storehouses of the Inner Court, possess wells. Some of them have one well, others two. Taken together, there may well be as many as seventy-two.

The wells have been carefully designed and installed. Stone covers, some drum-shaped and wooden covers are placed over the wells, all kept under lock and key. Judging from the marks left on these stones buckets tied to ropes were used at that time to draw water from the wells. Books kept in the tea rooms of the Palace of Gathering Excellence and the Palace of Eternal Spring in the Qing dynasty list such items as buckets and wicker-covered pitchers. Pulleys were used in some cases to make the work easier.

Most wells were built beneath small pavilions and nearly thirty of them still survive to this day. The vast number of well-pavilions, in fact, is a special feature of the imperial palaces. The specifications for the construction of well-pavilions had already been set down in the *Regulations for use in building and construction work* compiled in the Song dynasty. The purpose of these pavilions was to facilitate the drawing of water from wells, and to keep the water clean. Well-pavilions in the Forbidden City were built, despite their size and function, in grand palace manner with many brackets and rich painted polychrome decoration. Mostly square in shape, richly decorated stone drainage gulleys are laid around a stone platform to allow drainage of spilled water. Well-pavilions are usually of the half hipped flat top type (*lu ding*) although some have simpler roofs which are a combination of the pitched roof with overhanging eaves and rolled pitched roof. A square opening is usually left at the centre of the roof to allow in light and to facilitate the work of dredging the wells. The details of construction and design of these pavilions varied according to their location. Well-pavilions often built in pairs in the courtyards of palaces and halls are magnificent in style, and lavishly decorated. Intricate floral patterns are engraved on the drum-shaped stone covers and plinths.

Besides supplying water to the palaces, wells fulfilled other functions. The water of the well at the northwestern corner of the Hall of Military Eminence was directed along stone troughs into a room in the Hall of Bathing in Virtue. The Hall of Military Eminence served as a printing house during Qing times and the editorial office was located in the Room of Bathing in Virtue. The water from this well was supposed to provide water to be used in the printing of the books. But tradition also has it that there was a Uighur-style bathhouse located at the back of the Room of Bathing in Virtue and the well water was brought there to supply bath water for the imperial concubine Xiang Fei ('Fragrance'). Regardless of purpose, the method of directing water along stone channels from the well across a courtyard into a boiler, provided with a flue, to heat it is ingenious. Inside the courtyard of the Hall of Remitting the Mind to the east of the Hall of Literary Glory, there is a well which was called 'Big Kitchen Well'. It was already in existence during the Ming period, and became, from that time, the place where sacrifices were offered to the God of Wells. This practice of offering sacrifices to the God of Wells in the tenth month of the lunar calendar was adhered to until the Qing dynasty. According to written records, the water of this well is fresh and sweet. There was also a saying: 'Water from the Jade Spring Mountain is the best; that of the "Big Kitchen Well" on the east of the Hall of Literary Glory comes second.' This Big Kitchen Well can be regarded as the best well in the Forbidden City. Most of the wells in the City are now dry. But this well still contains plenty of water which is as clear and sweet as ever.

The water that the emperors drank did not come from these wells, but from spring water transported from the Jade Spring Mountain to the palace by water-carts. A line in one of the poems written by the Qianlong emperor reads, 'When eating and drinking seek out water from the Jade Spring Mountains'. The same spring water was used in the preparation of food and infusion of tea for the emperor and empress. When the emperor left the capital on tours of inspection, or went hunting, 'Jade Spring water was brought along for imperial consumption'. It is said that the Grand Scholar Li Guangdi was highly regarded by the Kangxi emperor and at his invitation became the Grand Tutor to the Heir Apparent. Li had a very bad stomach, and could only drink the best water; unfortunately he lived in the suburban area of the Gate of Proclaimed Military Prowess, south of Beijing, where the quality of the water was bad. Hearing this, the emperor ordered that Li's servant should take the fresh spring water to him each day. From this it can be seen that the spring water from the Jade Spring Mountain was re-

served for imperial use alone; others could only partake of it with the consent of the emperor.

The drainage system of the Forbidden City is well designed so that it guarantees quick and efficient drainage of water during the rainy season, thereby preventing flooding. It takes advantage of the natural gradient of the land, which can, with or without the use of stone gulleys direct water to underground waterways through coin-shaped stone grids, so-called because of their similarity to the ancient Chinese copper 'cash' with a square central hole. Take the group of buildings around the Hall of Supreme Harmony as an example. The height at the centre of the three-tiered terrace of the Hall of Supreme Harmony complex measures 8·13 m., sloping to the outer edges which measure 7·12 m. high. When it rains it is drawn down towards the edges where it passes through the projecting carved stone dragon heads and spurts out of their mouths to the lower terraces, and from there on to the courtyards. The courtyard itself slopes from the centre to its outermost edge, and from north to south. Surrounding the four sides of the platform are stone gulleys, known as open gulleys. At the point where these troughs meet the platform steps there are small stone arches which receive the water and carry it away. The same kind of drainage system can also be found in the courtyards of the Three Rear Palaces.

Two indispensable parts of the drainage system are the coin-shaped openings which receive surface water, and the mouths of culverts from which water empties. In the Forbidden City, all these inlets and outlets have been decorated with colourfully glazed brickwork and stone carvings.

The major arteries of the drainage network are spread all over the courtyards, with the open troughs and underground waterways criss-crossing one another. They cut off the natural flow of water from east to west and divert it into the open gulleys which run north–south so that they eventually all flow into the Inner Golden River.

The locations of some of the major arteries are as follows: inside the Gate of Martial Spirit north of the Inner City, an underground waterway runs from west to east, then turns to the south, covering nearly one half of the Forbidden City. The ground above is paved with stone slabs, with openings where water can run in. At its western extremity this culvert converges with the Golden River on the east of the Temple to the City God. Its eastern end passes through the northeastern corner of the Forbidden City, and then moves southward through thirteen drainage networks, arriving at the Official History Office section of the Inner Golden River.

Another major artery begins north of the east–west route described above, flowing southward via the narrow passage between the Six East Palaces and the Palace of Tranquil Longevity, then proceeds westward along the eastern wall of the Imperial Tea Room, and moves to the southeast, meeting the Inner Golden River on the eastern side of the Hall of Literary Glory. There is also a tributary which emerges from the southern end of the narrow passage, travels west through the Hall for Worshipping Ancestors, and then re-emerges in the southwestern corner of this courtyard, moves along the eastern wall of the Outer Court and the western wall of the Hall of Literary Glory, finally joining up with the Golden River.

Yet another tributary appears from the southwestern corner of the courtyard of the Palace of Heavenly Purity, passes through the Inner Right Gate, goes into the southern stores of the Hall of Mental Cultivation, re-emerges from its southern wall, then moves southward outside the Gate of Great Ancestors, until it comes to the Rainbow-Cutting Bridge to the east of the Hall of Military Eminence and finally joins the Inner Golden River. On both sides of the Hall of Heavenly Purity, the Hall of Union, the Palace of Earthly Tranquillity, and the East and West Long Alleys, there are subterranean drainage culverts running from north to south on one or both sides of the roads which receive all the water running off from the various halls and palaces. These waterways then converge with those running from east to west, and then pour into the above-mentioned tributaries.

All these deep-dug drainage networks were constructed during the Ming dynasty. The arched culverts below the southeastern corner building of the Hall of Supreme Harmony are 1·5 m. high, and 0·8 m. wide. The upper part of the culvert is formed of brick, while its bed and banks are laid with slabs. The culverts of the East and West Long Alleys are also 60–70 cm high, and built entirely of stone. The construction work involved in laying these drainage networks far exceeds that needed to dig the Golden River. According to the rules laid down in the Ming and Qing periods, all the drains in the palace had to be cleared regularly each spring (in the Qing dynasty, this was carried out during the third lunar month). Thanks to the continuous and methodical maintenance work carried out down the centuries these drains still carry away water smoothly after more than five hundred years of use.

This drainage system was never used to drain sewage, which was disposed of by other methods.

Fig. 63 Pavilion over a well inside the Palace of the Great Yang.

Fig. 64 Carved stone hornless dragon head gargoyle.

Fig. 65 Coin shaped drain and cover.

Fig. 66 Open gulley leading to arched inlets which direct channelled surface water underground.

437. Water-spouts in the wall running along the East Long Alley.
438. Pavilion covering a well in the Imperial Garden.
439. The well pavilion on the west of the Hall of Bathing in Virtue.
440. Large gilt bronze tub in front of the Gate of Heavenly Purity.
441. Bronze water vat in the Palace of Gathering Excellence.

Large bronze or iron water vats are arranged around the larger courtyards of the Forbidden City and along the East and West Long Alleys of the Inner Court. They fulfilled the dual role of fire prevention and decoration in the Ming and Qing dynasties.

During the Qing dynasty, these vats were always kept filled with water. Each year after the period of 'Slight Snow' (twentieth solar division), palace eunuchs would place cotton-padded coverings over these vats, cover them with lids and light charcoal fires in the stone stands beneath the vats to prevent the water from freezing. The fires were only put out during the period of 'the Waking Insects' (third solar term) after the Spring Festival.

442. Fire wall of the West Long Alley.

South of the Gate of Dragon Light on the east and the Gate of Phoenix Radiance on the west of the Palace of Heavenly Purity are two fire walls. They are 16 m. wide, built with bricks from floor to roof. Brackets, beams, purlins and roof boards of green stone are also employed as a protective measure against the spread of fire.

443. Hornless dragon head gargoyles overhanging the front three-tiered terraces of the Hall of Supreme Harmony.

The centre of each of the three terraces of the Three Great Audience Halls is 8·13 m. high sloping away towards the edges which stand at 7·12 m., drawing the water smoothly off the terraces. A small opening at regular intervals along the base of the enclosing balustrades carries water down to the grooved, exquisitely carved stone dragon head gargoyles. When it rains heavily, these gargoyles, numbering more than 1,100 throughout the city, can drain away water in no time, the tiers of cascading jets providing a unique and spectacular display.

禦寒、防暑

HEATING

Stoves were lit and the *kang*, hollow brick beds warmed by a fire below, prepared on the first day of the eleventh month of the lunar calendar every year in the Forbidden City. This was known as 'Stove-Lighting Day'. In practice, however, this date was not strictly adhered to, particularly during the late Qing period. This is probably because rules and regulations were not enforced at that time, so the emperor and the imperial family could do whatever they liked. Only subordinates and servants had to observe the regulations and began heating on the first day of the eleventh month.

Heating in the palace was either by a fire lit in a pit or flue built beneath the floor, or by the use of portable charcoal braziers.

Heating pits were constructed below the corridors of halls and palaces. Brick beds were constructed over these pits, or else lighted stoves placed inside. The mouth of a pit is about 1 sq. m. and its depth 1·5 m., and is covered by a lid. Brick ducts below buildings led away used air, gases and smoke from the pits to an exterior outlet. Basically, the same method is used for heating houses all over China, the only difference being that heating in the Forbidden City was much more sophisticated. Halls and palaces equipped with this kind of heating system are called *nuan ge*, 'heated halls'. This type of heating system is seen in the Palace of Heavenly Purity, the Palace of Earthly Tranquillity, the Six East and the Six West Palaces. The *Chronicles of the Ming imperial palace* state that 'a *kang* was built in the Hall of Industrious Energy during the Tian qi period (1621–7). The emperor often came and stayed there . . .' indicating that emperors and empresses made full use of halls and palaces with heated pits.

The heaters used in the palaces were for the most part braziers of different kinds. They were of two ordinary types: braziers and 'cage' or 'basket' braziers. The larger ones can weigh as much as 100 kg. and more, are usually over 1·5 m. high, and are supported on three or four legs which sometimes stand on a base. The smaller ones, the size of a watermelon, are portable and specially designed as hand or foot warmers. Each brazier is a work of art in itself.

Halls of the Outer Court did not possess their own heating systems, but had stoves placed in them every winter. The halls in the Inner Court, on the other hand, had both heated *kang* and braziers, the number of which was regulated. However, more stoves were brought if the temperature dropped below a given level. During the winter of 1723, for instance, the weather was so cold that the Yong zheng emperor ordered the chief eunuch to place more stoves in the Hall of Supreme Harmony, where the palace examination was in progress, so that the brushes and inks would not freeze and the candidates could write their papers in comfort. On one occasion, however, the braziers of the Hall of Supreme Harmony almost caused a fire. This occurred in 1819 while the Jia qing emperor was in the hall. A great number of stoves had been placed there and three rear doors had been left wide open. The wind blew sparks from the braziers all over the floor and had not the servants and the imperial guards had the presence of mind to stamp embers out quickly and efficiently the hall would have soon gone up in flames like so many buildings before. Following this the emperor decreed that whenever imperial banquets or title-conferring ceremonies were held in the Hall of Preserving Harmony and the Hall of Supreme Harmony, only two charcoal braziers, with mud covering the charcoal, could be placed at two of its corners. When the emperor was examining sacrificial wooden tablets bearing inscriptions, no braziers were to be brought into the Hall of Complete Harmony and the Hall of Supreme Harmony. Anyone placing more stoves than stipulated would be discharged without hesitation.

Needless to say, this elaborate heating system consumed a large quantity of charcoal, firewood, and coal every day. According to the information recorded in *Wan shu za ji, Miscellaneous jottings from Wan ping county office*, written by the district magistrate Shen Bang in the Ming dynasty, more than 500 kg. of charcoal were consumed during the course of one of the many palace examinations in 1590. The supply of firewood and charcoal was made according to a fixed apportionment. The portions during the Qian long period were set as follows: 55 kg. for the empress dowager and the empress; 45 kg. for imperial concubines of the first rank; 37·5 kg. for imperial concubines of the second rank; 15 kg. for prin-

cesses; 10 kg. for sons of the emperor; and 5 kg. for grandsons of the emperor. By the time of Pu yi, the last emperor of the Qing dynasty, the Palace of Gathering Excellence alone consumed 1,500 kg. of coal, 150 kg. of charcoal, 10 kg. of good quality 'red-basket' charcoal, and 30 bundles of inch-sized charcoal. Twenty-five kilograms of charcoal and an equal quantity of 'red-basket' charcoal were used every day to keep the water in which fish were kept warm in the Palace of Eternal Harmony. Ten kilograms of coal, two baskets of charcoal and forty baskets of 'red-basket' charcoal were burned daily to keep down the number of crickets in imperial gardens. Most of the firewood and charcoal, however, was consumed by the imperial family; their subordinates and servants receiving but a small portion of the total amount. Each watchroom of the imperial library, for instance, was only allowed 2·5 kg. of charcoal a day.

The 'red-basket' charcoal (*hong luo tan*) used by the palace was of the highest quality. It was made from the hardwood grown in the mountains of Yizhou. This kind of charcoal had been consumed in the palace during the Ming dynasty and in the Qing period officials from the Forbidden City went to the counties of Yi and Laishui every year to purchase supplies. It was ordered that the charcoal could only be sold to official storehouses, and no private sales were permitted. The charcoal was cut into a fixed size and put into round baskets which had been daubed with red earth, hence the name 'red-basket' charcoal, before being transported to the 'Red-Basket Charcoal Depots' outside the present-day Gate of Western Peace. This kind of charcoal gave out great heat and burned for a long time, without sending off sparks or smoke. Charcoal briquettes are still frequently used as fuel in north China.

During the Ming and Qing dynasties, an institution known as the 'Fuel-Saving Department' was set up to manage affairs relating to the use of fuel in the palace. In the Qing period, this institution was divided into the following three offices: the Maintenance Office which was responsible for the installation of stoves and the transportation of firewood and charcoal: the Firewood and Charcoal Office which was responsible for the distribution and storage of firewood and charcoal: and the *Kang*-Lighting Office which was responsible for lighting fires in the *kang*. This shows the complexities involved in managing the palace heating systems.

In order to meet the high demand for fuel by the Forbidden City in general permanent storage areas became necessary. Besides the abovementioned Red-Basket Charcoal Depot, six other storehouses, all under the administration of the Fuel-Saving Department, were located at easy access points outside the Forbidden City. They included the North, South, East, West, New West and New South Depots. Firewood and charcoal for burning in the individual palaces was stored behind the Five West Residences under the control of the Fuel-Saving Department.

Beijing has a continental climate, and so there is a great difference in seasonal temperatures. It is cold in winter and hot in summer. All the buildings in the Forbidden City have high roofs and thick walls, and are therefore insulated from both heat and cold. All the main halls face south and have windows at the front and back, making them warm in winter and cool in summer. When summer comes, windows are opened, bamboo curtains hung under the eaves of the verandah, and mat-awnings set up inside the courtyard to shade the buildings and keep them cool.

Other measures were taken to keep off the heat in summer. There are five ice-vaults inside the Forbidden City. Four of them have the capacity to store 5,000 ice blocks each, while the other one, as many as 9,220 blocks. In winter, the ice blocks cut from the Inner Golden River were kept in the ice-vaults, situated outside the Gate of the Great Ancestors. Iceboxes were kept in the tea rooms of such buildings as the Palace of Eternal Spring and the Palace of Gathering Excellence to supply cold drinks and chilled fruit. From the first day of the fifth month to the twentieth day of the seventh month of the lunar calendar, various offices under the Imperial Household Department were each allowed two blocks of ice daily.

From the time of the Kang xi emperor, Qing emperors simply left the Forbidden City in summer and went to such summer resorts as Yuan ming Garden, the Fragrant Hills and Chengde in order to escape the oppressive heat of the north China plain.

444. Lit openwork bronze brazier with openwork of prunus and cracked ice pattern.
445. Enamelled bronze brazier.
446. Gilt bronze brazier with mesh cover.
447. White earthenware inner brazier.
448. Openwork brazier with *kui* dragon and phoenix pattern and enamel inlay.
449. Bronze brazier with grid and mesh guard cover.
450. Portable bronze brazier engraved with characters *shou*, 'longevity', for personal use.
451. Stoke hole of the *kang* ducts in the Hall of Pleasurable Old Age.
452. Smoke flue outlet of the Hall of Pleasurable Old Age.

448

451

449

452

450

299

454. Evening scene in the second West Long Alley in the Inner Court.
455. Cloisonné table lantern.
456. *Nan mu* hardwood standard lantern in the shape of a bottle gourd.
457. Gilt table lantern.

Hanging lanterns.
458. Cloisonné palace lantern, the glass panels of which are decorated with polychrome oil-painted designs.
459. 'Prunus blossom' sandalwood-framed palace lantern.
460. Palace lantern with blue glass bulb.
461. Cloisonné palace lantern, the lower part in the shape of two fishes, the word for which, *yu*, is a homophone for 'fish' and 'plenty' and used in phrases for good wishes.
462. Sandalwood-framed palace lantern with the panels bearing calligraphy and paintings.
463. Lantern with fish-shaped shade.

464. Coloured candles used in the palace.
465. Cloisonné candlestick decorated with panels of bird and flower paintings.
466. Cloisonné enamelled candlestick, incorporating the Buddhist mystic knot symbolizing longevity, used in birthday celebrations.
467. Two small standard lamps, made of ox horn strips, flanking the imperial couch in the Palace of Earthly Tranquillity.

465

466

467

307

APPENDICES 附錄

PLANS OF THE MAIN STRUCTURES OF THE FORBIDDEN CITY

1. Vertical section through city wall corner watchtower.

2. Plan of city wall corner watchtower.

3. Horizontal sectional plans of roof of watchtower

4. Vertical section through the Three Great Audience Halls and terraces.

Imperial Way carved stone slab

5. Plan of Hall of Supreme Harmony.

6. Vertical section through Hall of Supreme Harmony and terrace.

7. Vertical section through end of Hall of Supreme Harmony.

Scale 1/20 metres

8. Vertical section through Pavilion of One Thousand Autumns (Imperial Garden).

Scale 1/20 metres

9. Sectional plan of roof of Pavilion of One Thousand Autumns.

316

10. Qing dynasty type balustrade.

11. Qing dynasty type Sumeru base.

Scale 1/10 metres

12. End elevation, plan and details of decoration on terrace of Hall of Supreme Harmony.

13. Glazed ceramic figures and tiles used on different types of roof.

14. End view of roof pommel of Hall of Complete Harmony.

15. Gaping dragon *wen* acroteria at end of ridge tiles on Hall of Supreme Harmony. End view.

16. Qing dynasty type eaves' bracket sets and terminology.

17. Qing dynasty type eaves' bracket set.

18. Eaves' bracket sets of the Palace of Heavenly Purity.

19. Four types of decoration of coffered ceiling

20. Detail of coffered ceiling, and section, of Hall of Supreme Harmony.

21. Section through and structure of Qing dynasty type coffered ceiling.

22. Sectional plan of roof and coffered ceiling of the Hall of Union.

Scale 1/25

metres

23. Scale drawing of *he xi* polychrome painted decoration showing *gu tou*, *zao tou* and *fang xin* sections and motifs.

321

24. Scale drawing of *xuan zi* polychrome painted decoration showing *gu tou*, *zao tou* and *fang xin* sections and motifs.

25. Scale drawing of Suzhou polychrome painted decoration showing disposition of elements and motifs.

26. Vertical section and front elevation of window and door.

27. Detail and section of partition in Hall of Preserving Harmony showing 'waterchestnut blossom' lattice and gilt embossed frame bracket.

28. Section through and front view of Qing dynasty type silled and top and horizontal hinged latticed window.

29. Song dynasty type partition door with circular lattice.

323

———·——— underground culverts

• waterwells

50　100　150　Scale

30. Distribution map of the drainage system and water wells of the Forbidden City.

CHRONOLOGY

(compiled by Zheng Lianzhang)

MING DYNASTY (1368–1644)

Year A.D.	Name of reign period	Year of reign period	Month	
1406	Yong le	4	7 (intercalary)	Yong le emperor proclaims construction work be started on new imperial palace in Beijing by fifth month of following year. Officials dispatched to provinces to gather building materials. Craftsmen, soldiers and commoners conscripted and ordered to present themselves in Beijing by the fifth month of the following year
1417		15	2	The Marquis of Peace and Tranquillity, Chen Gui, entrusted with administering the construction of the Beijing palace, assisted by Wang Tong and Liu Sheng
1420		18	12	Forbidden City in the new northern capital completed
1421		19	4	Hall of Serving Heaven (now Hall of Supreme Harmony), Hall of the Splendid Canopy (now Hall of Complete Harmony), and Hall of Respectful Care and Contentment (now Hall of Preserving Harmony), destroyed by fire
1422		20	12 (intercalary)	Palace of Heavenly Purity burnt down
1436	Zheng tong	1	9	Ruan An the eunuch, Shen Qing, military governor and Wu Zhong, junior guardian of the heir apparent, entrusted with rebuilding the Three Great Audience Halls in Outer Court
1439		4	12	Reconstruction of Palace of Heavenly Purity. Minister Wu Zhong offers sacrifices to the God of Works
1440		5	3	Halls of Serving Heaven, the Splendid Canopy, and Respectful Care, as well as Palaces of Heavenly Purity and Earthly Tranquillity were completed
1449		14	12	Hall of Literary Profundity, including the entire imperial library collection of books, destroyed by fire
1475	Cheng hua	11	4	Fire breaks out at the Gate of Heavenly Purity at night
1487		23	9	Reconstruction of Palace of Benevolence and Longevity and associated buildings
1490	Hong zhi	3	2	Construction of Palace of Glorious Virtue. Three hundred imperial guards were assigned to give assistance
1492		5	6	Qiu Junqing, member of the Han lin Academy, built a two-storeyed building near the site of the Hall of Literary Profundity, the imperial library, of brick and stone. The dynastic records and the imperial genealogy were stored on the upper floor, documents of the Inner Court kept on the lower floor
1498		11	10	Palace of Purity and Tranquillity destroyed by fire
1499		12	10	Reconstruction work on Palace of Purity and Tranquillity completed
1514	Zheng de	9	1, 12	New Year firework display led to the burning of the Palaces of Heavenly Purity and Earthly Tranquillity and surrounding buildings. Tax levied to raise an extra 1 million *taels* of silver for their reconstruction
1519		14	8	Reconstruction of the Palaces of Heavenly Purity and Earthly Tranquillity completed
1522	Jia jing	1	1	Three small palaces behind Palace of Purity and Tranquillity catch fire
1523		2	4	Hall of Honouring Compassion built behind Hall of Observing Virtue
1525		4	3, 8	Palace of Benevolence and Longevity catches fire. Ministry of Works hold discussion concerning this and begin the reconstruction of Palace of Benevolence and Longevity.
			10	Renovation work on Palace of Purity and Tranquillity completed
1526		5	7	The Jia jing emperor, critical of the plans drawn up for the Hall of Observing Virtue behind the Hall of Housing Compassion as too small and cramped, determines instead to construct an ancestral building on the east side of the Hall of Honouring Compassion to be called the Hall for Worshipping Ancestors, in memory of his father
1527		6	3	Hall for Worshipping Ancestors completed
1531		10	6	Sloping ridge of the corner pavilion on the Meridian gate and northwestern corner pillar of the West Glorious gate struck by lightning
1534		13	9	Construction of the Nine by Five Bays Hall of Abstinence and Room for Offering in Solitude for total abstention and offering of sacrifices completed behind the Hall of Literary Glory
1535		14	5	Palace of Infinity renovated. The Hall of Imperial Peace built for offering sacrifices to the Taoist Supreme Deity. Walls are built to enclose the Hall with the First Gate in Heaven as its main entrance. Also the names of twelve palaces are changed. (See pp. 72–3)
1536		15	4	Palace of Compassion and Good Luck built behind the Palace of Purity and Tranquillity to be used as the residence of the abdicated emperor and empress dowager. The Palace of Compassion and Tranquillity was built on the site of Palace of Benevolence and Longevity as the palace of the empress dowager
			11	Hall of Literary Glory, originally the study of the crown prince, was covered with green-glazed tiles. Became, from this date on, the place where the emperor heard the exposition of the classics. Thus the green tiles were replaced with yellow, the imperial colour
1537		16	4	The Jia jing emperor orders the extension and renovation of the Grand Secretariat.
			5	Construction work of the dining hall of the Palace of Purity and Tranquillity, Hall of Uprightness and Respect, the Imperial Mess Hall, the Great and Glorious Hall, the Square Hall, hedge for Guarding against Transgression, and the Administrative Office completed and the Hall of Ancient Physicians also erected in their honour behind the Hall of Literary Glory
1537		16	6	Hall of Mental Cultivation completed
1538		17	7	Palaces around the Palace of Compassion and Tranquillity completed
1539		18	1	Hall for Serving Ancestors completed.
			10	Palace of Eternal Longevity completed.
1540		19	11	Palace of Compassion and Good Luck, and complex of the Hall of Original Favour completed
1557		36	4	Thunderstorm on the thirteenth day. The three main halls of the Inner Court, the Literary Building (later Pavilion of Manifest Benevolence), the Military Building (later Pavilion of Glorifying Righteousness) and fifteen gates are laid waste by a fire caused by lightning
			10	Jia jing emperor offers sacrifices prior to the reconstruction of the halls and gates
1558		37	6	Reconstruction of the Meridian Gate, the Gate of Supreme Harmony, the East and West Corner Gates, and the Left and Right Gates of Compliance completed
1562		41	9	Many palaces and gates renamed upon the orders of the Jia jing emperor
1566		45	6	Lei Li entrusted with the building of Palace of Highest Supremacy to honour the father of the Jia jing emperor. Work completed in the ninth month
1567	Long qing	1	4	Renovation of Palace of Great Benevolence. Palace of Great Happiness renamed Hall of Exuberance
1569		3	6 (intercalary)	Eaves and verandahs of the Palace of Heavenly Purity repaired
			11	Refurbishment of Palace of Inheriting Heaven and Eternal Harmony
1570		4	2	Long qing emperor orders the construction of buildings including Pavilion of Spiritual Nature, Hall of Benevolence and Virtue and Room of Loyalty and Righteousness
1573	Wan li	1	9	Central multi-storeyed building of the Meridian Gate renovated
			11	Rear rooms of Palace of Compassion and Tranquillity destroyed by fire
1575		3	5	Heated pavilion of the Palace of Compassion and Tranquillity renovated
1578		6		Hall on the Brink of the Brook completed
1580		8	4	The beam of Gate of Imperial Supremacy (later Gate of Supreme Harmony) becomes defective and orders given for its substitution
			4 (intercalary)	Construction work begins on the above
			6	Work completed on the above gate
1583		11	2	Wan li emperor orders renovation of Hall of Military Eminence
			5	Hall on the Brink of the Brook renamed Pavilion on the Brink of the Brook
			8	Hall of Military Eminences completed
			9	Temple for Worshipping the Four Gods and Hall of Contemplating Flowers demolished. An artificial mountain, called the Hill of Piled Elegance, is erected and the Pavilion of Imperial Prospect constructed on top. Fish ponds are dug on both the eastern and western sides of the Imperial Garden and the Jade-Green Floating Pavilion and Pavilion of Auspicious Clarity are built over them. Other garden pavilions also constructed
1584		11	12	Fire breaks out in Palace of Compassion and Tranquillity at night
		12	2	Wan li emperor issues an edict to the Grand Secretariat proclaiming that renovation work on the above palace should begin without delay, as it was the residence of the empress dowager

325

Year A.D.	Name of reign period	Year of reign period	Month	
1585		13	2	Reconstruction work begins on the above palace
			6	Work completed on the above
1591		19		Several garden structures in the Rear Court Garden (the Imperial Garden) are demolished
1594		22	4	Ramparts of the Forbidden City wall renovated
			6	Fire breaks out in the gate tower of West Glorious Gate during a thunderstorm
1596		24	3	Fire breaks out in Palace of Earthly Tranquillity and spreads to Palace of Heavenly Purity, burning both to the ground.
			7	The Wan li emperor orders the Imperial Astrologer to choose an auspicious date on which to rebuild Palace of Heavenly Purity
			8 (intercalary)	Reconstruction work of superstructure of the West Glorious gate completed
1597		25	1	Reconstruction work of Palace of Heavenly Purity and Earthly Tranquillity begins
			6	The three main halls of the Inner Court catch fire, spreading all along the connecting corridor and galleried buildings of the complex
1598		26	7	Renovation of Palace of Heavenly Purity, Hall of Union, Palace of Earthly Tranquillity, etc. Two hundred and forty upright cabinets and 2,400 chests are made at the same time at a total cost of 720,000 *taels* of silver.
			11	Construction work on Gate of the Great Ancestors begins
1599		28	8	Palace of Compassion and Good Luck completed
1603		31	4	Garden of the Palace of Compassion and Good Luck completed. The Imperial Astrologer sets the sixteenth of the month as an auspicious day for clearing the sites of the three main halls of the Inner Court
1608		36	9	Laying of the beams for the Gates of Meeting the Ultimate and Returning to the Ultimate (renamed Unified Harmony and Splendid Harmony respectively)
1615		43	8 (intercalary)	Reconstruction work begins on the three main halls of the Outer Court
1616		44	11	Hall of Glorious Virtue burns down
1620	Tai chang	1	8	Construction work starts on the Gate of Imperial Supremacy
			10	Palace of the Singing Phoenix catches fire
1625	Tian qi	5	2	Cabinet Minister Cui Chengxiu is commanded by the Tian qi emperor to make an inspection of reconstruction work of the three main halls of the Outer Court as well as that of the gates and galleries. Work commences on building of the Gates of Great Government (renamed Luminous Virtue) and Proclaimed Government (renamed Correct Conduct)
1626		6	9	Hall of Imperial Supremacy (renamed Supreme Harmony) completed. The Tian qi emperor accepts congratulations from officials in the hall
1627		7	3	Reconstruction work on Hall of Glorious Virtue begins
			4	Work completed on the above
			8	Reconstruction work on the three main halls of the Inner Court completed

QING DYNASTY (1644–1911)

Year A.D.	Name of reign period	Year of reign period	Month	
1645	Shun zhi	2	5	Three Great Audience Halls and other buildings in the Outer Court given their present names (Gate and Halls of Supreme Harmony, Complete Harmony, Preserving Harmony etc.)
				Renovation of Palace of Heavenly Purity begins
1647		4		Meridian Gate refurbished by order of the emperor
1653		10		Palace of Compassion and Tranquillity rebuilt to become the residence of the empress dowager
1655		12		Mass renovation of palaces of the Inner Court undertaken
1657		14		Construction begins on the Hall for Worshipping Ancestors upon the instructions of the emperor
1669	Kang xi	8		Hall of Supreme Harmony and Palace of Heavenly Purity are rebuilt
1672		11	7 (intercalary)	Reconstruction of the Three Great Audience Halls and other buildings, gates, galleries and verandahs in the vicinity as well as replacement of roof tiles and restoration of decoration
1673		12		Reconstruction of Hall of Union, Palace of Earthly Tranquillity and the Gates of Supreme Harmony and Gate of Prosperity and Happiness
1679		18		Renovation of Hall for Serving Heaven. Palaces built as residences for the heir-apparent are built. Hall of Supreme Harmony catches fire
1682		21		Rebuilding of the Palace of Universal Peace (renamed Palace of Longevity and Peace)
1683		22		Reconstruction of Hall of Literary Glory. Renovation of Palace of Initiating Auspiciousness (renamed Hall of the Ultimate Principle), Palace of Eternal Spring and Complete Happiness
1685		24		Hall of Mental Transmission built to the east of the Hall of Literary Glory
1686		25		Renovation of the Palaces of Prolonged Happiness and of the Great Yang
1688		27		Palace of Tranquil Longevity built
1695		34		Reconstruction of Hall of Supreme Harmony begins
1697		36		Reconstruction of Hall of Inheriting Heaven and Hall of Eternal Longevity. Halls equipped with heating facilities are built on the left and right sides of Palace of Earthly Tranquillity
1698		37		Reconstruction work on Hall of Supreme Harmony completed
1726	Yong zheng	4		The Yong zheng emperor orders the construction of the Temple to the City God in the northwestern corner of the Forbidden City
1731		9		The Yong zheng emperor orders the construction of the Hall of Abstinence at the East Long Alley
1734		12	9	Plan for the renovation and reconstruction work of the area of Palace of Compassion and Tranquillity submitted to include its extension. The cost amounts to more than 69,000 *taels* of silver
1735		13	12	Construction of Hall of Longevity and Good Health begins
1736	Qian long	1	10	Qian long emperor inspects construction work on the Palace of Longevity and Good Health. Completion of construction work. Including courtyard walls and galleried buildings, screen wall, lamps etc. 74,123,698 *taels* of silver and 188·7 *taels* of gold were needed.
1737		2		Renovation of the Hall for Serving Ancestors
1740		5		Construction of Palace for the Establishment of Happiness and its attached garden and other nearby buildings begins. The garden succumbs to fire on the night of 26 June 1923, when many buildings are gutted
1743		8		Refurbishing of Palace of the Bringing-Forth of Blessings at an approximate cost of 48,980 *taels* of silver
1745		10		Renovation of Palace of Doubled Brilliance, restoration of painted decoration in the Hall of Imperial Peace, Palace of Eternal Longevity and high wall built around the Palace of Complete Happiness, costing more than 25,600 *taels* of silver
1746		11	3	Work to reconstruct Pavilion of Gathering Flowers as the residence of the royal princes (the South Three Residences) begins
1747		12		Twelve one-storey office buildings are built to the left and right outside Gate of Heavenly Purity (the offices of the Nine Ministries and the Office of the Grand Council). To the south, five south-facing offices are built to be used as offices for secretaries of the Grand Council and the Office of the Mongolian Princes. Construction work on the South Three Residences completed
1750		15		Construction of Pavilion of the Rain of Flowers and other subsidiary structures and interior as well as exterior decorations costs 22,533 *taels* of silver, and 196·81 *taels* of gold
1751		16		Palace of Complete Peace rebuilt and renamed Palace of Tranquil Old Age; Palace of Compassion and Tranquillity also rebuilt
1754		19		Reconstruction of Imperial Garden begins
1758		23	4	At noon on the twenty-eighth day, fire breaks out in a gallery of the Hall of Supreme Harmony and spreads, destroying some forty-one different storehouses
			12	Reconstruction of the above buildings, at a cost of 103,943 *taels* of silver
1759		24		Three glazed tile archways built to the north of the stone bridge inside the East Glorious Gate
1760		25		Three hundred and sixty rooms built to house the royal princes, and twenty-seven classrooms of the Palace of Complete Peace renovated
1761		26		Reconstruction of lower level of the Imperial Way at the back of three-tiered terrace of the Hall of Preserving Harmony
1762		27		Row of single-storey houses numbering 121 units east of Gate of Martial Spirit converted into residential apartments for imperial descendants. Hall of Literary Glory renovated
1763		28	2	Renovation work on the rear eaves of the Three Great Audience Halls and balustrades of the three-tiered terrace
1765		30		Renovation of the Three Great Audience Halls. One rear tower, two side towers, the Building of Auspicious Clouds and Building of Buddha's Features, and two side rooms added in the garden of Palace of

Year A.D.	Name of reign period	Year of reign period	Month	
				Compassion and Tranquillity, costing 59,452 *taels* of silver
			4	Renovation work on over ten minor structures including Temple to the City God, Temple of the Horse God etc. at a cost over 9,180 *taels* of silver
1766		31	5	Renovation work on 140 buildings including the Three South Residences, tea rooms and dining rooms at a cost of approximately 3,900 *taels* of silver
1767		32	12	Palace of Compassion and Tranquillity converted from a single-eaved to double-eaved building and its subsidiary structures renovated or rebuilt at a total cost of 108,744 *taels* of silver
1770		35	11	Plan and model of Palace of Tranquil Longevity complex made
1771		36		Building in the area around Palace of Tranquil Longevity begins
1772		37		The Imperial Household Department declares it would take years to complete the construction work on the complex of the Palace of Tranquil Longevity. Work on palaces and other structures at the rear part would come first. These include Hall of Spiritual Cultivation, Hall of Pleasurable Old Age, Pavilion of Great Joy, Pavilion of Gathering Flowers, Pavilion of the Ceremony of Purification, Study of Peaceful Old Age etc., at an estimated cost of 719,357 *taels* of silver
1774		39		Qian long emperor orders the work be started on the Hall of Literary Profundity behind the Hall of Literary Glory for the storage of the encyclopedic *Si ku quan shu*, Complete history in four branches of literature
1776		41		Construction of buildings in the area of the Palace of Tranquil Longevity completed. Altogether, 1,183 units were built and the total cost amounted to 1,270,340 *taels* of silver, excluding the re-use of old materials
1783		48	6	Pavilion of Manifest Benevolence catches fire
			7	The above pavilion reconstructed at a cost of 41,171 *taels* of silver
1790		55		The cost of rebuilding the Fresh Fruit Store, the guardhouse of the Silver Vault and the other damaged storehouses estimated to be 5,521 *taels* of silver
1795		60	2	Reconstruction of the hall in front of the Palace of the Bringing-Forth of Blessings. Architectural models are submitted for approval
1797	Jia qing	2		Fire breaks out in the Palace of Heavenly Purity, and spreads to the Hall of Union, Hall of Glorious Virtue and Hall of Luminous Benevolence, destroying all of them. Reconstruction of these buildings undertaken
1798		3		Reconstruction of the above halls and palaces completed
				On the tenth day of the tenth month, the retired Qian long emperor and Jia qing emperor are invited to inspect the Palace of Heavenly Purity and Hall of Union
1799		4		The theatrical stage in the courtyard of the Palace of Tranquil Old Age pulled down and the materials handed over to the construction department of the Yuan ming yuan Garden (Summer Palace)
1801		6		Renovation of the Meridian Gate and the Hall of Abstinence
1802		7		Renovation of Hall of Mental Cultivation, Palace of Doubled Brilliance, Palace for the Establishment of Happiness, Palace of Gathering Excellence, Palace of Prolonged Happiness and the Imperial Reading Room
1819		24		Renovation of Palace of Tranquil Longevity, the theatrical Pavilion of Pleasant Sounds, and the building for viewing performances, Building of the Buddhist Sun and the Buddhist Building at a total cost of 49,571 *taels* of silver
1831	Dao guang	11		Renovation of the Hall of Sacred Flowers. Ninety-one Buddhist scrolls in the hall are removed and presented to the Dong Huang Temple
1869	Tong zhi	8	6	On the evening of the twentieth day the Hall of Military Eminence inside the West Glorious Gate catches fire which spreads, destroying more than thirty adjacent buildings. Reconstruction work started later
1870		9	1	The Wood Store in the Five North Lodges destroyed in fire
1888	Guang xu	14	12	On the evening of the fifteenth, fire breaks out in Gate of Correct Conduct, destroying it and spreading to Gate of Supreme Harmony and the side buildings
1889		15		Reconstruction of the Gates of Supreme Harmony, Correct Conduct and Luminous Virtue
1891		17		Renovation of Palace of Tranquil Longevity and Palace of Doubled Brilliance

OUTLINE OF THE MAJOR DYNASTIES OF CHINA

Chinese emperors were given posthumous ancestral or temple names, as well as adopting a name for the period of their reign. Earlier, period names were altered within the reign of an emperor, but during the Ming and Qing dynasties a reign period corresponded to the duration of each emperor's rule. Thus, these emperors are often referred to by that title and dates are given according to the year of that reign period, even though the Ming emperors, a plebeian-based group, possessed ordinary Chinese names (family name followed by given name). For example, the founder of the Ming was called Zhu Yuanzhang; his temple is Tai zu (Great Ancestor) and reign era name Hong wu ('vast martial'). Similarly, the Qing emperors also possessed personal Manchu names.

Xia dynasty	2100–1600
Shang dynasty	1600–1100
Western Zhou dynasty	1100– 771
Period of the Spring and Autumn Annals	770 – 476
Period of the Warring States	475 – 221
Eastern Zhou dynasty	770 – 257
Qin dynasty	221 – 207
Western Han dynasty	206 – 208
Xin (interregnum)	9BC – 23
Eastern Han dynasty	25 – 220
Period of the Six dynasties	220 – 580
Sui dynasty	581 – 618
Tang dynasty	618 – 907
Five dynasties	907 – 960
Song dynasty	960 –1279
Liao dynasty	916 –1125
Jin dynasty	1115–1234
Yuan dynasty (Mongol)	1271–1368
Ming dynasty (Chinese)	1368–1644

Name of reign period	First year of reign period
Hong wu	1368
Jian wen	1399
Yong le	1403
Hong xi	1425
Xuan de	1426
Zheng tong*	1436
Jing tai (interregnum)	1450
Tian shun	1457
Cheng hua	1465
Hong zhi	1488
Zheng de	1506
Jia jing	1522
Long qing	1567
Wan li	1573
Tai chang	1620
Tian qi	1621
Chong zhen	1628

*resumed government as Tian shun

Qing dynasty (Manchu)	1644–1911
Shun zhi	1644
Kang xi	1662
Yong zheng	1723
Qian long	1736
Jia qing	1796
Dao guang	1821
Xian feng	1851
Tong zhi	1862
Guang xu	1875
Xuan tong	1909
Republic of China	1912
Peoples' Republic of China	1949

BIBLIOGRAPHY

(in Chinese)

1. 申時行〔明〕等重修，《大明會典》，明萬曆年刊本。
2. 張廷玉〔清〕等撰，《明史》，北京中華書局，1974年第一版。
3. 《明實錄》，江蘇圖書館傳抄本，1940年。
4. 劉若愚〔明〕著，《明宮史》，北京古籍出版社，1980年。
5. 龍文彬〔清〕撰，《明會要》，光緒年刊本。
6. 孫承澤〔清〕撰，《春明夢餘錄》，光緒九年刊本。
7. 孫承澤〔清〕撰，《天府廣記》，北京人民出版社，1962年。
8. 沈德符〔明〕編，《萬曆野獲編》，北京中華書局重印本，1959年。
9. 趙爾巽等修，《清史稿》，北京中華書局，1977年第一版。
10. 《大清會典》，清雍正年刊本。
11. 托津〔清〕等撰，《欽定大清會典事例》，清嘉慶年刊本。
12. 王先謙〔清〕撰，《東華錄》，長沙王氏刊本。
13. 《大清會典事例》，清光緒年印本。
14. 于敏中〔清〕等撰，《國朝宮史》，東方學會據乾隆版鉛印本，1925年。
15. 桂〔清〕等編，《國朝宮史續編》，故宮博物院，1932年。
16. 《欽定內務府現行則例》，故宮博物院，1937年。
17. 繆荃孫〔清〕等纂，《順天府志》，清光緒年刊本。
18. 黃彭年〔清〕纂，《畿輔通志》，光緒年刊本。
19. 朱彝尊〔清〕撰，《日下舊聞》，康熙二十七年刊本。
20. 于敏中〔清〕等編纂，《日下舊聞考》，乾隆四十三年刊本。
21. 高士奇〔清〕著，《金鰲退食筆記》，北京古籍出版社，1980年。
22. 震鈞〔清〕著，《天咫偶聞》，光緒年刊本。
23. 吳長元〔清〕輯，《宸垣識略》光緒年刊本。
24. 翁同龢〔清〕撰，《翁文恭日記》，上海涵芬樓影印本，1952年。
25. 《工程作法》，清雍正九年纂，乾隆元年刊本。
26. 《內庭工程作法》，清雍正九年纂，乾隆元年刊本。
27. 梁思成・劉敦楨著，〈清故宮文淵閣實測圖說〉《中國營造學社滙刊》第六卷第三期。
28. 劉敦楨著〈清皇城宮殿衙署圖年代考〉，《中國營造學社滙刊》，第六卷第三期。
29. 單士元著〈故宮〉，《文物參攷資料》，1957年第一期。
30. 王璞子著〈元大都平面規劃述略〉，《故宮博物院院刊》總第二期，1960年。
31. 于倬雲著〈故宮三大殿〉，《故宮博物院院刊》，總第二期，1960年。
32. 單士元著〈文淵閣〉，《故宮博物院院刊》，1979年第二期。
33. 王璞子著〈太和門〉，《故宮博物院院刊》，1979年第三期。
34. 王義章著〈故宮午門的油漆彩畫〉，《故宮博物院院刊》，1979年第四期。
35. 于倬雲・傅連興著〈乾隆花園的造園藝術〉，《故宮博物院院刊》，1980年第三期。
36. 賈俊英・鄭連章著〈紫禁城宮殿屋頂式樣〉，《故宮博物院院刊》，1980年第三期。
37. 茹競華・鄭連章著〈慈寧花園〉，《故宮博物院院刊》，1981年第一期。
38. 傅連興・白麗娟〈建福花園遺址〉，《故宮博物院院刊》，1980年第三期。
39. 北京故宮博物院《紫禁城》雜誌社編，《紫禁城》第一期至第十二期（1980—1982年）。

SELECTED FURTHER READING

Arlington, L.C. and Lewisohn, W., *In Search of Old Peking* (Peking: The French Bookstore, 1935).

Cao Xueqin (trans. D. Hawkes), *The Story of the Stone* (Harmondsworth, Penguin Books, 1973–82), 4 volumes.

Feng Yu-lan, *A Short History of Chinese Philosophy* (London: Collier-Macmillan, 1948; New York: The Free Press, 1966).

Haldane, C., *The Last Great Empress of China* (London: Constable, 1978).

Huang, R., *1587 A Year of No Significance: The Ming Dynasty in Decline* (New Haven, London: Yale University Press, 1981).

Keswick, M., *The Chinese Garden* (London: Academy Editions, 1978).

Johnstone, R.F., *Twilight in the Forbidden City* (London: Gollancz, 1934).

Medley, M., *A Handbook of Chinese Art* (London: Bell, 1964).

Palludan, A., The *Imperial Ming Tombs* (New York, London: Yale University Press, 1981).

Reischauer, E. and Fairbank, J.K., *East Asia*, 1. *The Great Tradition*; 2. *The Modern Transformation* (London: Allen & Unwin, 1958, 1965), 2 volumes.

Sickman, L. and Soper, A., *The Art and Architecture of China* (Harmondsworth, Penguin Books, 1960).

Spence, J.D. (compiled and translated), *Emperor of China: Self-Portrait of K'ang hsi* (Harmondsworth: Penguin Books, 1977).

Warner, M., *The Dragon Empress: Life and Times of Tz'u-hsi 1839–1908* (London: Weidenfeld & Nicolson, 1972).

Werner, E.T.C., *A Dictionary of Chinese Mythology* (New York: Julian Press, 1961; reprint of Shanghai 1932).

Wu, Silas Hsiu-liang, *Passage to Power: K'ang-hsi and His Heir Apparent 1661–1722* (Cambridge, Mass., London: Harvard University Press, 1979).

Zhong guo jian zhu shi bian xie zu. Zhong guo jian shi (*History of Chinese Architecture*) (Beijing, Zhong gou jian zhu gong ye chu ban she, 1982).

INDEX AND GLOSSARY

Altar of Earth and Grain, 18
 of the Earth, 19, 176–7
Annotated catalogue of the imperial library, 200–201
Arhat (Chinese: lohan): a worthy or saint of Mahayana doctrine, the most widespread form of Buddhism in China, 162
Azure Gemstone Kiosk, 120–21, 136

ba gua – *see* – eight trigrams, diagram of
Bao he dian – *see* – Hall of Preserving Harmony
Bao xiang lou – *see* – Building of Buddha's Features
Bao zhong dian – *see* – Hall of Luxuriant Foliage
Bei hai – *see* – North Lake
Bell tower, 28
Bi lin guan – *see* – Azure Gemstone Kiosk
Bi luo ting – *see* – Pavilion of the Jade-Green Conch Shell
Bi shu shan zhuang yan xi tu – *see* – paintings
Big Kitchen Well, 176–7, 292–3
Bo shan, 21
Bodhi tree (*Ficus religiosa*): the tree under which Shatyamuni Buddha attained enlightenment, 72–3, 195
braziers, 82
Bridges, 288–9
Bridge, Inner Golden River, 38–9, 48–9, 50–51, 217, 288–9, 290
 Rainbow-Cutting, 212, 220, 288–9, 290
Building, Buddhist, 176–7, 178, 180–85
 Xian ruo Buddhist Building, 120–21
Building of Appreciating Lush Scenery, 72–3, 120–21
 Auspicious Clouds, 120–21, 176–7, 189
 Buddha's Features, 120–21, 176–7
 Compassionate Shelter, 120–21, 176–7
 Extended Delight, 120–21, 152–3
 the Ancestors of Brahma, 176–7
 Wisdom and Sunlight, 120–21
 Xian ruo Buddhist, 176–7, 186–7
Bureau of National History, 200–201, 206–7

Cai Xin, master builder, 22–3
Canal, Glazed Tile – *see* – Glazed Tile Canal
Carpenters' Square Gallery, 148
Chang an gong – *see* – Palace of Eternal Peace
Chang chun gong – *see* – Palace of Eternal Spring
Chang le gong – *see* – Palace of Eternal Happiness
Chang shou gong – *see* – Palace of Longevity
Chang xi men, Gate at the West of the Works, 21
Chang yang gong – *see* – Palace of the Eternal Yang
Chang yin ge – *see* – Pavilion of Pleasant Sounds
charcoal, 296–7
Chen Gui, Marquis, 18–19, 22–3
Chengde, 169, 200
Cheng guang men – *see* – Gate of Inherited Light
Cheng huang miao – *see* – Temple to the City God
Cheng lu tai – *see* – Terrace of Receiving Dew
Cheng qian gong – *see* – Palace of Inheriting Heaven
Chang rui ting – *see* – Pavilion of Auspicious Clarity
Cheng tian men – *see* – Gate of Succeeding to Heaven
chi: Chinese unit of length=33·3 cm.
chi – *see* – dragon
chi wen – *see* – dragon
Chi zao tang – *see* – Hall of Literary Elegance
Chong hua gong – *see* – Palace of Doubled Glory
Chuan xin dian – *see* – Hall of Remitting the Mind
Cijiawu, 21
Ci ning gong – *see* – Palace of Compassion and Tranquillity
Ci qing gong – *see* – Palace of Compassion and Good Luck
Ci xi, Empress Dowager (1835–1908), 26–7, 72–3, 92–3, 98, 102
Ci yin lou – *see* – Building of Compassionate Shelter
clay, 20–21
Classic of documents, 26
coal, 296–7
Coal Hill – *see* – Prospect Hill
Collected statutes of the Qing dynasty (Da Qing hui dian), 52
Complete library in four branches of literature (Si ku quan shu), 200–201
crane: often occurs in association with pine, both symbols of longevity, 63, 78, 89
Cui shang lou – *see* – Building of Appreciating Lush Scenery
Cun xing men – *see* – Gate of Preserving the Spirit
'cup-floating' stream, 120–21, 146–7

Daibaikou, Men tov gou, 21
Dadu: Chinese name of Yuan dynasty capital, Khanbaligh (Beijing), 18–19, 288–9
Da fo tang – *see* – Hall for Worshipping the Great Buddha
Da mu cang hu tong – *see* – Great Timber Warehouse
Da nei – *see* – Great Inner Court
Da pao jing – *see* – Big Kitchen Well
Da Qing men – *see* – Gate of the Great Qing Dynasty
Da Ming men – *see* – Gate of the Great Ming Dynasty
deng jiang zhuan – *see* – bricks
deer – *see also* – hundred deer, 98
Di an men – *see* – Gate of Earthly Peace
Di tan – *see* – Altar of the Earth
dismounting stone, 32–3, 43
Dong lui gong – *see* – Palaces, Six East
Dong hua men – *see* – Gate, East Glorious
door, 24–5
dragon: unlike their Western counterparts, the many types of Chinese dragon symbolize goodness and strength. They inhabit the skies and watery places. When depicted with five claws, and usually chasing a flaming pearl amidst waves or clouds, they represent the emperor, 48–9, 65–7, 78–9, 98, 189, 212–13, 215–17, 220, 235, 245, 252, 253–8, 260, 261, 265, 266–73, 280–83, 298
 chi, hornless dragon, 212, 219, 235, 292–3, 294, 317
 chi, chi wen (gaping dragon), 24–5, 228–9, 232, 325, 318
Drum Tower, 28
Duan hong qiao – *see* – Bridge, Rainbow-Cutting
Duan men – *see* – Gate of Uprightness
Duan ning dian – *see* – Hall of Accomplishing Uprightness
Dui xiu men – *see* – Gate of Piled Excellence
Dui xiu shan – *see* – Hill of Piled Excellence

eight trigrams, Diagram of the, 300
Empress Dowager – *see* – Ci xi
Essentials of the imperial library, 200–201, 205

fa jia lu bu: imperial insignia – *see* – paintings, 52
Fan hua lou – *see* – Building, Buddhist
Fan zong lou – *see* – Building of the Ancestors of Brahma
Feng cai men – *see* – Gate of Phoenix Radiance
Feng Qiao, master carpenter, 22–3
feng shui – *see* – geomancy
Feng tian dian, Hall of Serving Heaven – *see* – Hall of Supreme Harmony
Feng tian men – *see* – Gate of Serving Heaven
Feng xian dian – *see* – Hall for Worshipping Ancestors
Five Phoenix Turrets, 38–9
Fo guang si, Shanxi province – *see* – Temple of the Light of Buddha's Halo
Fou bi ting – *see* – Pavilion, Jade-Green Floating
Fu wang ge – *see* – Pavilion of the Anticipation of Good Fortune

Garden, Imperial, 84, 120–21, 122–3, 132–3, 222–3, 225, 266–7
 of the Palace for the Establishment of Happiness, 120–21, 136–7
 of the Palace of Compassion and Tranquillity, 120–21, 138–41, 162
 of the Palace of Tranquil Longevity, 120–21, 142
 Summer Palace (Beijing), 162–3
 Summer Palace (Chengde), 22–3
 West, 176
 Yi he yuan, 163
 Yuan ming yuan (Beijing), 22–3, 296–7
gaping dragon – *see* – dragon
Gate, East Glorious, 43
 First, of Heaven, 24–5, 280, 285
 Front: official name – *see* – Gate, Southern
 Inner Right, 85
 Meridian, 24–5, 33, 36–9, 53, 222–3
 South Water, 288–9
 Southern; i.e. Southern gate of the old Inner City, 28
 West Straight, 288–9
Gate of Correct Conduct, 48–9
 Doubled Glory, 280, 285
 Dragon Light, 294
 Earthly Peace, 29
 Earthly Tranquillity, 10–11
 Following Righteousness, 281
 Gathering Essence, 225
 Glorious Harmony, 48–9
 Harmony and Righteousness, 19
 Heavenly Peace, 222–3, 281
 Heavenly Purity, 74–5, 200–201, 206–7, 237, 261, 280, 285
 Imperial Supremacy, 9–10
 Inherited Light, 134
 Initiating Auspiciousness, 209
 Literary Glory, 228–9, 231
 Luminous Virtue, 48–9, 227
 Martial Spirit, 25, 29, 33, 42, 222–3, 231, 235, 245, 275, 292–3
 Phoenix Radiance, 294
 Piled Excellence, 259
 Preserving the Spirit, 136
 Prolonged Harmony, 134
 Serving Heaven, 23
 Spreading Happiness, 143, 239
 Succeeding to Heaven, 18
 Supreme Harmony, 48–9, 50–51, 52, 54, 68–9, 222–3, 227, 231, 232, 261, 289
 the Glorious Moon, 200–201
 the Great Ancestors, 227, 275
 the Great Ming Dynasty, 18–19
 the Great Qing Dynasty, 18–19, 28
 the Pursuit of Truth, 122–3
 Tranquil Longevity, 115, 239
 Truth and Compliance, 142
 Unified Harmony, 48–9, 275
 Uprightness, 222–3
 West Glorious, 222–3
 Worshipping Heaven, 19
geomancy, 26–7
Glazed Tile Canal, 20–21
Glazed Tile Works, 20
Gold, 20, 65
Grand Canal, 20
Grand Council, 205, 206–7, 208
Grand Secretariat, 206–7, 208, 222–3
Great Imperial Ancestral Temple, 19
Great Inner Court: one of the three Yuan dynasty palace complexes, 18–19, 222–3
Great Liquid Pool, 18–19
Great Timberyard Hutong (Alley), 20
Gu hua xuan – *see* – Pavilion of Ancient Flowers
Gu jin shi wu kao ji – *see* – *Verified notes on things past and present*
Gu jin tu shu ji cheng – *see* – *Synthesis of books and illustrations past and present*
Gu lou – *see* – Drum Tower
Guo shi guan – *see* – Bureau of National History

Hall for Worshipping Ancestors, 176–7, 222–3, 245, 273, 275
 Worshipping the Great Buddha, 72–3, 176–7
Hall of Abstinence, 176–7, 257, 285

329

Abstinence (Temple of Heaven), 176–7, 252
Accomplishing Uprightness, 72–3
Active Retirement, 72–3, 120–21, 149
Ancient Physicians, 200–201
Bathing in Virtue, 292–3
Celebrating Old Age, 72–3
Complete Harmony, 48–9, 56–7, 70, 222–3, 296–7, 312, 318
Crystalline Splendour, 136
Establishing Supremacy, 71
Extended Long Life, 138
Exuberance, 176–7, 193
Heavenly Favours (at tomb of Yong le emperor), 212
Imperial Peace, 176–7, 196–9, 222–3, 225, 242, 252, 271
Imperial Supremacy, 114, 115, 222–3, 227, 231, 242, 245, 271, 275
Industrious Energy, 72–3, 200–201, 296–7
Literary Elegance, 200–201, 205
Literary Glory, 48–9, 222–3
Luminous Benevolence, 200–201
Luxuriant Foliage, 200–201
Manifest Harmony, 277
Manifest Origin, 162
Mental Cultivation, 72–3, 86–96, 235, 240, 252, 254, 300
Middle Supremacy, 70
Military Eminence, 48–9, 200–201, 222–3, 292–3
Pleasurable Old Age, 72–3, 115–19, 247, 249, 252, 262, 299
Praying for a Good Harvest (Temple of Heaven), 212
Preserving Harmony, 48–9, 56–7, 71, 222–3, 225, 261, 271, 296–7, 312, 323, 332
Remitting the Mind, 292–3
Respectful Care and Contentment, 21
Southern Fragrance, 257, 266–7, 273
Spiritual Cultivation, 72–3, 115
Supreme Harmony, 48–9, 56–7, 58–67, 222–3, 225, 227, 228–9, 231, 235, 236, 240, 252, 253, 261, 268, 271, 285, 292–3, 296–7, 312–15, 317, 318, 320
the Splendid Canopy, 61
the Treasures of the Sky, 176–7
the Ultimate Principle, 72–3, 106–7, 231
Union, 72–3, 74–5, 80–81, 222–3, 225, 233, 240, 245, 254, 321
han bai yu, white marble, 21, 212–21
Han lin Academy: during the Ming and Qing dynasties, this the Imperial Academy, at the apex of the intellectual pyramid, was responsible for re-establishing literary pursuits according to Confucian orthodoxy and imperial utterances, 72–3, 200–201
Han qing zhai – *see* – Study of the Embodiment of Purity
He Kun, 300
he xi: polychrome painted decoration reserved for the highest ranking imperial buildings, 54, 65, 266–7, 321
He yi men – *see* – Gate of Harmony and Righteousness
Hill of Piled Elegance, 120–21, 134

Hong yi ge – *see* – Pavilion of Glorifying Righteousness
hu: an elongated ceremonial tablet, pointed at the top when held upright by high-ranking officials and the emperor. Usually made of jade or ivory, it originally bore the requests made to and replies received from the emperor when memorializing the throne, 49, 61
Hua gai dian – *see* – Hall of the Splendid Canopy
Huang di fa jia lu bu tu – *see* – paintings
Huang di nei jing, 26
Huang he lou tu – *see* – paintings
Huang ji dian – *see* – Hall of Imperial Supremacy
Huang ji men – *see* – Gate of Imperial Supremacy
Hui feng ting – *see* – Pavilion of Favourable Breezes
Hui yao lou – *see* – Building of Wisdom and Sunlight
Hundred antiquities: traditional subjects and themes for use in decoration employ 'one hundred' to denote profusion, e.g. sons or children, deer, flowers. Included in the 'hundred antiquities' are objects from the scholars desk and archaic bronze vessels, symbolizing the literary and cultural pursuits of the Confucian gentlemen, 247
 deer, 159
 sons or children: denotes great progeny for the receiver of a gift bearing this design, 83
 flowers, 262

Imperial Library – *see* – Pavilion of Literary Profundity
Imperial Reading Room, 200–201
Imperial Way: the main thoroughfare following the south to north axis which bisects the Forbidden City, 24–5, 48–9, 212–17, 289, 313
Important documents of the Tang dynasty (Tang hui yao), 232
Inner City: during the Qing period, the capital of Beijing was divided into main areas by walls pierced by gates; the inner Manchu and imperial (including Forbidden) cities in the north and central part, and the outer Chinese city to the south
Inner Court: the residential area of the Forbidden City, 24–5, 26–7, 56–7, 72–3, 280, 300
Inner Golden River – *see* – Rivers

Jade Spring Mountains, 288–9
Jasper Island, 18–19
Ji yun lou – *see* – Building of Auspicious Clouds
Jian fu gong – *see* – Palace for the Establishment of Happiness
Jian ji dian – *see* – Hall of Establishing Supremacy
Jian ting – *see* – Arrow Pavilion
Jiang xue xuan – *see* – Pavilion of Red Snow
Jiao tai dian – *see* – Hall of Union
jin: Chinese measure of weight = 0·5 kg.

Jin Fei, concubine, 73
Jin shen dian – *see* – Hall of Respectful Care and Contentment
Jin shui he – *see* – River, Golden
jin zhuan – *see* – bricks
Jing fu gong – *see* – Palace of Great Happiness
Jing qi ge – *see* – Pavilion of Great Happiness
Jing ren gong – *see* – Palace of Great Benevolence
Jing shan – *see* – Prospect Hill
Jing sheng zhai – *see* – Study of the Respect of Excellence
Jing yang gong – *see* – Palace of the Great Yang
Jing yi xuan – *see* – Pavilion of Quiet Harmony, Pavilion of Serene Tranquillity
Jing yun men – *see* – Gate of Great Fortune
jiu long bi – *see* – Nine Dragon Screen
Jiu qing fang – *see* – Nine Ministries
Ju ting – *see* – Pavilion of the Carpenters' Square
Juan qin zhai – *see* – Study of Peaceful Old Age
Jun ji chu – *see* – Grand Council

kang: hollow platform bed widely used in north China usually made of bricks and heated from below, 83, 150, 296–7, 299
Kang xi nan xun tu – *see* – paintings
Kiln Terrace, 21
Kuai Xiang, master craftsman, 21
Kun ning gong – *see* – Palace of Earthly Tranquillity
Kun ning men – *see* – Gate of Earthly Tranquillity

Lamaism, 72–3, 83, 176–99
Lei, family 22–3
Le shou tang – *see* – Hall of Pleasurable Old Age
Lei Fada, 22–3
Lei Li, master builder, 22–3
Li: Chinese measurement of distance = 0·5 km.
Li Guangdi, 292–3
Li he dian – *see* – Hall of Manifest Harmony
Li yuan dian – *see* – Hall of Manifest Origin
Li Zicheng (1605?–1645): bandit leader who rebelled against, and contributed towards the downfall of, the Ming dynasty, 48–9
lime, 21
Lin xi ting – *see* – Pavilion on the Brink of the Brook
Ling en dian – *see* – Hall of Heavenly Favours
Ling xing si – *see* – Temple, Ling xing
ling zhi: *ganoderma lucindum*, fungus of immortality associated with Taoism which can only be found by the Sika deer, 98
lion: the animal is not indigenous to China but as a subject in art was introduced along with Buddhism from India; it is a symbol of princely virtues and is the defender of the Buddhist law. Hence they are often found in pairs – the male playing with a ball, the female with a cub – outside temples and the palaces of princes, 55, 110, 212, 217, 220, 232, 235, 239
Liu li wa chang – *see* – Glazed Tile Works
Liu Tingqi, 22–3
Liu Tingzhan, 22–3
Long fu gong – *see* – Palace of Prosperity and Happiness
Long guang men – *see* – Gate of Dragon Light
Long zong men – *see* – Gate of the Great Ancestors
Longevity Hill – *see* – Prospect Hill
Lord of the Black Pavilions of Heaven, 197–9
Lu Xiang, master craftsman, 21
Lu shan, 21

Middle Lake, 146
Ming gong shi – *see* – *Chronicle of the Ming imperial palace*
Miscellaneous jottings from Wan ping county office by Shen Bang, 296–7
moat, 18–19, 44, 46–7, 288–9
Mongolian Princes' Office, 206–7, 208
moon door, 151
moon gate, 160
Mountain-Climbing Gallery, 149

Nan chan si – *see* – Temple, South Chan Buddhist
Nan hai – *see* – South Lake
nan mu: *Machilus nanmu* or *Phoebe nanmu*. Commonly referred to as cedar. Hard wood reserved for the finest work as well as for coffins, 20, 200, 252, 304
Nanjing, 18–19, 200–201
Nan shui guan – *see* – Gate, South Water
Nan xun dian – *see* – Hall of Southern Fragrance
Nei cheng – *see* – Inner City
Nei ge – *see* – Grand Secretariat
Jei jin shui he – *see* – River, Inner Golden
Nei ting – *see* – Inner Court
nine: nine and its multiples are the most 'perfect' numbers of Chinese philosophy and incorporated into the construction (e.g. number of bays in a building, stone flags paving temples etc.) of the highest ranking of buildings, 24–5, 214
'nine and five', 32–3
Nine Dragon Screen, 280–83
Nine Ministries, 206–7
Ning hui tang – *see* – Hall of Crystalline Splendour
Ning shou gong – *see* – Palace of Tranquil Longevity
North Lake (Beihai Park, Beijing), 20–21, 288–9

Outer City – *see* – Inner City
Outer Court: the ceremonial area of the Forbidden City, 24–5, 26–7, 40–41, 48–9, 296–7, 300

Pa shan lang – *see* – Mountain-Climbing Gallery
paintings

330